Patterns that Connect

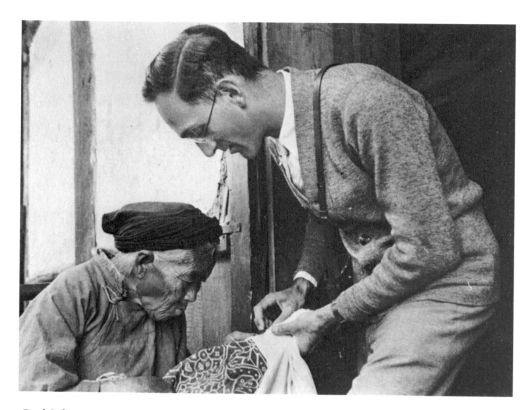

Carl Schuster, West China, 1935

PATTERNS THAT CONNECT

Social Symbolism in Ancient & Tribal Art

Carl Schuster *&* Edmund Carpenter

Harry N. Abrams, Inc., Publishers
New York

Library of Congress Cataloging-in-Publication Data

Schuster, Carl, 1904–1969.
 Patterns that connect : social symbolism in ancient & tribal art /
Carl Schuster & Edmund Carpenter.
 p. cm.
 Includes bibliographical references.
 ISBN 0–8109–6326–4 (cloth)
 1. Art, Primitive. 2. Art, Ancient. 3. Folk art. 4. Material
culture. 5. Symbolism in art. I. Carpenter, Edmund. II. Title.
N5310.S365 1996
709'.01'1—DC20 96-12825

Published in 1996 by Harry N. Abrams, Incorporated, New York
A Times Mirror Company

Printed and bound in the United States of America by The Stinehour Press

Table of Contents

Preface

Before writing this book, I published a larger edition of it entitled *Social Symbolism in Ancient & Tribal Art*: 3500 pages, 7000 illustrations, 12 books in all; and deposited sets in 600 academic libraries. Both editions are based on the researches & writings of Carl Schuster (1904–1969). The larger edition honors him in a way space precludes here.

In writing both texts, I used his words wherever possible. I also followed his approach, excluding no relevant category of traditional culture, since evidence from various categories often interlocked. Moreover, I juxtaposed data from diverse cultures, periods, continents. I did so in the belief that the proposed analogies are more real than the boundaries they transgress and that certain preconceptions of cultural history need revision, not the evidence that violates them.

Nothing about Carl Schuster's work evoked greater skepticism than this approach. The notion that incised stones in Spain might relate to similar stones in Patagonia seemed absurd to specialists. Henri Breuil warned him: 'Everytime is mixing thing from quite different counties one will arrive to nothing!'

Past foolishness by popularizers provided Carl's critics with labels of derision: Diffusion, Psychic Unity, Universals, Archetypes, etc. None fit. His superb library ignored Frazer, Frobenius, Jung, Campbell, diffusionists generally and the entire Kulturkreise school. If he had any mentor (he didn't), it might have been Ananda K. Coomaraswamy.

'Whoever wishes to understand the real meaning of these figures of speech [figures of thought]', wrote Coomaraswamy, 'must himself learn to think in these terms. Only when it is found that a given symbol . . . has a genetically consistent series of values in a series of intelligible contexts widely distributed in time and space, can one safely "read" its meaning elsewhere. . . . It is in this universal, and universally intelligible, language that the highest truths have been expressed'.

Carl Schuster's primary interests were patterns of organization underlying traditional arts. To discover such patterns, he turned from historical analysis to pattern recognition. This meant foreswearing context in favor of an unflinching look at the designs themselves.

Mark Siegeltuch writes: 'Today's speed-up of information flow, with consequent information overload, forces us to abandon analysis in favor of pattern recognition. This shorthand is really a dismemberment of history in which all context is lost. History survives only as an art form in print culture. The public has already lost the sense of chronology, once fundamental to Western education. The right approach is more important than all the details.

'The central role of memory in perpetuating [traditional] cultures generates formal patterns of organization which are remarkably ancient and remarkably stable over time. This is why we feel such a similarity in religious doctrine, folklore, art, and architecture throughout the world. With the death of the comparative method after World War II, American universities embarked on a program of specialization in all areas of history, religion, and anthropology which has all but obliterated those "patterns that connect"'.

In 1955, Carl submitted for publication a study of paleolithic survivals. It was rejected on the advice of an editorial reader who wrote: 'the premise that prehistoric art can be interpreted by modern primitive art is out of date'.

Fashions aside, tribal arts offer a valuable—perhaps the only—means of penetrating certain areas of ancient art, hitherto *terra incognita*. Schematic art of prehistoric times will remain a subject of futile speculation as long as it is *not* placed on a comparative basis with modern tribal designs. The basis for this approach is simple: art begets art; if you seek the springs of traditional art, be prepared to dig deep.

The problem isn't lack of evidence. The reality of paleolithic 'geometric' art is hardly in doubt. Much of it has been carefully recorded, published, above all named. In that sense, it is well known. But we are still far from understanding it. Its motifs, insofar as they surpass mere scribblings or show some degree of purposeful organization, have defied many efforts to penetrate their meaning.

Yet variants occur in widely separated paleolithic manifestations: they cannot be casual, local inventions. They must be products of tradition. I find it impossible to believe that they have no reference to the lives of the people who conceived & executed them. Yet it is widely accepted that their meaning can no longer be determined because of the enormous lapse of time since these designs were made, during which, presumably, the cultures in which they arose ceased to exist.

I disagree. I believe certain paleolithic images, customs, even modes of thought, survived in recognizable form into later periods, and that this was true, perhaps especially true, of paleolithic 'geometric' art. Much of it never ceased to exist at all. We simply didn't know where to look for its survivals, or failed to recognize them for what they are.

Many reasons explain this default: specialists unwilling to venture beyond their specialties, anthropologists regarding every culture as unique, authorities regarding their own works as final, etc. Above all, nobody even dreams of such a thing as a serious comparative, morphological study of traditional designs among modern tribesmen. 'Decorative' art in itself is presumed to be devoid of content, of little historical consequence, suitable only as a plaything for dilettantes, or at best as the subject for purely descriptive monographs which make no attempt to fathom historical depth.

Yet the schematic art of modern tribesmen clearly has deep roots. This goes unrecognized when viewed through a microscope. Carl Schuster's telescopic vision reveals grand continuity.

All efforts to trace a memory-link through yesterday to the ancient past have met with justifiable caution, especially in art & mythology. Obviously a symbol can mean different things at different times & places. Its meaning can change in the presence of other symbols, just as a word's meaning can change (somewhat) in the presence of other symbols. We rightly apply the word 'mad' to any enthusiast who chooses a simple design, assigns it one meaning, then bestows that meaning on all examples. We regard as madder still the person who creates a fictitious model, like the bride of Frankenstein, by assembly, an arm from here, an ear from there.

Art & mythology are always at the service of man's madness. When I compare a Papuan pattern with a Patagonian one, or juxtapose a modern motif and a mesolithic one, then assign a common origin to them all, don't I fall into this same madness? Possibly I do. But the question really doesn't matter: even if these comparisons are legitimate and these interpretations correct, no serious critic would accept them without further evidence.

There is further evidence. *Social Symbolism in Ancient & Tribal Art* illustrates thousands of examples. Many more can be found in museum vaults, ethnographic texts, distant villages. The ideal reader is an informed reader, with broad field experience. For every example illustrated here, that reader knows a dozen more, plus the context from which they come.

The evidence is vast, far beyond what I offer here. And so consistent I cannot attribute it to chance. Those who dismiss these correspondences as mere coincidences remind me of the man who approached the Duke of Wellington, mistaking him for a London school inspector: 'Mr. Brown, I believe?' To which the Duke replied, looking down, 'Believe that, sir, and you'll be capable of believing any damned thing'.

'The problem in archeology', writes Glyn Daniel, 'is when to stop laughing'.

Edmund Carpenter

Family Tree

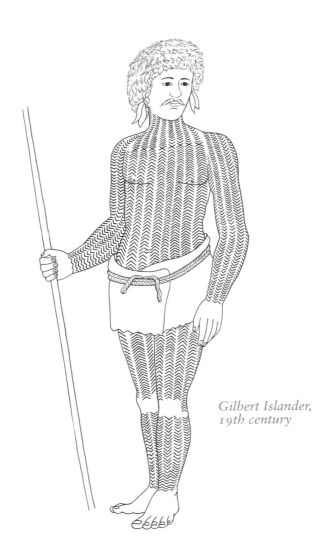

*Gilbert Islander,
19th century*

Anthropomorphic Y-posts

A single idea underlies all of the evidence offered in this book: equating the image of a tree with the branching of the human race. This correspondence between Tree & Genealogy lies beneath a wide range of phenomena in a wide range of cultures, in fact, Culture. Ultimately it rests on the analogy of plant propagation and the notion of human birth from budding.

By its branching, the Tree symbolizes the Tribe, and thereby especially its ancestors to whom sacrifice must be brought. Forked posts used in house construction reflect this symbolism, the house itself being a symbol of the social group (as today in our own language). To me, the forked post is *the* symbolic reduction of the Tree (its use in connection with sacrifice, though important, merely extends its basic meaning as Tree).

Thus the Tree is simultaneously a cosmic man and a tribe whose limbs or branches represent successive generations: the man of many limbs; Wordsworth's 'a tree of many one'.

Tree-men take various forms: notched posts, shaved sticks, anthropomorphic ladders, etc. Notches or shavings serve as artificially-made limbs: each tier or tread represents a generation, with the godhead (First One) or godheads (First Couple) at the top and their lineal descendants below, generally shown headless.

Similarly, the nodes or knots of a branching tree are conceived as tantamount to human 'joints' and act as symbols of propagation. Notches may be substituted for nodes or joints.

This association of Tree & Genealogy dates from at least Upper Paleolithic times. What began, I assume, as a 'natural' metaphor, became—quickly, perhaps—an elaborate symbolic system that included limb-sharing ancestors; two-headed, joint-marked figures; and much more. There is nothing 'natural' about these systems: they are inventions, transmitted by word & practice.

Many people equate the branching of a tree with the genetic union & division by which every family, clan or tribe perpetuates itself. They express this association of ideas in language & myth, and visually depict a 'family tree' as anthropomorphic, providing it with appropriate human attributes.

Branching tree trunks make ideal Y-posts to support crossbeams. But many are more than architectural: just as a tree provides a simple metaphor for the inevitable 'branching' of all genealogies, so a Y-post provides a simple genealogical diagram.

Carving a human head at the end of each branch makes this symbolism explicit. Generally the right branch represents the paternal heritage; the left branch, the maternal. Breasts & genitals are often added at appropriate places, or a face carved at the fork of the Y. Even without these additions, a tree or post may be venerated as a symbol of tribal unity. Among the Pacific-island Tikopians, certain house posts are apostrophized, clothed & anointed as deified ancestors, without being carved to represent them.

But, sooner or later, and probably very soon, people began to express the anthropomorphism implicit in this concept of a family tree. The simplest method was to carve human heads or faces on posts. Such posts often marked places of sacrifice, indeed *the* places of sacrifice, sometimes for the sacrifice of humans. Virtually everything we are told by people who erect such posts, or remembered the days when they were ceremonially important, indicates their importance to the social group. I doubt that this importance can be understood without reference to the central concept of the Family Tree.

Miniature, portable versions often coexisted with large Y-posts and enjoyed the same symbolic associations.

All this reflected a theology in which God & man alike are Trees, the latter in the likeness of, as well as an offshoot of, the former. Traces of this vegetative symbolism survive in many later religions: 'As is a tree, yea just as is the Lord of Trees, is verily the man' (*Brihadāranyaka Upanisad* III:9,28). 'I am the vine, ye are the branches' (*John* 15,5).

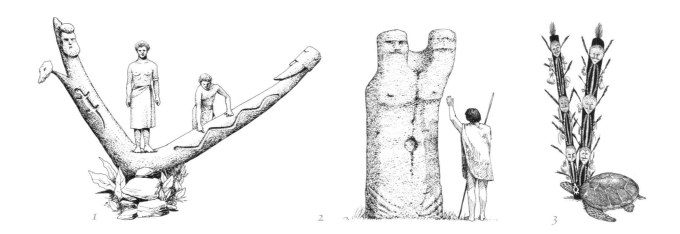

Captured warriors were once impaled on *1*, a Y-post in New Ireland, then eaten. The cup-shaped receptacle in *2*, a two-headed stone post on Easter Island, was designed to receive offerings of human flesh. Scarcity of trees may explain why it was carved of stone, not wood, which symbolically might have been more appropriate.

The appropriateness of the Y-shape is best seen in *3*, from the Torres Straits: two carved & painted boards, slanting outward, were erected for ritual turtle sacrifice.

Y-post *4*, from the Sepik area of New Guinea, has a human figure at each branch, and human faces, including inverted examples, on the trunk. Burying a captive alive beneath such a post was once traditional in this area.

Anthropomorphic forked posts were common in the neighboring Lake Sentani area, *5*. Here 'mythological couples' lean away from each other, like Y-post branches. In the New Hebrides, anthropomorphic forked sticks, *6*, co-existed with forked posts.

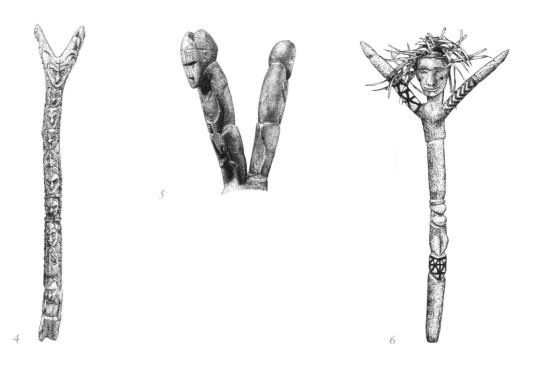

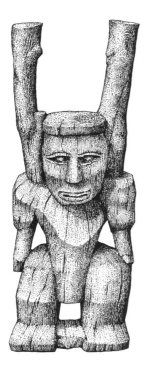

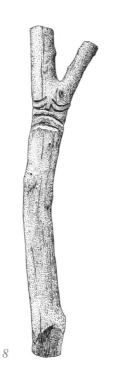

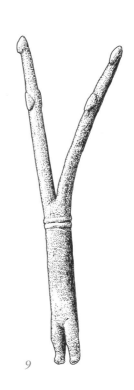

7 8 9

Forked, anthropomorphic posts were ritually significant in Micronesia, 7, from a men's house on Palau. They were equally significant in Polynesia, 8, from the Hawaiian Islands. The forked stick in 9, from Mangareva, has a human torso & legs, plus knobbed ends and raised elliptical forms on each branch suggesting abbreviated heads.

Post 10, from Borneo, though not specifically a Y-post, helps us to understand such posts. The Nias of Sumatra had both Y-posts & Y-sticks, 11, some anthropomorphic, and all with ancestral associations. Example 12 adds one key element: notching. I see those notches, here and on a variety of related posts, as representing ancestral generations, with the figure as a whole constituting a simple genealogical diagram.

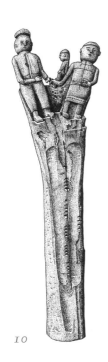

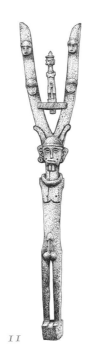

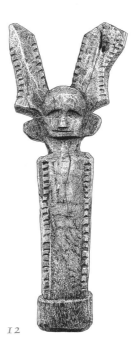

10 11 12

Traditionally the Kuttia Kond of northern India erected forked pillars, *13*, for human sacrifice. Designs on these pillars appear to be merely 'geometric', but more probably survive from ancient patterns with genealogical intentions. Every Kuttia Kond house once displayed a Y-post, always forked, sometimes anthropomorphic, *14*.

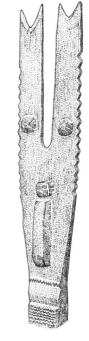

14

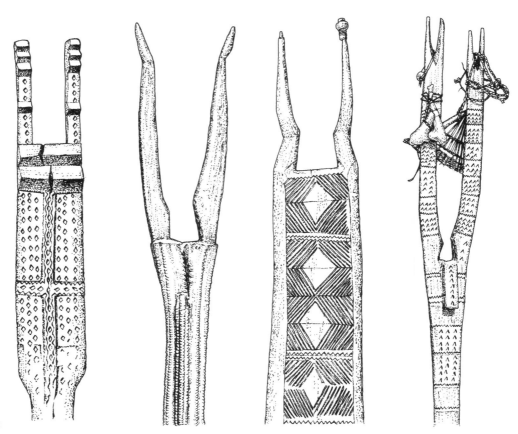

13

Stone menhirs were interchangeable with wooden Y-posts (and presumably derived from them) in Indonesia, Melanesia, parts of Africa, and particularly in the Naga Hills of Assam. The Angami Naga post in *15* has a human head at each extremity, a column of heads on each branch of the 'Y', and breasts on the trunk.

The Ao Naga, who erected *16* as a monument to a warrior, sacrifice buffalo at such posts. Conceivably buffalo now substitute for human victims. The association here & elsewhere of horns & branches may be fortuitous. The original association, I think, was between the limbs of a tree and the limbs of a deity.

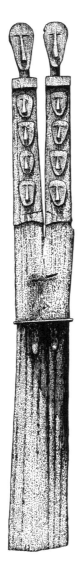

15

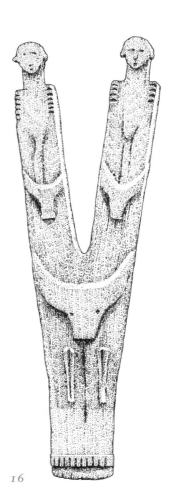

16

The anthropomorphic Y-post is well represented across Siberia, *17*, a two-headed example from the Ude. Two petroglyphs near Yenisey, *18*, dated circa 200–0 BC, show sacrificial animals tethered to a leafless Y-post.

Miniature Y-posts occur widely in Siberia, *19*, from the Teleut. They are said to embody all the characteristics of their full-scale analogs.

Each 'arm' of *20*, an Ostyak shaman's drum, from the extreme western Siberia, carries a series of human faces, with the lowest faces inverted.

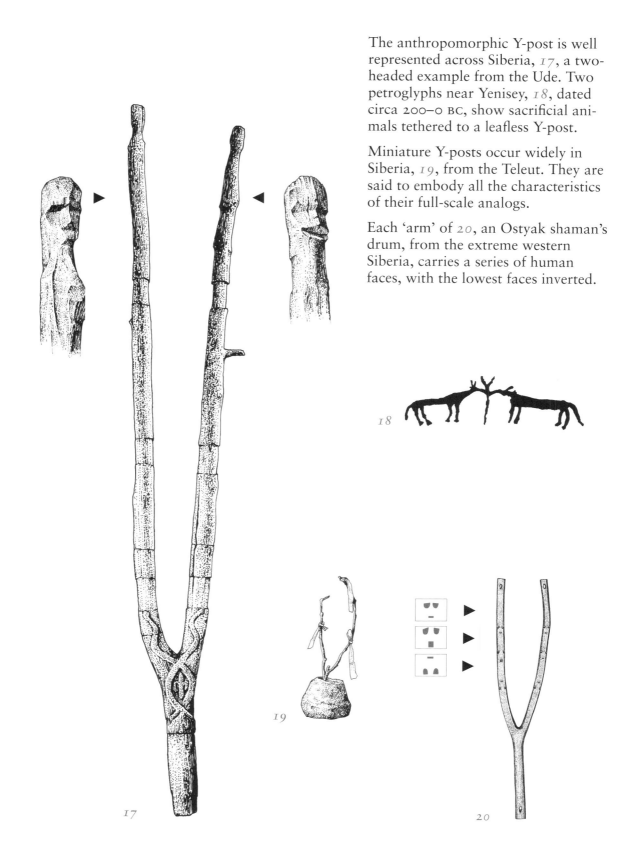

17

18

19

20

Figure 21, an iron pendant attached to a Ket shaman's costume, represents a human tibia. At the upper end, in the position of the knee-cap, are two human heads. No record survives telling us why the Ket rendered a knee-cap in this particular form, but in various parts of the world, the knee-cap, as a primary joint, is depicted as a human face representing an ancestral spirit. In the case of a shaman, his 'ancestors' presumably were shamans whose powers he inherited.

Nor are we told why this knee-cap is doubled, but in view of the widespread occurrence of double-headed images and especially anthropomorphic Y-posts among Siberian peoples, perhaps this object merely fused two related motifs. Here the patella, as a pair of human heads, plays upon the mystique of origin & descent, especially upon the symbolism of 'branching'.

To the south of the Kets live the Enets, who made the diminutive wooden fork in 22. We are told that the two heads represent 'the father and mother of fire'. It was thus a tutelary divinity and was kept in the tent as protection against death from cold.

The clothed figure in 23 had a similar function. This two-headed 'spirit of the tent' comes from eastern neighbors of the Enets on the Taimyr Peninsula, and thus extends this tradition to the extreme inhabited north of Arctic Asia.

To the south, Y-posts served the Ainu as grave-posts, 24.

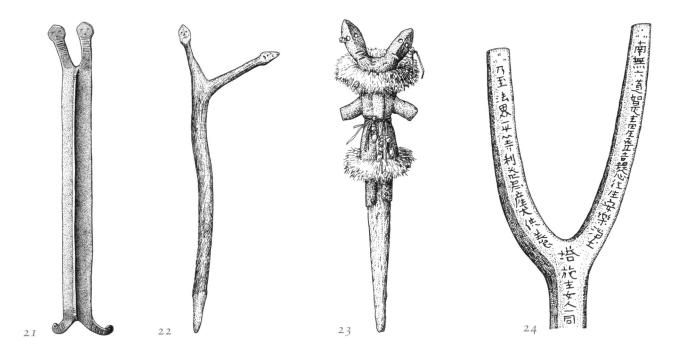

21 22 23 24

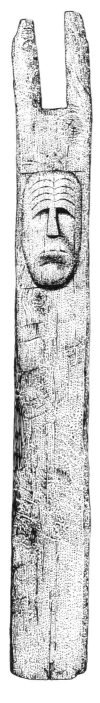

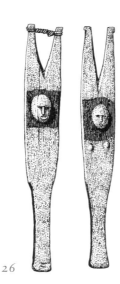

There seem to be no clear-cut examples of anthropomorphic forked posts in North America. The closest example I can offer is 25, one of twelve Delaware houseposts lining the walls of a ceremonial Big House. Each bore the image of a human face. Two larger faces were carved on the center post, which supported the roof: one faced east, the other west. Each face was divided down its center: one side red, the other black.

The Lenape-Delaware had paired, sacred drumsticks, one male, the other female, 26. These weren't two-headed, but they were forked. So were sticks used by Laplanders for tapping 'the magic drum'.

The Klamath of Oregon used a forked-stick with mnemonic notches along each branch for counting in a game. The Arapaho used a ceremonial forked-stick to take meat from kettles at certain dances. Neither stick was two-headed, nor even anthropomorphic, yet I think these pronged drum-sticks, game-counters and ritual meat-prongs derive ultimately from the same ancient tradition.

On the Northwest Coast, forked elk-horn clubs, 27, were reputedly reserved for human sacrifice. Like their Athabaskan counterparts, 28, their designs often included genealogical motifs. Miniature clubs co-existed with larger ones.

Branching elk-horn clubs with genealogical motifs occur in the Hopewellian culture of Ohio & New York, circa AD 300, 29.

26

25

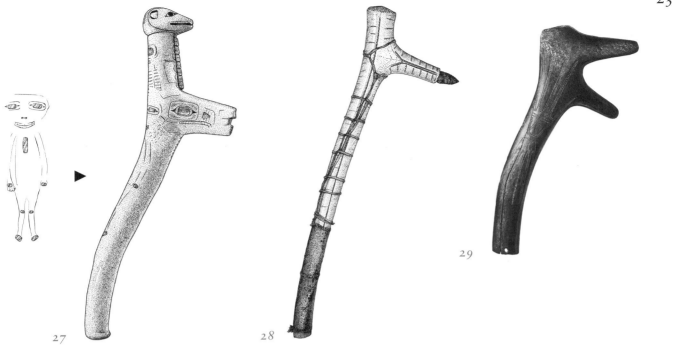

Carvings *30* & *31*, from the Cuna & Choco of Panama, share many features with double-headed forked posts, including sex-differentiated branches.

In ancient Peru, anthropomorphic forked posts, *32*, served as memorials, though I know of none with two heads. However, spear-throwers or ritual objects resembling spear-throwers, *33*, were forked, with male & female branches.

New World evidence is very weak, perhaps diluted by time. Clearly the custom of making anthropomorphic Y-posts never prospered in the Americas. What little survives is mostly in miniature, with the best examples from Central & South America.

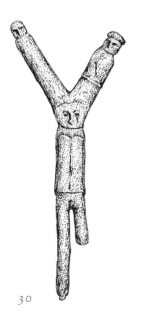

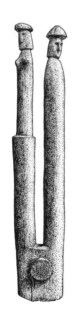

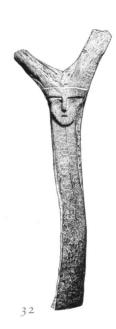

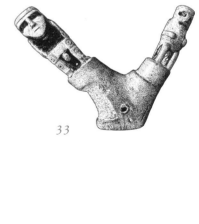

30

31

32

33

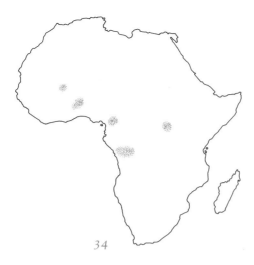

34

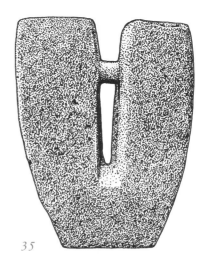

35

Y-posts in Africa are confined princi-
pally to Negro West Africa, but occur
as far east as Ethiopia, *34*. The vast
majority—and that majority is vast—
are of wood, but a few were fashioned
in stone, *35*, AD 7th–8th century,
Senegal.

The Dogon of Mali commonly carved
anthropomorphic (female) forked
posts, *36*, including notched exam-
ples, *37*, and miniature, segmented
ones as well, *38*. Certain of the last
resemble grave-makers, *39*, made by
the Moro Kodo of the Nilotic Sudan,
who sometimes clothed them, *40*.

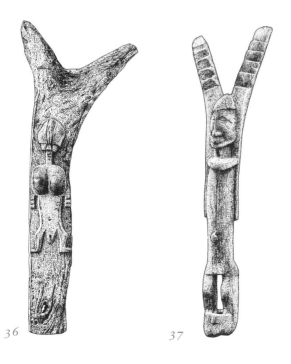

36 37

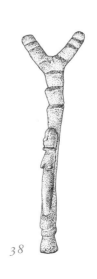

38

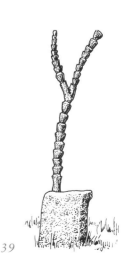

39

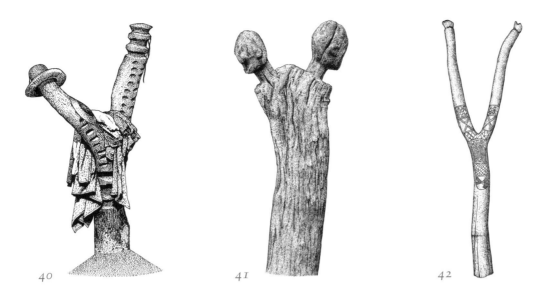

40 41 42

Two-headed forked posts occur in Nigeria among various tribes, including the Dahomey, 41. Example 42, from Cameroon, has nobbed branches.

Of three Lori grave posts, 43, from the Congo, one has a human face, breasts & vulva; another has a human face & penis; the third has breasts & vulva. Each has a natural 'kink', accented by carving, in the position of the buttocks. The prongs or limbs of all three are notched along each edge.

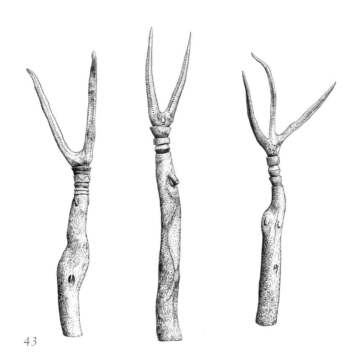

43

Great antiquity could explain the wide distribution of double-headed Y-posts, yet no truly ancient example is known to me. Wood survives for many millennia only under extreme dryness, permafrost, submersion in liquid, or chemical alteration. Unless & until hazards of archeology reveal a wooden forked-post with two heads, the best example remains 44, a single-headed post excavated from a neolithic lacustrine deposit in northern Germany, early 4th millennium BC.

The head of 44 has a flat anterior surface on which features may have been painted. Two vertical channels between the rump & neck delimit arms. The whole is simple & crude, much like Siberian posts. The carver used a kink in the trunk to serve as a rump. Steatopygia (massive buttocks), a prominent feature of paleolithic art, continued to characterize female images into neolithic times, and even later.

Two shorter poles flank 44. The excavator of this site guessed they stabilized the main post by means of cords. My guess is they represented subsidiary figures, 'children' of the clan ancestress'. Like megalithic stone 'families', these are not 'family' in a social sense, but in a cosmic way: Tribal Founders and their lineal descendants.

Is there earlier evidence? Perhaps, but if so, it's indirect. Compare the design on 45, a modern New Guinea house post, and the design engraved on 46, a Magdalenian *baguette* from France. Both designs are classic genealogical patterns, actually the same basic pattern. This makes no sense at this point, but it will in Chapter 2.

Of course, 45 is a wooden house post, while 46 is a small, bone object of uncertain use. They come from opposite sides of the world. Millennia separate them. Yet 46 may once have been attached to a stick, perhaps a forked stick, and served as a genealogical staff, in the manner of others described here. If so, the genealogical staff, and by implication the genealogical post, go back to at least the upper paleolithic.

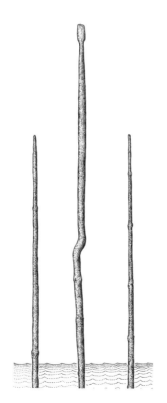

44

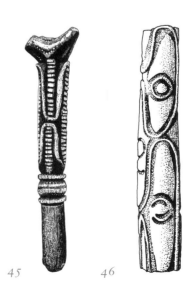

45 46

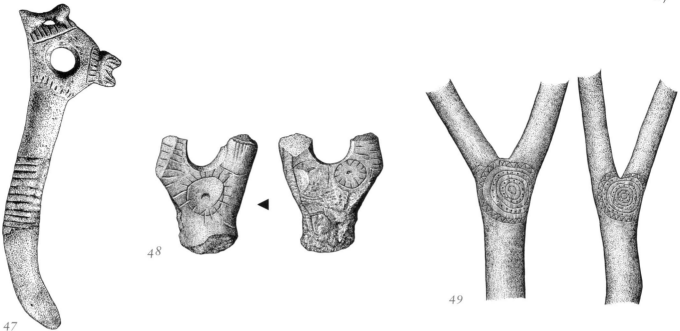

47

48

49

No satisfactory explanation has been offered to date for pierced staffs common in the Upper Paleolithic in Europe. Each consists of a reindeer horn, cut & perforated at its branching, eg 47. Many are richly decorated. About a third have phalliform handles.

They were first called *batons de commandement*, as if they were ancient swagger sticks. But this hardly explains their form. Then they were compared to Eskimo arrow-straighteners. But their holes show little evidence of use, at least from spear straightening, though a few are broken at the hole, 48.

I think it more likely they were ceremonial staffs—miniature Y-posts, like the full-sized Y-posts in 49, from West Africa. Conceivably the hole or circle represents a vagina. Examples that survive are almost uniformly made of antler. In many ancient cultures, antlers & horns were regarded as symbols of fertility & power. As outcroppings of the head, they were thought to possess divine potency.

Putting antlers ('horns of consecration') on the head of a shaman in paleolithic Europe or modern Siberia, on an Iroquois chief or European folk-performer or ancient Hopewellian, presumably transformed each into a living Y-post—a symbol of tribal unity.

We call an antler shaft a 'stock', a word whose meanings also include: 'The original progenitor, as a man, a race, or a language, from which others have descended or have been derived. The race or line of a family; the progenitor of a family or his direct descendants; line of descent; lineage; family'. *Webster's New International Dictionary*, 1928.

The main shaft of a stag's horn is also called a 'béam' (*OED*:1,12). More commonly, that word is used in two other senses: 'timber' & 'ray'. Originally, all three meanings were related. 'Hornbeam' is simultaneously a tree, an antler and 'a beam of light issuing like a horn from the head of a deity' (*OED*:2).

As 'timber', beam (OE *béam*, 'tree') symbolized the World Tree: rooted in the Underworld, penetrating the Sky Door, branching out over the roof of the Earth, with twelve fruit representing ancestors, its trunk simultaneously an anthropomorphic housepost, sacrificial stake, heavenly ladder, *axis mundi* and rood-tree, the cross on which Christ died.

In *50*, a tree grows out of the chest of the sleeping Jesse. From its branches come Christ's ancestors, the Kings of Judah, here numbering twelve. At the top of the tree is its 'flower', the Virgin & Child. On either side of Jesse stand Christ's spiritual ancestors, the Old Testament prophets who foretell His Coming.

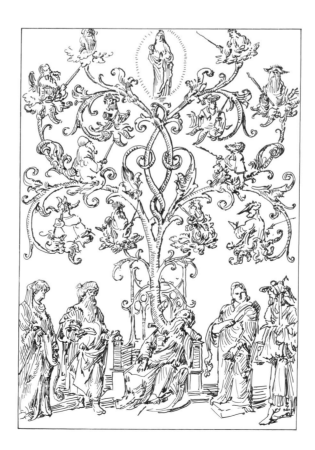

As 'ray', beam symbolized, at least in the Old World, the Sunpillar, a column of radiance emanating from the sun or from God's eye. 'Dear God, don't let me go out of the beam of your eye' was a popular medieval prayer. For those lost in the storm of life, beam became the Eddystone Light; for Southern prisoners, it was the locomotive headlight: 'Shine your ever-loving light on me'.

Eastern & Western religions counseled we human puppets to hold on to, and be guided by, that beam: Plato's 'golden cord', Blake's 'golden thread', etc., with gold symbolizing divine radiance, immortality, truth.

The connection between tree & ray, coincident in the expression *rubus igneous*, echoed the original conception of the immanence of Fire in the 'wood' of which the world is made: 'And the Angel of the Lord appeared unto [Moses] in a flame of fire out of the midst of the bush; and he looked, and behold, the bush burned with fire, and the bush was not consumed', *Exodus* 3,1.

To 'release' fire, the Koryak of Siberia rotated a shaft (symbolizing the *axis mundi*) on the navel of a wooden figure representing the First One. Ancestral helpers, in the form of anthropomorphic forked sticks, 51, often accompanied this fire-related figure.

Branching trees symbolized branching families. Trimmed, they became Y-posts. Trimmed antlers became Y-staffs. Like the larger posts, whose multiple meanings they shared, Y-staffs were often explicitly anthropomorphic. Staff 52, from the Swedish mesolithic, is 'clothed' in heraldic devices.

Our word 'bough' comes from the Indo-European root *bhaghu* (arm). The German marriage memorial in 53, dated 1563, bears the 'family arms' of husband & wife.

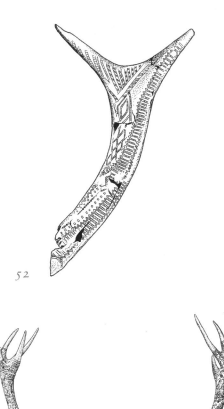

52

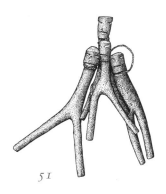

51

53

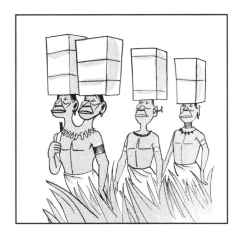

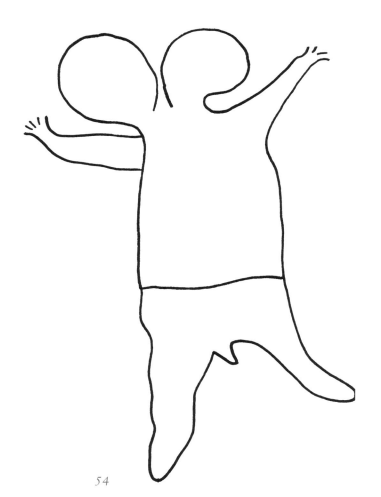

54

Double-headed Figures

The image of the double-headed figure is found on all continents. I doubt that it was independently reinvented over & over again. I believe this motif everywhere derived from anthropomorphic Y-posts. I base this judgement not on double-headedness alone, but on a particular form of double-headedness, plus highly specific details & associations.

I exclude from consideration 'Janus' figures. Two heads placed side-by-side, looking forward are rarer and somehow more peculiar than two heads back-to-back, looking in opposite directions.

No lore is recorded about 54, an Australian petroglyph in New South Wales, 2.9 metres long. But it may correspond to human effigies carved on the ground by the neighboring Kamilaroi, and said by them to represent primordial ancestors.

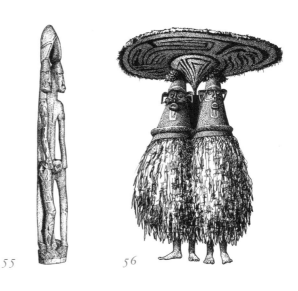

55 56

The wooden post in 55, from south-western New Guinea, was executed in a style thoroughly characteristic of the art of that area. I don't know what two-headedness meant to its carver, but posts of this type were set up, usually in series of four (four clan founders?) within a specially erected ceremonial building. This was done on the occasion of a festival celebrating the creation of the human race, ie this particular segment of it: the tribe.

There are two Sulka dancers beneath 56, from New Britain. Still, I think their common mask represents one figure. The chalk carving in 57, also from New Britain, is in keeping with the distinctive style of the Baining people who made it. This is less true of 58, a chalk figure from New Ireland, but at least it extends the motif to another island in the Bismarck Archipelago.

Figure 59 shows a memorial figure from Vanuatu. Its two heads are clay-coated skulls, modeled into living likenesses. The natives say these two heads represent a deceased chief and his son. The style is thoroughly typical of this part of Vanuatu.

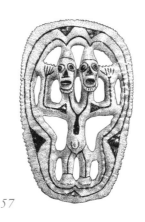

57

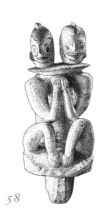

58

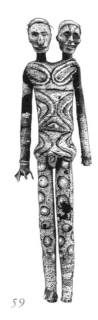

59

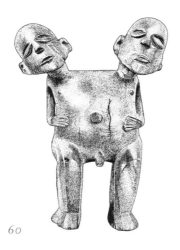

60

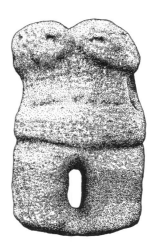

61

Figure 60 comes from Tahiti, while the massive stone carving in 61 comes from the Marquesas Islands.

In many cultures, especially in the Pacific and in Africa, the double-headed figure appears to occur only once. Of those known from Easter Island, only 62 is in the traditional style of that culture. The others, mostly Janus-faced, all look as if they belonged to the decadence after European contact. So 62 may be unique.

Of course, Easter Island may have had other portable examples executed in the good old style, just as it may have had two-headed sacrificial posts other than 2, each for a different clan. If so, then the double-headed image, as a type, probably referred to a particular clan represented by a particular double-headed post.

If this was true of Easter Island, it would be a classic situation, explaining the development of double-headed images in other cultures, even those lacking ritually significant forked-posts.

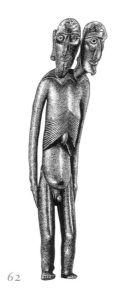

62

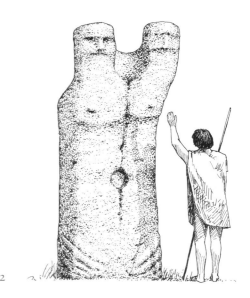

2

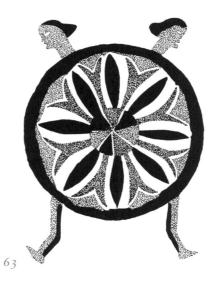

The Pacific evidence shows widespread variations on a common theme: many branches from a common trunk. A Micronesian design from Palau, *63*; and an Indonesian statue from Bali, *64*, corroborate the Melanesian & Polynesian evidence. Again, each is rendered in a style peculiar to its area.

I doubt that this motif, or its underlying concept, was recently transmitted from culture to culture in this vast, culturally diverse area. I think its origin lay in some deeper cultural stratum, antecedent to many of the movements by which various archipelagos were populated & repopulated. I see it as a symbol of great antiquity, one that spread early enough to take on the guises of local styles, as these slowly evolved in various areas.

It has been proposed, especially by medical writers, that double-headed images reflect knowledge of double-headed babies. Yet such phenomena occur only once in many millions or even hundreds of millions of human births. Island populations are very small. I dismiss such rationalizations. I think this motif represents an important tribal belief, not isolated obstetrical observations.

63

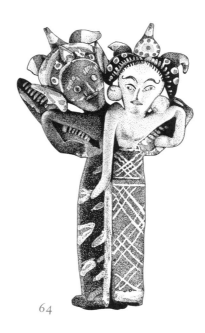

64

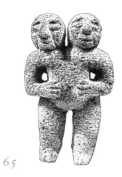

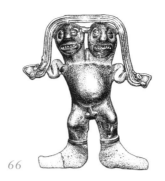

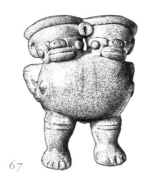

65

66

67

Double-headed figures in Central &
South America include archeological
examples from Costa Rica of stone,
65; gold, 66; and terracotta, 67. The
painted pottery design in 68 comes
from Coclé, Panama.

At least a dozen such images, 69, have
been recovered from the Valdiva cul-
ture of coastal Ecuador, circa 2300
BC. The stone example in 70, from
Argentina, dates after AD 500.

Stela 71, from Chile, has a 'branch-
ing' body. So does 72, a much smaller
figure, probably from Bolivia, circa
500 BC–AD 100.

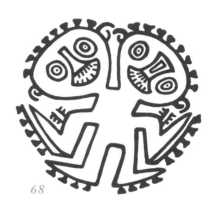

68

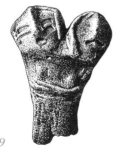

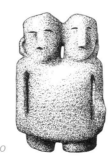

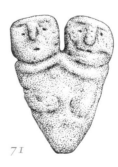

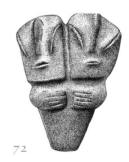

69

70

71

72

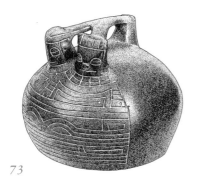

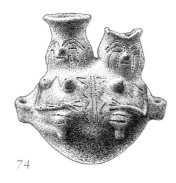

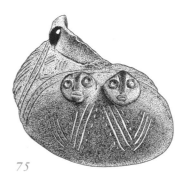

73

74

75

The two-headed (male & female) fig-
ure in *73*, from Peru, dates no earlier
than 600 BC. Like *74*, a Candelaria
vessel from Argentina, it represents a
single figure, as does *75*, with two
heads over one pair of arms.

Pottery vessels with this motif caught
on in Ecuador, eg *76* & *77*, with more
known examples from the Highlands
than elsewhere in all of South Amer-
ica. The Quimbaya pot in *78*, is prob-
ably male, with genitals knocked off.

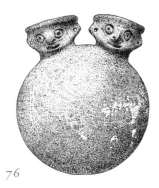

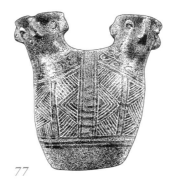

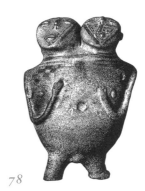

76

77

78

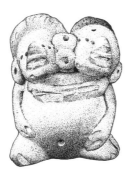

79

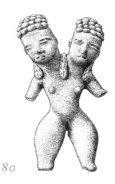

80

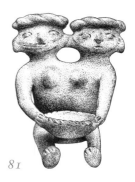

81

In most parts of the world, double-headed figures occur rarely or only once. But in pre-classical Mexico, circa 500 BC, potters mastered the art of rendering plausible replicas of human figures and mass-produced double-headed images. This proliferation has the appearance of an exceptional, almost freakish development.

Examples range from Huasteca, *79*; to the Valley of Mexico, *80*; to the Pacific coast. For each example illustrated here, dozens more could be shown. Clearly these small pottery effigies were immensely popular over a wide area. They were also popular over a long time span. Vessel *81*, from western Mexico, dates from circa AD 300–600.

Did the ease of clay modeling tempt potters to produce endless copies of a powerful, unique image, simply to supply a vulgar demand for talisman? Such multiplication implies loss of significance. As long as double-headed images were made of wood, and their heads carved from branch stumps, they probably still reflected the inherent genealogical symbolism of branching. But when made of stone or pottery, there may have been a tendency to forget this symbolism. The very naturalism of these Mexican two-headed figurines, as well as their multplication, suggests oblivion of their symbolic origin.

Yet the form survived. This distinctive image apparently remained endemic on Mexican soil for at least 2000 years, periodically re-embodied in various forms, including visions. Sketch *82*, from Fray Sahagun's early post-conquest manuscript, shows one of several visions that appeared to the Aztecs as omens of the impending arrival of the Spanish. The fact that the Aztecs could dream or imagine a double-headed man is itself an indication that the type was still somehow known in Mexico as late as the 16th century.

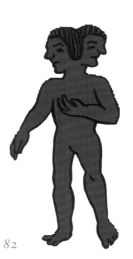

82

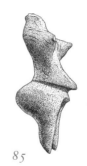
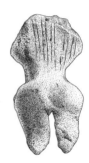

83 *84* *85*

Consider *83–86*. Each belongs to a class of remarkable pottery figurines found archeologically in northwestern Mexico. Most are single-headed, armless, with feet tapering to a point, as in *83*. A few separate the legs. And a surprising number have two heads, *84–86*.

These effigies were probably made by ancestors of the modern Seri who inhabit the area today. On the basis of many (mostly unpublished) examples, those illustrated here can be recognized as female figurines, all but one with two heads, exaggerated breasts, and a type of body-marking practiced by the Seri. Generally the heads are featureless stumps, but on *84*, each head has a nose and perforated septum. Many of these figurines have a series of punch-marks along the shoulder ridges.

Modern Seri disclaim any knowledge of these figurines and are not, themselves, sufficiently capable potters to produce such finely executed, hard-fired images. Yet it is still possible for a modern Seri to imagine double-headed beings. A tracing made in the sand, *87*, shows a ghost or demon who appeared to a Seri boy in a dream—just as a 'double-headed man' appeared to the Aztecs of Central Mexico over 300 years earlier in what turned out to be a very bad dream!

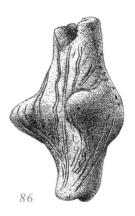

86

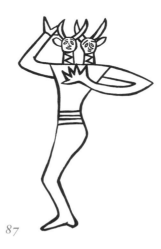

87

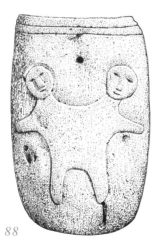

88

North American examples are rare, perhaps reflecting the rarity or absence of ritually significant Y-posts in this area.

The bone carving in *88* was made by a late 19th century Alaskan Eskimo, while the memorial post in *89* marked a Haida shaman's grave, British Columbia.

Other examples could be offered, including an earthwork in Wisconsin. But not all of these are wholly convincing. The importance of two-headed images in Siberia may explain *88 &* *89*. But what explains the absence or near-absence of this motif elsewhere in North America, I don't know.

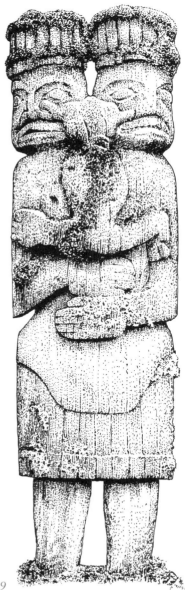

89

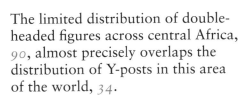

90

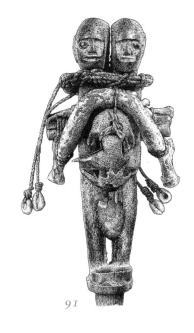

91

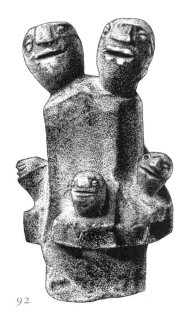

92

The limited distribution of double-headed figures across central Africa, *90*, almost precisely overlaps the distribution of Y-posts in this area of the world, *34*.

Dahomey double-headed images include fetish *91*. A double-headed Kissi figure with three smaller heads, *92*, resembles both a family and a Y-post encircled by branches.

The Lobi figure in *93* comes from the Upper Volta; *94* from the lower Congo; *95* from the Dogon of Mali.

93

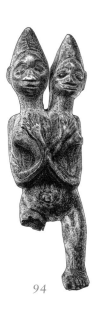

94

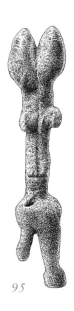

95

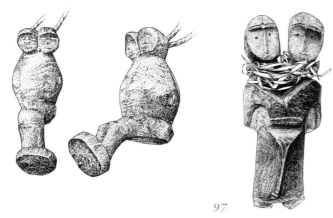
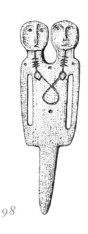
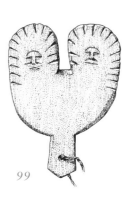

96

97

98

99

Both double-headed forked posts and double-headed figures embody the same conceptions and are generally carved out of branching wood.

In Siberia we find 'archaic' examples of both types. From the island of Sakhalin come two double-headed wooden images: *96*, made by the Gilyak; and *97*, by the Ainu. The two-headed, armless, one-legged Gilyak 'charm' strangely resembles certain two-headed Seri Indian figures with joined legs tapering to a point; in fact, Gilyak charms and Seri *santos* show a remarkable correspondence in their exploitation of grotesque aberrations of the human figure. Two-headedness is only one of these aberrations, but it may be the most important.

Another wooden charm from this area, *98*, has two heads, shoulder holes, and what looks like a 'life-line' connecting each mouth to a common heart or lungs.

'Charm' *99*, from the neighboring Chukchi, may be a portable Y-post. The virtues of the Y-post were then concentrated for the benefit of the wearer. Its owner, a blacksmith, said it represented himself and his spirit-helper or 'assistant' in the blacksmith craft, a craft which, in Siberia, related to shamanism.

Its peripheral notching resembles notching found on the arms, and sometimes on the shafts, of large-scale Y-posts, as well as on single-headed ancestral figures in shamans' cemeteries.

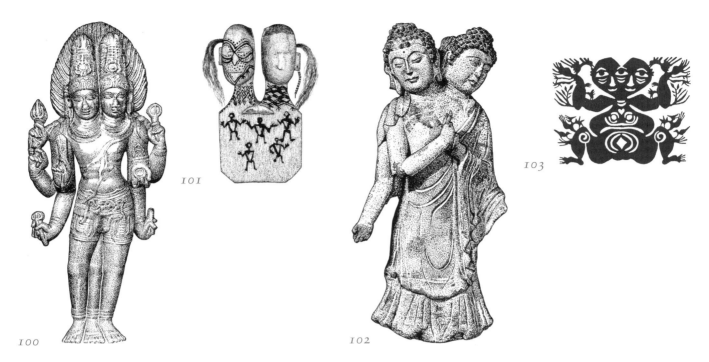

100

101

103

102

Asiatic examples aren't confined to tribesmen. Many gods in the Hindu pantheon are multiple-headed, including Agni, generally depicted Janus-fashion. Why, then, *100*, a two-headed Agni with heads placed side-by-side looking forward? Did the Hindu adopt into their pantheon an image traditional among certain hill tribes of India, for example the Naga of Assam? The Naga had both double-headed images, *101*, and, as we have seen, double-headed forked posts.

When the Chinese pilgrim Hsuan Tsang visited Central Asia in the 7th century, he heard the story of two poor men who separately ordered, at great sacrifice, a splendid image to be made of the Buddha. The craftsman with whom they placed their orders, however, made only one image for the two clients. When they complained that they had been deceived, the image miraculously split in two.

Figure *102*, a two-headed image of the Buddha, Eastern Turkestan, may have been made to illustrate this story, but I think it more likely the story is a rationalization of an ancient image, in keeping with Buddhist piety. Given the prevalence of two-headed images in northern Asia and the great spiritual importance attached to such images, since time immemorial, I suspect that Buddhists of Central Asia adopted into their iconography this potent symbol from a neighboring culture.

That same symbol, in less elegant, more traditional form, occurs in Chinese folk art, *103*, as a two-headed, shameless hocker. Branches with birds on them sprout from her fingers, toes & joints.

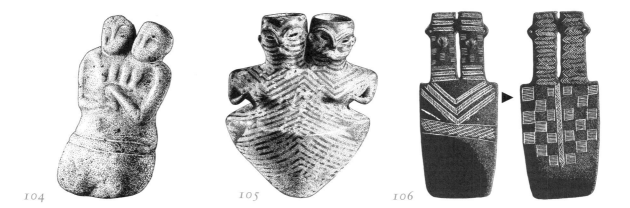

104 105 106

Figure *104*, of stone, dates from the mid-7th millennium BC; and *105*, of pottery, from the late 6th millennium BC. Both come from tumuli in southern Anatolia. They are the oldest two-headed figures known to me, but I doubt that these sophisticated images represent the beginning of that tradition.

Double-headed figurines were found on several early sites in Cyprus, *106*; as well as at Tell Brak, Syria, *107*; and Kul Tepe, Anatolia, *108*. They also occur in Rhodes, *109*; Sicily, *110*; and particularly in the Vinca culture of Central Europe. I offer only one Vinca example, *111*, from Yugoslavia, circa 4000 BC, but I have nearly a dozen others in hand.

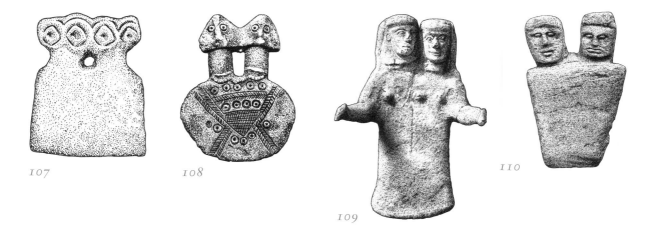

107 108 110

109

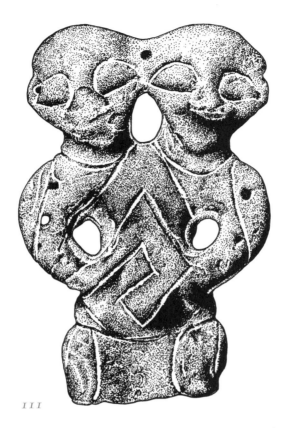

III

All of these examples survive archeologically only by virtue of their imperishable materials. Were there wooden analogs? The triangular shape of *110* suggests that its carver was familiar with wooden forked-posts ending in human heads. And the strongly conventionalized bodies of many of these examples, in contrast to their elaborate heads, suggests the same thing.

This widespread image of a First Being —two-headed, divided down the center male/female—included the androgynous Adam. In *Pagan Mysteries in the Renaissance*, Edgar Wind cites Philo *&* Origen, whose authority ranked high with Renaissance Platonists, that the first *&* original man was androgynous and the division into male *&* female belonged to a later state of creation.

Figures in *112*, from an illuminated manuscript of the *Sachsenspiegel*, a 14th century German legal codex, includes a naked figure with two heads, one male, the other female. This curiously 'primitive' image enabled the largely illiterate people of that time to visualize a scheme of family relationship in cases of litigation over inheritance.

The text accompanying the *Sachsenspiegel* explains that the two heads represent the father *&* mother, while the red spot at the juncture of the neck represents the children. Similar red spots, placed successfully at the joints of the upper limbs, represent succeeding generations: grandchildren at the shoulders, great-grandchildren at the elbows, great-great-grandchildren at the wrists, and succeeding generations at the successive joints of the middle finger of each hand. Presumably the extra dots at the shoulders stand for the heads themselves; they occur, as well, on other surviving codices of the *Sachsenspiegel*, eg *113 & 114*.

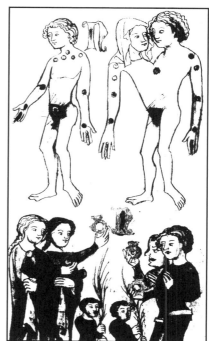

112

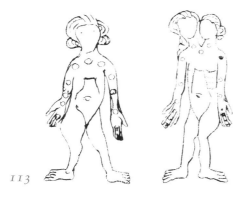

113

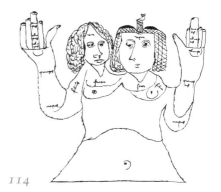

114

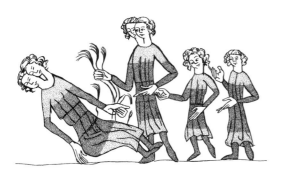

115

Radcliffe-Brown explains: 'The arrangement of kin by degrees of nearness or distance was based on sib-ship (English *sip*, German *Sippe*). A man's sibs were all his cognates within a certain degree. One method of arranging the sib was by reference to the human body and its "joints" (*Glieder*). The father and the mother stand at the head, full brothers and sisters at the neck, first cousins at the wrists, fourth and fifth cousins at the joints of the fingers . . . '.

The explicitly genealogical connotation of *112–115* supports the inference that many double-headed figures, and especially two-headed forked-posts, referred—at least originally and in principle—to genealogical 'branching', whether ascending or descending. Most probably and most often, as in a number of forked-posts, the two heads represent 'clan' ancestors, and only exceptionally *&* conversely, their living descendants.

The red spots on the upper body *&* arms of *112* function as a mnemonic device, but I doubt that medieval jurists invented this kinship chart. I think they merely codified an image from earlier times. I see the red dots as joint-marks.

Is there a special relationship between joint-marks *&* two-headedness? In the *Sachsenspiegel*, each double-headed figure is accompanied by a single-headed figure with identical marks on the limbs. This duplication may represent nothing more than a visual exegesis, as if to say: 'Should you find the double-headed image monstrous or disturbing, you can read the same essential data from a normal, single-headed figure, here provided as a convenient alternative'.

In other words, the double-headed figure with joint-marks represents the older tradition, retained out of deference to antiquity, but provided with a normal counterpart as a gesture to the rationalistic requirements of the age, or perhaps as more appropriate to the dignity of the legal proceedings.

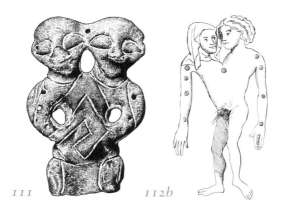

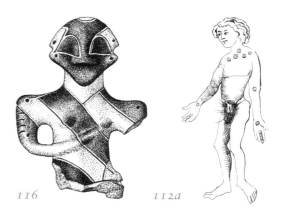

III *II2b* *II6* *II2a*

I see *III* as equivalent to the two-headed *Sachsenspiegel* figure *II2b*; and see the far commoner, more rationalistic Vinca examples like *II6*, as equivalent to the single-headed *Sachsenspiegel* figure *II2a*. The time span between these examples is formidable, but not empty of other examples.

Seri figurines belong to a class of pottery figurines in which single-headed examples, *83*, far outnumber double-headed ones, *86*. Most single-headed examples (and at least two of the known double-headed ones), have series of punch-marks along their arms & shoulders. I suspect that this symbolism belonged first to the double-headed examples, and was derivative in single-headed examples.

If so, double-headed Seri figures with punch-marks on their arms may indicate great archaism—a suggestion supported by other apparently 'archaic' traits in this group of images: steatopypia, hypertrophied breasts, legs ending in a footless point, etc. I know of no other double-headed figures with such markings in the New World.

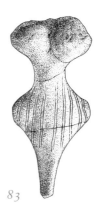

83

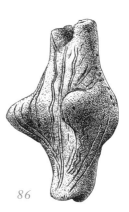

86

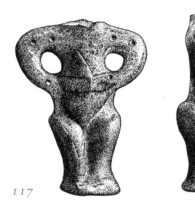 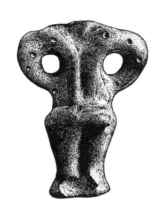

117

I detect a 'natural' association between joint-marks *&* branching: branches grow from the joints of stalks *&* trunks. Joint-marks *&* branching (two headedness) are aspects of the same basic symbolism and originally were united, I think, in one image. A two-headed figure should be joint-marked; a jointmarked figure should be two-headed.

Vinca specimen *111* has an engraved design which I assume represents a mosaic garment, and holes at its shoulders, elbows *&* wrists. These punch-marks give a very tentative impression of being joint-marks, but they do correspond to markings on single-headed Vinca figurines. Note punch-marks at the shoulders *&* elbows of *116*; and at the shoulders, upper arms, elbows *&* wrists of *117*.

European alchemical manuscripts sometimes show a human form with two heads. To indicate the cosmological significance of this figure, alchemists included the sun & moon as background or held in outstretched hands, *118*. Characteristically, but not always, the two halves of this single-bodied figure are separately clothed male & female. Usually, but not always, the two heads are distinctive, each with its own neck. Sometimes these heads face in opposite directions; more frequently they face forward. The tradition survives in puppetry, *119*.

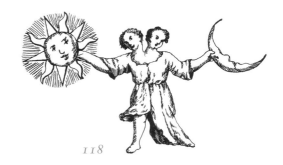

It survives as well in astrological charts of a cosmic figure with twelve zodiacal signs loosely located at its twelve primary joints. Zodiacal figures are often split vertically: half-male, half-female.

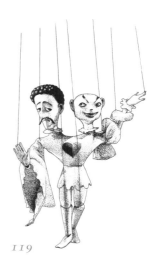

By the Renaissance, two-headed, joint-marked figures had become much debased: Janus-faced, both heads of the same sex, two joined bodies, etc. Increasingly, artists rendered the androgynous form unsympathetically. One alchemist warned that 'the hermaphrodite, like a deadman in the darkness, needs Fire', *120*.

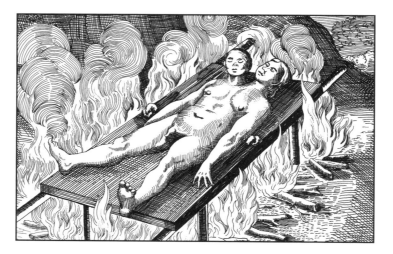

I doubt that the double-headed figure was invented over & over again. Its wide occurrence, in so many different cultures, suggests an old, significant tradition. Only the forked-post, with implied or represented human heads, enjoyed a distribution wide enough, and a meaning deep enough, to have stimulated the development of so many different examples in so many different cultures. I see double-headed figures simply as elaborations of Y-posts—a completion of their anthropomorphism.

Where the ritual forked post and its mobile counterpart existed, eg Siberia & Easter Island, surely the two were associated in the minds of their makers. But, generally, double-headed figures lack symbolic importance. We are left with an impression of vagueness about their meaning, as opposed to the clear meaning of double-headed posts, which can be inferred from ritual usage.

I detect both a special significance and a common conceptual thread running through many examples of forked-posts, but I detect neither of these features in double-headed images. This suggests their derivative nature. A few enjoy genealogical explanations. Others are said to be no more than 'dolls' or children's playthings, mere objects of trivial use—surely the ultimate debasement of an image that may once have symbolized the Tribal Tree.

The apparent absence of double-headed forked-posts in the New World is puzzling. The few anthropomorphic Y-posts that exist have the head at the fork. Yet double-headed images are fairly abundant in certain areas. Does this mean that this motif, at the time it reached the New World, was already established as a separate type, having long before evolved from the forked-post?

I prefer to assume that, contrary to appearances, ritual forked-posts were made in the New World and may yet come to light. If they do, then it was presumably from such antecedents that double-headed figures evolved in the New World, as they evidently did in Asia, Oceania & Africa.

Shaved-sticks

In Asia, Australia & America, shaved sticks enjoy slightly different meanings and play slightly different roles. Yet all closely resemble one another. In material culture, as in language, form persists even when meanings change.

Shaved-sticks occur extensively throughout large parts of Southeast Asia and neighboring areas. In Burma, *121* was set up 'to ward off evil spirits', while *122* served this same function in the Philippines. Example *123*, made by the Penan, a nomadic tribe in the interior of Borneo, has its top split to hold a sacrificial offering, in this case an egg. Tribesmen in this same area combine such sacrificial sticks in groves or fences, *124*. So do the Ainu of Sakhalin Island, *125*.

Elsewhere in Southeast Asia, this sacrificial split-top may be greatly elaborated, *126*, from the Marma of East Pakistan. In 1851, the Riang, a neighboring hill people, erected shaved sticks around a place of human sacrifice and there sacrificed six Kukis.

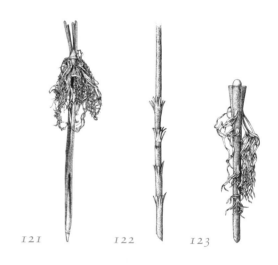

121 *122* *123*

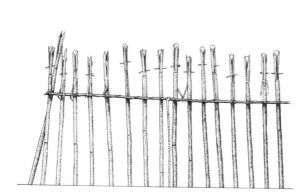

124

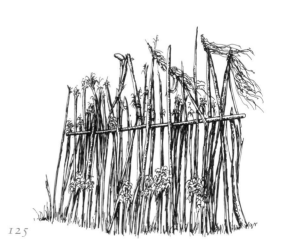

125

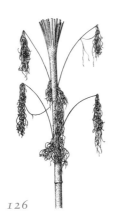

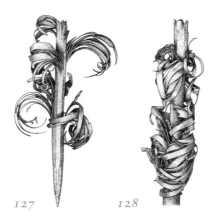

126

127 128

Shaved-sticks or *inao*, used in a religious cult by the Ainu of Hokkaido & Sakhalim, were also split at the top to receive offerings, *127* & *128*. These receptacles are smaller and less conspicuous than the receptacles of shaved-sticks in Southeast Asia, but their function is the same. I think both types relate to each other and ultimately to sacrificial Y-posts & Y-sticks. If so, then Ainu *inao* with tops split for offerings may be rudimentary survivals of a type whose more original form occurs in Southeast Asia and Indonesia.

Shaved-sticks in Southeast Asia, especially those in Borneo, often include the clear representation of a human face. By contrast, the anthropomorphism of Ainu *inao* is relatively unnaturalistic, merely applied by notches, whose resemblance to various parts of the human body or face is purely schematic.

Certain shaved-sticks of the Gilyak, and especially of the Oroks, neighbors of the Sakhalin Ainu, are more obviously anthropomorphic. Compare *129* & *130*—differentiated as 'male' & 'female' by the shapes of their heads —from the Sahkalin Orok, with *131* & *132*, from the Penan of Borneo. The resemblance is obvious. Taken together with the split-top to hold offerings, such anthropomorphism may be further evidence of relationship between the ritual shaved-sticks of Northeast & Southeast Asia.

Two carvings, *133*, made by the Senoi-Semai in Malaya, represent spirits or demons of certain sicknesses. Their shavings clearly represent upper limbs —just as shavings, I believe, originally represented human limbs on Ainu *inao*. Were these Malayan images archaic or prototypic in relation to the *inao*?

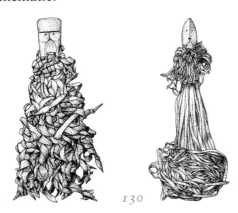

129 130

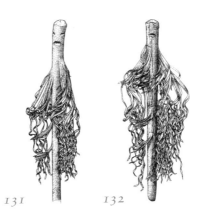

131 132

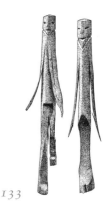

133

There is a striking resemblance between Ainu & Australian shaved-sticks. Yet Australian examples, *134 & 135*, are neither anthropomorphic, nor split at the top for insertion of sacrifices. Moreover, as far as I can learn, they aren't stuck in the ground, but inserted into dancers' headbands, especially in rituals of vengeance.

The distribution of shaved-sticks in Australia suggests that the tradition is old there. Moreover, they are found among aborigines who, in many respects, preserve a very ancient way of life. Conceivably, they represent an early stratum, or remnant of a stratum, of the same tradition of which Asian examples represent a later phase. Yet Asian examples, not Australian, provide the most plausible antecedents for shaved-sticks in prehistory.

In the New World, two Algonkian tribes, the Menominee, *136–138*, and the Potawattami, *139*, placed shaved-sticks on warriors' graves as memorials. Though this tradition survived in only a limited area in Wisconsin and (as far as I know) nowhere else in the New World, I regard it as very old and ultimately of Asiatic origin.

134 *135*

136 *137*

138 *139*

For me, the most important clue to the origin of the shaved-stick is its anthropomorphism. I see the shaved-stick as an anthropomorphic tree, really a family tree, ie a genealogy composed of spiral-limbed figures representing ancestors. In terms of this image, its shavings represent the multiple limbs of a succession of ancestors on a family tree. Thus the shaved-stick is, or originally was, the symbol of an invocation to the ancestral spirits: the more shavings, the more ancestors; the more ancestors, the more help.

There are many indications of the conceptual equivalence of shaved-sticks with trees. The Oroks, whose shaved-sticks take the form of a human figure with a clearly represented face, carve exactly this same face, in larger scale, on the trunk of a living 'holy tree', and place it at such a height that the tree's lowest branches appear as the limbs of a human body under the head. The shavings of the Orok shaved-stick are thus equivalent to the limbs of such a tree.

The same inference can be extended to the Ainu *inao*: shavings on them represent artificially multiplied limbs, both of a tree and a human figure. In other words, shaved sticks are miniature anthropomorphic trees, which can only be understood as personified family trees, symbolic of the ramifications of a social group. Each shaving equals an ancestor; each tier equals a generation.

How 'natural' that the tree or its branching should serve as a symbol of the social group itself: tribe, clan or family. This semantic sequence explains, I think, Ainu preoccupation with branches on grave-posts & libation sticks, and on many of their *inao*, *140*.

140

If the shaved-stick symbolizes the family tree, with the shavings as its branches, how natural to give such a 'tree' human parts, especially a face. Basically & originally this face probably was the face of the clan or tribal ancestor; and insofar as the symbolism of genealogy requires a multiplication of branches, we arrive at the image of an ancestor with many limbs.

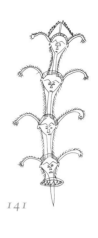

141

This image exists in many cultures, modern & ancient. Limbs are sometimes explicitly plant-like, *141*. The same symbolism occurs in language. In English, 'trunk' & 'limb' simultaneously apply to people & trees, while 'family tree' and 'family branch' extend both metaphors. The most diverse languages employ these metaphors, for the genealogical tree in quasi-human form has deep roots and many branches.

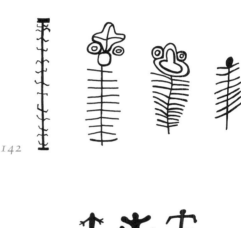

142

Many human/tree images are highly abstract. Yet G. Luquet, who assembled & studied simplified examples from New Caledonia, *142*, recognized their anthropomorphism, as well as their 'phytomorphic appearance' — in other words, the appearance of a tree with many branches. Gutorm Gjessing, who assembled & studied the examples in *143* (from California, British Columbia, two from Polynesia, New Caledonia, Australia & New Zealand), also recognized them as human figures stacked like branching trees.

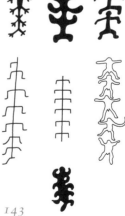

143

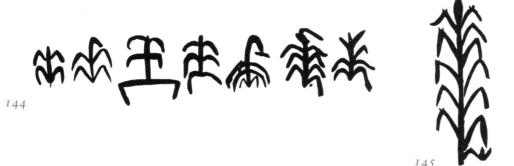

144

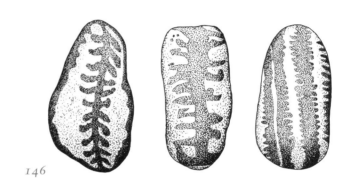

145

Henri Breuil called Spanish examples of circa 4000–3000 BC, *144 & 145*, 'pine-tree men'. Hugo Obermaier, in turn, recognized the kinship of these Iberian 'tree-men' to similar designs on the famous painted pebbles of Mas d'Azil, France, dating from mesolithic times, *146*. I see them all as manifestations of the same basic symbolism underlying shaved-sticks—namely, a family tree.

Breuil also identified three 'pine-tree men' painted on *147*, a dolmen in Portugal. That same motif appears in *148*, prehistoric Hawaiian tattoo; and *149*, modern Moroccan tattoo.

146

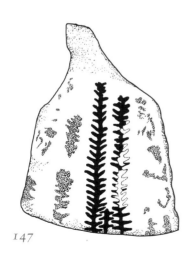

147

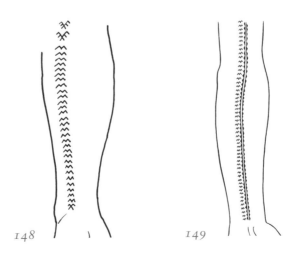

148 149

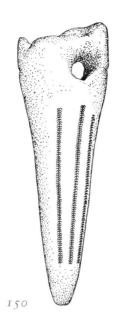

150

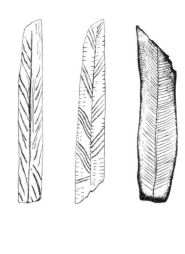

151

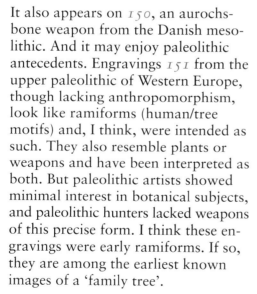

It also appears on *150*, an aurochs-bone weapon from the Danish meso-lithic. And it may enjoy paleolithic antecedents. Engravings *151* from the upper paleolithic of Western Europe, though lacking anthropomorphism, look like ramiforms (human/tree motifs) and, I think, were intended as such. They also resemble plants or weapons and have been interpreted as both. But paleolithic artists showed minimal interest in botanical subjects, and paleolithic hunters lacked weapons of this precise form. I think these en-gravings were early ramiforms. If so, they are among the earliest known images of a 'family tree'.

Even if we accept this interpretation, it must be admitted that surviving examples from the paleolithic are ex-tremely rare, in contrast to those from the mesolithic. Yet there is much evi-dence of continuity of artistic tradi-tions from the late upper paleolithic into the mesolithic. Why, then, this rarity?

What survives of paleolithic art was made of imperishable materials, pre-sumably by men. This can only be a tiny fraction of what ordinarily ex-isted. We know almost nothing of the paleolithic arts of women. Yet surely they decorated the skins of their bod-ies and the skins of their garments. If their decorations resembled those of later times, as evidence suggests they did, then paleolithic art most likely in-cluded ramiforms.

Did shaved-sticks exist in paleolithic art? It's not necessary to assume they did. The concept of genealogy, ex-pressed in the form of a branching tree, could have become traditional long before it was embodied in shaved-sticks. Even so, shaved-sticks provide a natural, appropriate image of this concept and probably took form very early—at least, early enough to have been carried, by prehistoric migrations, from one part of Asia to another—presumably from the Southeast to the Northeast. In other words, while shaved-sticks appear to be very old, the concept underlying them could be even older.

152 153 154 155 156

Some examples look more like cen-
tipedes than trees: *152*, tattoo, Algeria;
153 & 154, Melanesian designs; *155*,
body decoration, Ecuador; and espe-
cially *156*, curved to fit the contours of
a prehistoric vessel from New Mexico.
But contexts *&* associations suggest
ramiforms, not insects.

Stacked torsos, surmounted by a sin-
gle head, enjoy a wide distribution:
157, Batak of Sumatra; and *158*, from
the Navaho of Arizona. Prehistoric
antecedents include neolithic painted
pottery from eastern Europe, *159*. To
these three examples, thousands more
could be added.

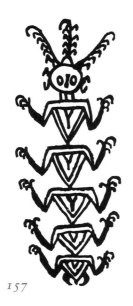

157

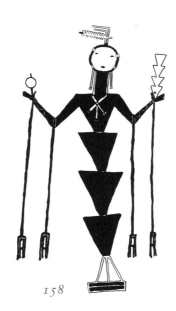

158

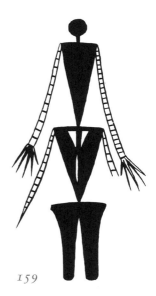

159

On rare occasions, two heads may be shown: *160*, a New Guinea spear. Or heads may simply be omitted: *161*, Melanesian design engraved on bamboo.

When ramiforms decorate a human body or garment, the head may be replaced by the living head of the wearer, thus animating the many bodies below: *162*, on the back of a Micronesian woman; *163*, tattooed or painted on a Sioux warrior; *164*, Solomon Islands rain-cape; and *165*, shield from Luzon. The point, of course, is not that the ramiform acquires a head, but that the living head exhibits a lineage.

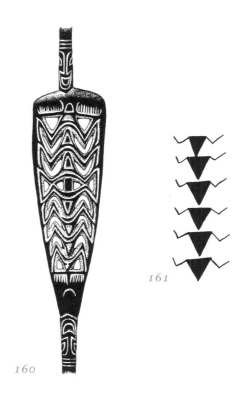

160

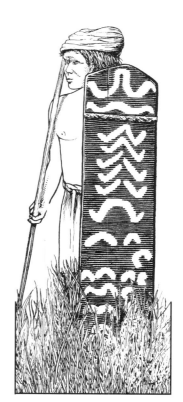

161

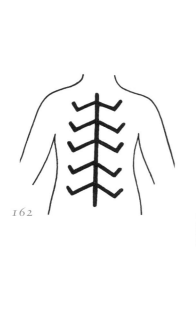

162

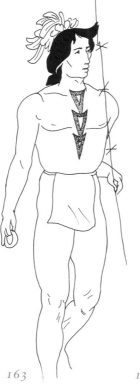

163

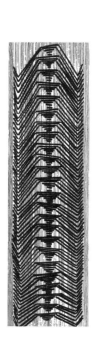

164

165

Without heads or spines, stacked chevrons are reduced to columns of W's or M's:

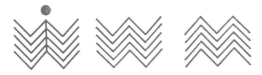

or to bands of ⋜'s & ⋝'s:

This is by far the most common motif in tribal art, worldwide. As a design, it is so simple, so easily executed, so common, it might seem like the height of foolishness to treat all examples, even a significant number of them, as somehow related, however distantly. Yet I believe a case can be made for doing so.

Ancient & modern examples aren't mixed casually with unrelated motifs. They appear most frequently in settings reserved for genealogical statements. Moreover, if they were meaningless doodles, we could rightly expect to find them spread uniformly throughout history. That is not the case. As tribalism faded, stacked chevrons declined in popularity, almost to the point of extinction. But not completely: they survived as military insignia, denoting rank.

When Henri Matisse designed hooded costumes for three 'Mourners' in the ballet *Le chant du Rossignol*, he ran a great chevron down each spine, *166*. No motif could have been more appropriate. Assuming it enjoyed in ancient times the same meaning—lineage, rank, ancestry—as it did in tribal & medieval heraldry, by 1920 it was at least 10,000 years old and probably much older.

How did Matisse hit upon this motif? Was he simply recycling tribal art in the modern fashion? I suspect a less conscious source. I'm reminded of small children who say they have 'always known' something.

Art, like language, is a great echo chamber, reverberating with ancient images, some so familiar we tend to forget their origins and to think of them as 'natural' choices.

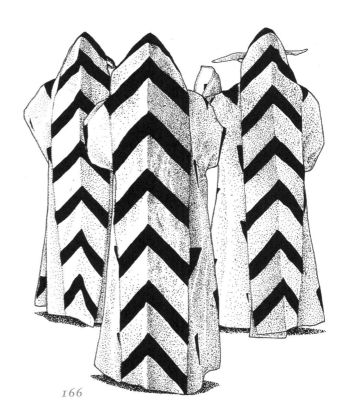

166

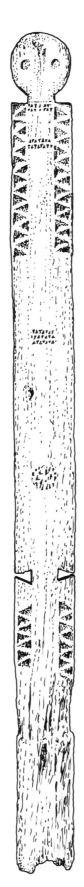

167

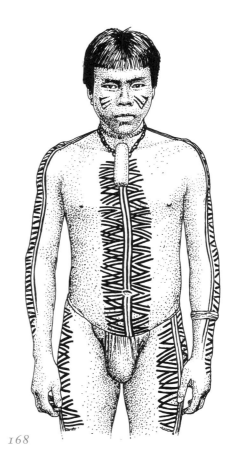

168

Split Trees

One of the most common motifs in tribal art is a vertical band bordered by zigzags. It resembles a notched post. I interpret this motif as a 'human tree' with trunk & limbs. Not everyone who still makes this motif assigns it this meaning, but some do and others place it in contexts supporting this interpretation.

Examples are legion. From several thousand examples in the Schuster Archiv, let me offer eight: *167*, memorial post, Kenya; *168*, tattoo, Brazil; *169*, stela, Ethiopia; *170*, Ibo bronze casting, West Africa; *171*, New Guinea shield; *172*, detail of a *sarong* worn so the vertical band centrally divides the wearer's body, Borneo; *173*, tattooed thigh, Kayan woman, Borneo; and *174*, mesolithic (Azilian) painted pebble, France.

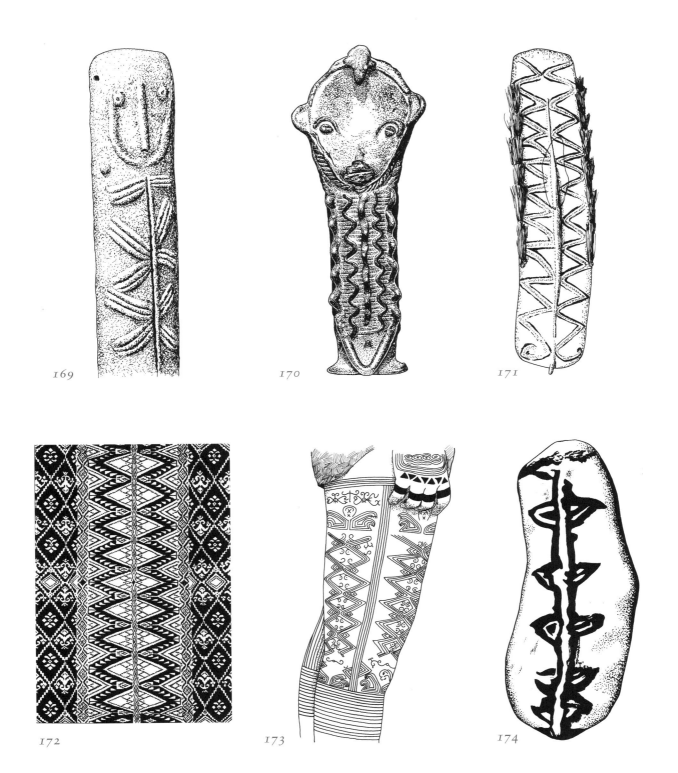

169

170

171

172

173

174

Similar designs on other Azilian pebbles, eg *175*, suggest this motif was already a distinctive entity as early as mesolithic times in the Old World. But it's unlikely that 'split zigzags' were invented in Azilian times, and far more likely that the principle which they illustrated had already been established earlier, in the traditional decoration of paleolithic skin garments.

A third Azilian pebble, *176*, doesn't fit into this series, though it, too, probably represents clothed human figures. While its zigzags are parallel rather than opposed, and a 'blank band' intersects them transversely rather than separating them longitudinally, precisely this arrangement also characterizes certain traditional robe decorations. Pebble *176* might be regarded as the irreducible symbol of a 'robe'.

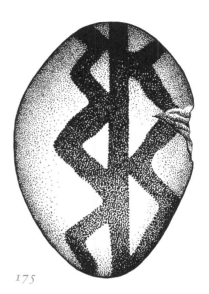

175

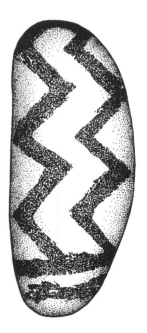

176

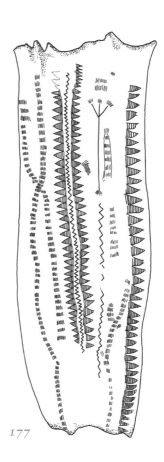

Each of these examples consists essentially of a pair of zigzags (single, double, or multiple) aligned vertically with their points opposed, but separated from contact by a blank band. What is the meaning of this divided motif? Why is it split?

Much evidence could be adduced indicating that the 'human tree' was itself often 'split'. A fairly continuous tradition of 'split trees' runs from at least mesolithic to recent times, eg *177*, Maglemosan engraving, Denmark; and *178*, Polynesian tattoo, as recorded in 1828.

This motif survives widely today as both body & garment decoration, as well as on pots & baskets. Until recently, it was important especially in Siberia where 'split ramiforms' served as ownership marks, a usage suggesting derivation from the basic image of a 'family tree'.

177

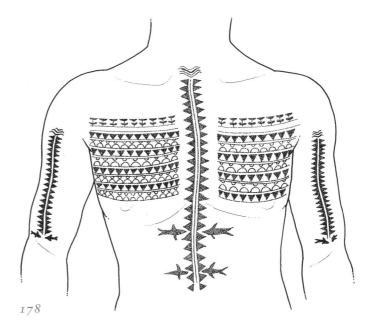

178

Founder & Descendants

The door post in *179* comes from the
Batak of Sumatra. At the top is Batara
Goeroe, Lord of Creation. Coming
out of his mouth are two boys, proba-
bly twins born during the carving.
Below are four sons, still children,
and finally two older, initiated sons,
indicated by hands on penes.

The 'staff god' in *180*, from Rarotonga,
Polynesia, represents the god Tangaroa
and his immediate lineal descendants,
shown below as alternate male & fe-
male hockers (stylized figure in squat-
ting posture) linked limb-to-limb. Fig-
ure *181*, also from western Polynesia,
represents the god Terongo above his
three sons. Note 'branching' legs. A
second figure of Tangaroa, *182*, stands
on a notched pedestral, its notches
representing a generalized genealogy.

The Maori of New Zealand employ
long staffs, *183*, as mnemonic devices
in genealogical enumeration. Each
stick has a human effigy at one end
(progenitor?) and a series of knobs
along its length. These knobs, alter-
nately engraved, are touched succes-
sively as an aid to memory when
reciting genealogies. Each knob repre-
sents an ancestor or generation.

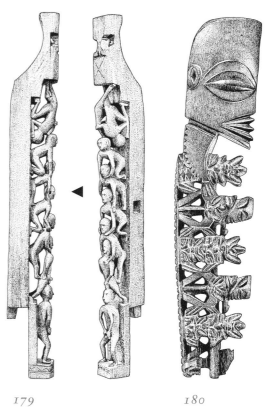

179 *180*

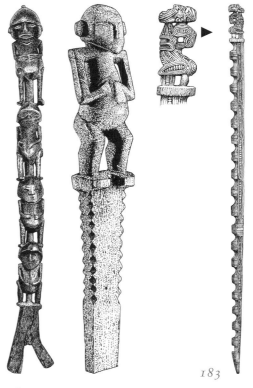

181 *182* *183*

In Borneo, notched posts, *hampa-tongs*, support ancestral figures, *184*. Their notches are generally explained as a tally of enemies killed by the deceased, probably a modification of an original meaning in which notches represented ancestors.

Hampatongs may be no more than simplified ramiforms, akin to the Nias example in *185*, the stacked torsos of *184* having been reduced to notching. Or perhaps the notching was shifted from its proper place on the figure itself to the post below. Either way, meaning remains the same: a lineage of ancestors, descended directly from the First One.

The bamboo tally in *186*, from the Chin Hills, Burma, uses notches to enumerate & classify members of a specific community. On the right, in descending order, are: the headman, 4 married women, 3 elderly bachelors, 3 unmarried younger men, and 4 male children; opposite them, the headman's wife, 4 married women, 4 girls over ten years of age, and 3 younger girls. This tally resembles a bullroarer, but whereas notches on a bullroarer merely illustrate a generalized genealogy, here they record a specific census.

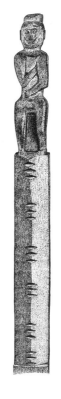

184

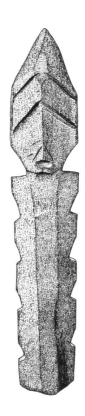

185 *186*

In many parts of the world, notches (representing ancestors, with the Founder sometimes shown as an extra large notch) are arranged peripherally on a disk, including a disk that might be rotated. The endless repetition of this pattern symbolizes the endless repetition of the genealogical chain.

Notched disks take various forms, including buzzers. Most buzzers are pierced twice and strung on continuous strings. The loops are alternately tightened & loosened: the disk revolves, giving out a buzzing sound, often identified as the voice of an ancestor.

Today buzzers are playthings in Britain & Asia, but they were once made & used by adults in Siberia; North America, *187*; and elsewhere.

Compare an Eskimo example, *188*, with a Choco example from Colombia, *189*, keeping in mind that the hourglass motif commonly represents a female ancestor. South American buzzers include, as well, standard disk types, *190*.

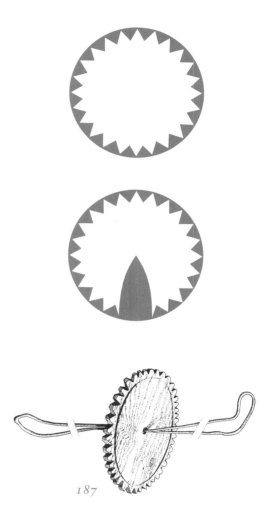

187

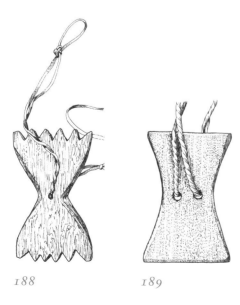

188 *189*

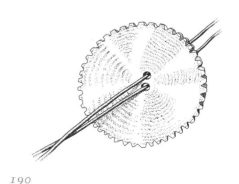

190

The notched, anthropomorphic bull-roarer in *191* comes from the Naga of India. Where bullroarers are still associated with traditional rituals, their makers almost uniformly say they represent or embody ancestral spirits.

If such is their basic meaning and if, when used, they represent the voices of ancestors or ghosts, then the *designs* applied to them presumably represent those ancestors. At least, this may have been so in remote prehistoric times, and traces of this anthropomorphism conceivably persist in the 'decoration' of modern bullroarers, found on all continents save South America.

Bullroarers are neither disks, nor centrally perforated. But when notched, as many are, they form an endless chain of notches comparable to those on notched-disks. The form is different, but the principle is the same. Moreover, bullroarers rotate as they whirl through the air on the end of a cord, and that rotation can be increased, along with the sound, by attaching the string to a handle, eg *192*, from Siberia.

When *193*, from Denmark, circa 5500 BC, was whirled, it 'roared'. Like *194*, from Germany, circa 9000–8000 BC, it is unnotched. But *195*, from the Aurignacian site at Isturitz, is notched and may have been a bullroarer.

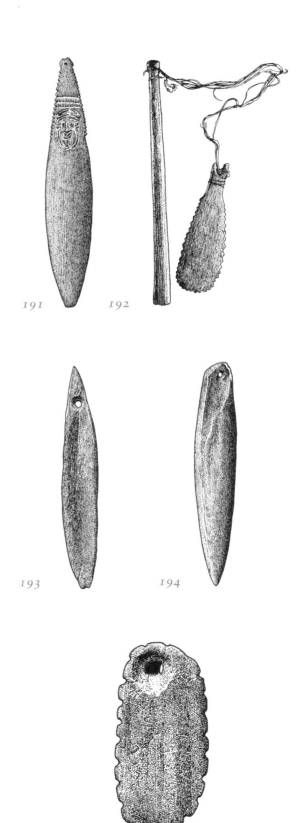

191 *192*

193 *194*

195

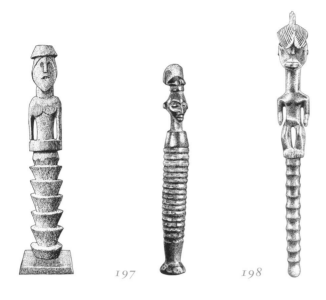

196 197 198

Segmentation serves the same function as notching, equally on posts, staffs & pendants. At the top comes the figure or head of a mythic ancestor, with its decendants below, each reduced to a segment: *196*, New Guinea; *197*, Zaire; *198*, Hawaiian Islands. Some examples are headless: *199*, Bari, Nilotic Sudan; *200*, Cheyenne, Oklahoma; *201*, Azande, Nilotic Sudan.

Equally common are stacked hour-glasses: *202*, Mossi dance mask, Sudan; *203*, dance staff, Solomon Islands; *204*, Yurok stirring paddle, California; *205*, Yami ancestral post, Botel Tobago, off Taiwan.

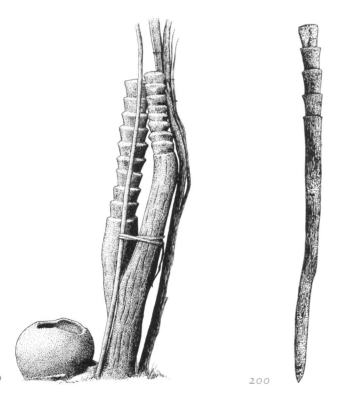

199 200

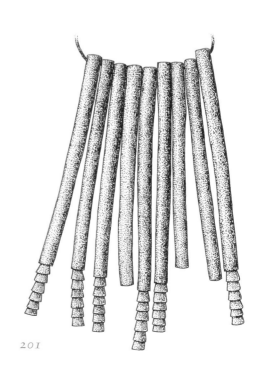

201



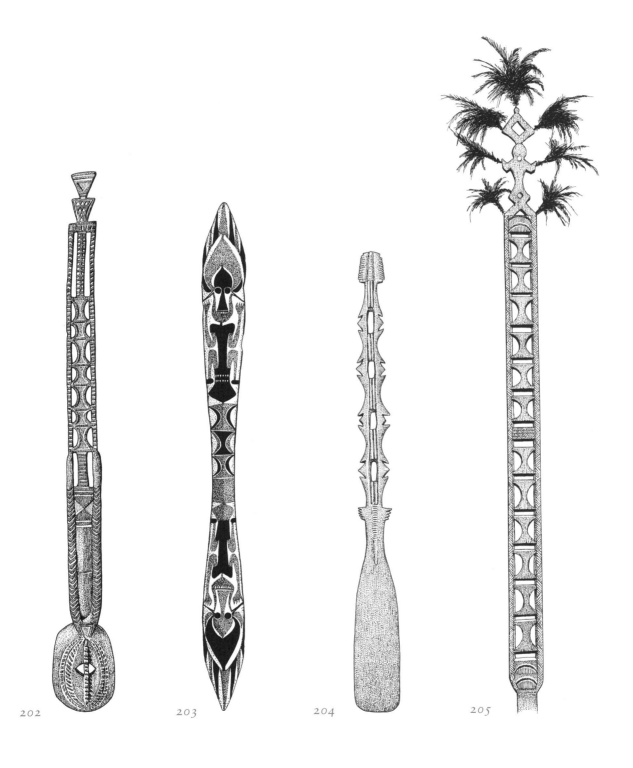

202 203 204 205

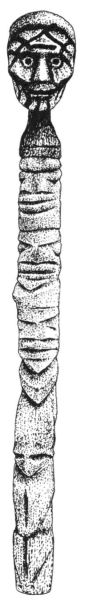

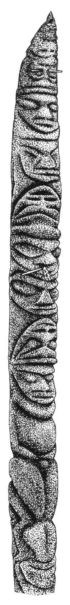

Ancestral-posts *206 & 207* come from Vanuatu: the first consists of a column of human faces capped by a modelled skull; the second mixes upright *&* inverted faces.

Dancing staves *208*, from Torres Strait, Melanesia, symbolize both Cosmic Lineage *&* Cosmic Pole, ie a lineage traceable to a divine source.

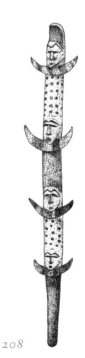

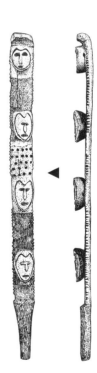

206 207 208

71

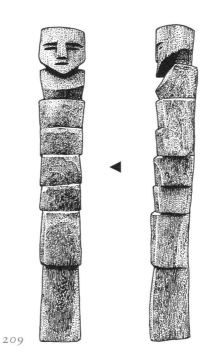

209

For me, the most intriguing examples fall mid-way between anthropomorphic notched-posts and anthropomorphic notched-ladders: *209*, Polynesian godhead surmounting a column of headless torsos; *210*, miniature post from a Metoko grave-house, Congo; and *211 & 212*, identified by the Dogon, Mali, as a 'heavenly-ladder' & 'spirit-ladder' respectively.

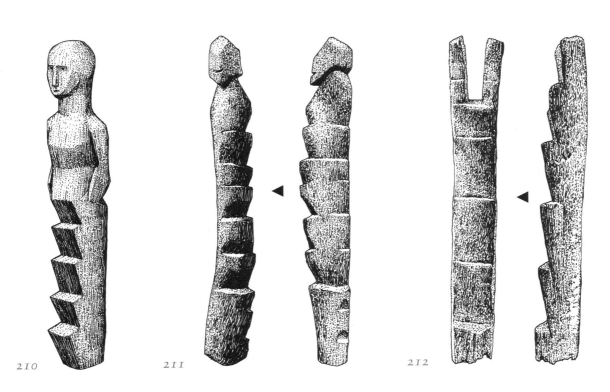

210 211 212

Heavenly Ladders

Anthropomorphic ladders can be climbed, either practically, to enter an elevated house, or symbolically, to enter the Upper World. Examples 213 come from Melanesia. Surmounting each is the head of the Founder. Below come his lineal descendants, their heads serving as treads. All represent ancestors, successively arranged. Ascent symbolizes retracing one's ancestry back to the Founder; descent symbolizes rebirth and return to Earth.

Human ladders occur frequently in the western Pacific; occasionally on the mainland of Southeast Asia; only once, as far as I know, in Northeast Asia (among the Koryak of eastern Siberia); and in the New World in only two places (Central Chile and Panama-Colombia).

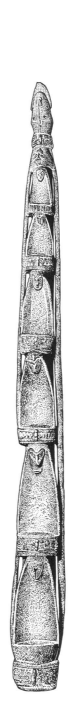
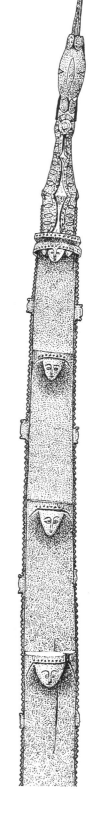

213

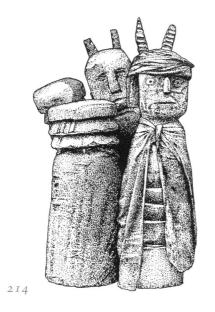
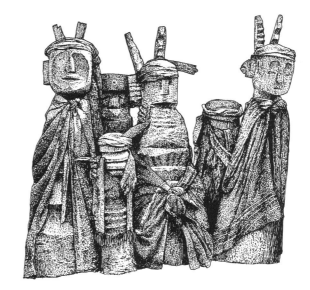

214

The Garo of Assam, a Tibeto-Burman hill people in northeastern India, erect memorial posts, *kimas*, 214, under the eaves of the deceased's house, immediately after cremation. One post is sometimes carved with a face, in the likeness of the deceased, while its companion is used to support the horns of a bull sacrificed during the ceremony. Both posts are 'stepped' in the manner of ladders and both are adorned with the clothing & ornaments of the deceased.

Each step in 215, another Garo example, is conceived as a headless human figure with free-standing 'limbs'. Collectively, these steps symbolize the successive generations of a clan or family, with the 'head' of the family at the top. Ascent of the ladder means identification with each successive ancestor, ultimately with the founder of the lineage. Thus the ladder as a whole represents a genealogy, the mounting of which is an act of ceremonial or ritual significance. The Founder stands at the head or top of the lineage, at the threshold to Another World. Reunion with the First One constitutes the 'last step' in rebirth.

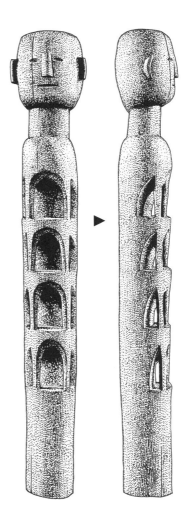

215

216

217

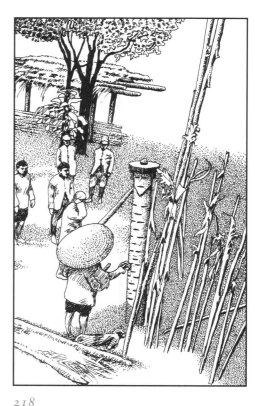

218

Ladders with breasts were once common in Vietnam, *216*. In Sarawak, anthropomorphic ladders were either male, with a penis at the base, or female, with a vulva at the base, *217* (now eroded).

Among the Bidayuh of Sarawak, girl's souls are believed to be taken in marriage by gods of the mountain. The community celebrates this wedding by erecting a notched post, a 'Stairway to the Gods', by which gods may descend and girls ascend to meet them, *218*. At the top is the godhead. The 'trunk' is notched, with most notches serving as the eyes & mouths of stacked heads. Offerings are brought to the soul of the tree.

In *219* we see two models of such offering-poles, the first with a human figure, the second with stacked heads, and both decorated with croton leaves.

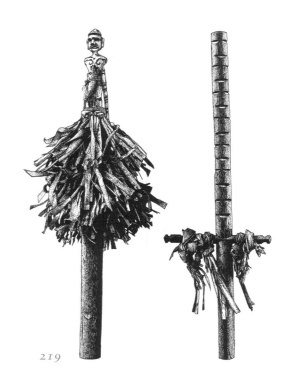

219

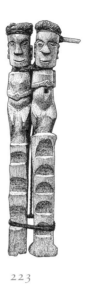

223

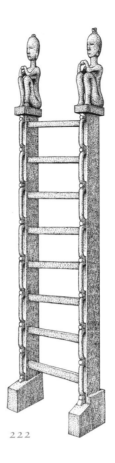

222

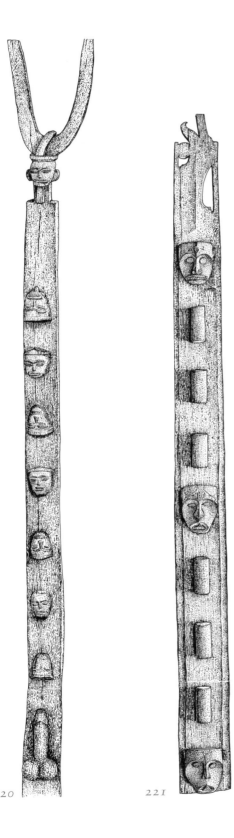

220 221

'Ladder' 220, from Sumatra, has a human head with forked top-piece surmounting a series of human heads, alternately erect & inverted, and an erect penis. Compare this to 221, from Borneo, with 'treads' in the form of male & female heads, plus six impractical vertical cylinders.

In eastern Indonesia, house ladders often have separate sidepieces, into which rungs are inserted. The top of each sidepiece is a human figure, one male, the other female. The sex of the two figures in 222 isn't clear, but the ladder itself, at the entrance to a Ngada house in North Central Flores, is identified as a 'spirit ladder'.

Compare this to 223, a pair of male & female figures from Sumatra, regarded as founders of the tribe.

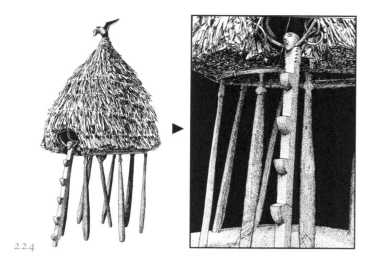

224

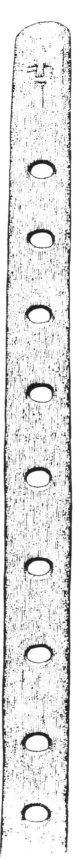

Model 224 offers a reasonable like-
ness of a full-sized house on Enggano
Island, Indonesia. The entrance to
such a house, at the top of the ladder,
was a circular frame symbolizing the
Sky Door. Thus the visitor ascended
the pole (notched trunk) until reach-
ing the First One, then passed through
the Sky Door to enter a house shaped
like the Cosmic Dome and guarded by
the Cosmic Bird.

Nowhere are anthropomorphic ladders
more common today than in Melane-
sia. Are these merely survivals of a
Southeast Asian tradition, possibly
late in origin? Anthropomorphic lad-
ders in Siberia and South America
suggest a much earlier beginning for
all such ladders.

The Koryak of Siberia gained access
to their winter homes by means of a
ladder, many of which had a crudely
carved face at the top, 225. In Siber-
ian shamanism, domed houses provide
a model of the Sky Dome in micro-
cosm. The shaman climbs the central
ladder (symbolizing the *axis mundi*)
and thrusts his head through the smoke-
hole (symbolizing the Sky Door). Then
he returns to earth 'reborn' and reports
his experiences to waiting kinsmen.

225

2

Genealogical Patterns

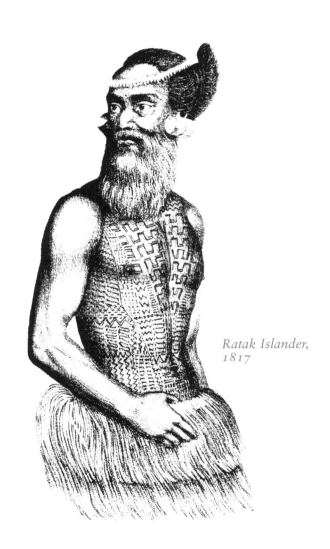

Ratak Islander, 1817

Paleolithic peoples invented an iconography to illustrate their ideas about genealogy. They painted such 'statements' on their bodies & clothing, carved them on tools, and carried these with them wherever they went.

Thus the same intelligence lies behind all genealogical patterns. No matter how varied the art style, the rules governing their composition are everywhere alike. This makes them easy to decode, once those rules are understood.

For thousands of years, this iconography served as a single system, everywhere obedient to the same rules, everywhere addressing itself to the same ideas. It was never a true 'language', but its glyphs were simple, its rules clear. With ease & clarity, one could illustrate a symmetry of silent assumptions underlying tribal genealogies.

These assumptions, along with their special iconography, fell into disfavor with the rise of the city-states and the invention of writing. But neither wholly disappeared. Both survive as living traditions among isolated tribesmen and as deep metaphors in urban cultures.

The repeating pattern in 229, an Indonesian *ikat* from the Celebes, is a human figure with distended ear-lobes and prominent spinal column. Two bands form the sides of its body. These closely flank the spine, except in the middle where they diverge to form the navel, and at the top & middle where they diverge to form arms & legs.

Each limb then continues through a 'Z' to link with an arm or leg diagonally above or below. Alternate figures lack spines. No matter. As long as both sides of the body are shown, spines are dispensable, mere attributes of identity. What is crucial is that these sides extend to form continuous limbs with bodies diagonally above & below.

The significance of 229 can best be understood with reference to the genetic theories of certain Indonesian peoples. According to these beliefs, the body of each person is composed of two halves, derived respectively from the corresponding halves of each parent. When viewed in terms of this idea, the figures to the right & left immediately above each individual represent the father & mother, each of whom contributes one half to his formation. The figures to the right & left immediately below the same individual represent his children, or rather his share in their creation, by virtue of marriage.

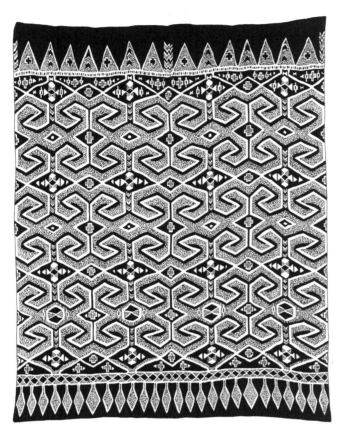

229

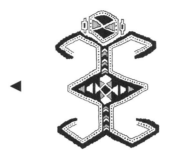

Thus the continuum of human figures in 229 finds its most plausible explanation as a symbol of the endless continuity of the genetic process. Its component figures represent members of a social group, visualized vertically in terms of ancestors & descendants, and horizontally in terms of living relatives. Such patterns are, accordingly, 'tribal' in the sense that they actually represent members of the tribe in their social relationship. Each pattern provides an image of the 'social fabric'.

The endless repetition of this pattern illustrates the endless repetition of the genetic process. True, the ties of familial relationship cannot be fully or accurately illustrated by such a pattern. But at least in principle, this endless network of arms & legs superbly illustrates the idea of descent & relationship. Hence the designation 'genealogical pattern'.

Father

Mother

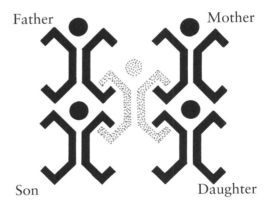

Son

Daughter

The basic 'bricks' used in the construction of genealogical patterns are conventionalized human figures:

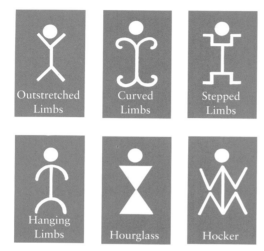

Each figure is designed to be joined limb-and-limb with adjacent figures, the intention being to illustrate descent or relationship.

To depict descent, figures are generally linked arm-and-leg with diagonally adjacent figures:

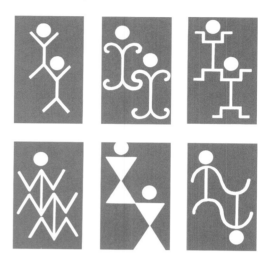

Patterns of such figures are so constructed that arms & legs are indistinguishably fused, and the observer is lost in an anatomical puzzle. But the confusion is deliberate: this is a graphic representation of the puzzle of procreation itself, in which there is neither beginning nor end.

Any design of headless human figures, linked limb-and-limb, can be extended, at least potentially, endlessly in all directions, eg *230*, a stool from Cameroon. Such a pattern, especially one encircling a cylinder (human trunk, post, pot), superbly illustrates the genealogical process, for a genealogy, by its nature, lacks a beginning and an end.

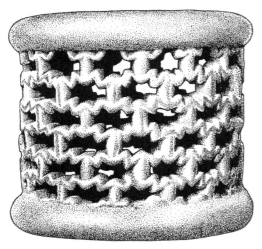

230

In many all-over patterns of human figures, heads disappear. Their disappearance is deliberate & symbolical: figures are headless because a genealogy is composed of ancestors, therefore dead and, where ancestral skulls were stored, headless.

In all genealogical patterns, the intention to represent human figures is evident, but the details are altogether a type, without individual peculiarities. Stylized images are indistinguishable. Every figure is inseparably linked—upward-downward-horizontally—to figures identical to itself.

Clearly, this uniformity is deliberate. If these stylized figures represent ancestors, they must be categories of ancestors, not forbears as they actually appeared at death or in life. The intention goes further. Every pattern shows every tribal member, living & dead, unalterably linked together and together constituting the tribe.

The constraints of genealogical patterns rule the design of figures. Most are simply headless stick-figures. Limbs may be straight, stepped, curved. But whatever their form, figures are designed to share their limbs with adjoining figures.

Stepped figures, reduced to a few lines, look non-representational, 'geometric', abstract. This was not their creator's intention. When excerpted from the patterns that gave them birth, these same figures often acquire clothing & anatomical details.

Patterns of curved-limbed figures, common in Old World genealogical patterns, appear to be absent in the New World. This is curious since single hockers with curved limbs are common in South America, eg 231, painted vessel, Ecuador.

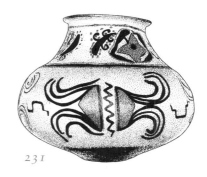

231

Did the specific patterns from which these single hockers derived die out in the New World, leaving behind only the figures themselves? Or did those figures arrive in the New World independently, already detached from their original patterns?

New World examples may be unique in another respect: the limbs from some curve down from the shoulders, up from the hips, eg 232, a calabash from Colombia; and 233, engraved on a club, Guiana. A hypothetical pattern is shown between them. Such figures may, of course, be no more than excerpted hockers whose limbs curled.

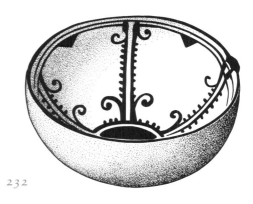

232

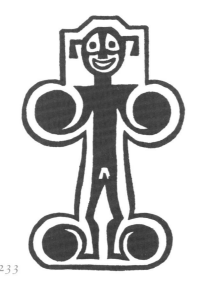

233

Type 1

In 234, a painted gourd from Guiana, circles of dots represent heads, zigzags represent spines, and stepped limbs link diagonally adjacent figures leg-to-arm. Heads & spines are omitted in 235, from Brazil, simplifying this pattern still further. Housepost 236, from New Guinea, repeats this same basic pattern, with an hexagonal design as body decoration.

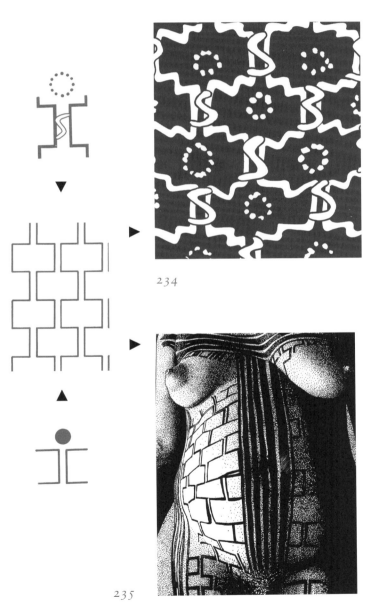

234

235

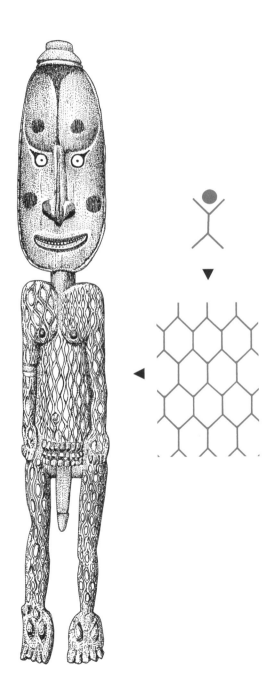

236

Variant Type 1

Less frequently, figures connect arm-and-arm with inverted figures diagonally above and leg-and-leg with inverted figures diagonally below. Again, the two upper quarters of each figure derive from its 'mother' & 'father' diagonally above, while its two lower quarters contribute to its children diagonally below.

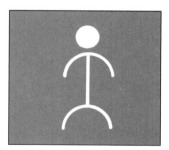 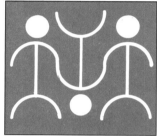

The bamboo pipe design in 237, from New Guinea, illustrates this scheme. Compare it to 238, pottery design from Marajó Island, Brazil; 239, prehistoric potsherd, Celebes; 240, wooden cup design, Congo; 241, shield design, New Guinea; and 242, pottery design, circa 3000 BC, Iran.

Though I call such patterns variants of *Type 1*, this may be, as we shall see, the original form from which all genealogical patterns derive.

A design like any one of these examples is not the work of one woman. It is the result of a constantly refined tradition. Over ten thousand years of history lie behind that design.

Not by borrowing and not by invention, but only by long inheritance can we explain these widespread, remarkable parallels.

237

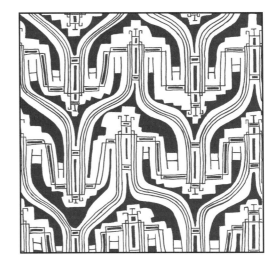

238

239

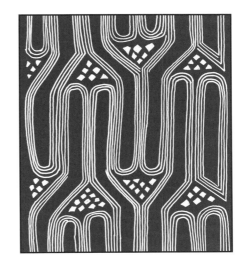

240

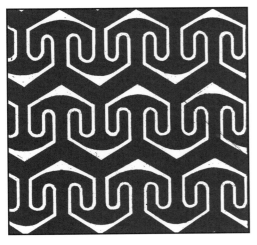

241

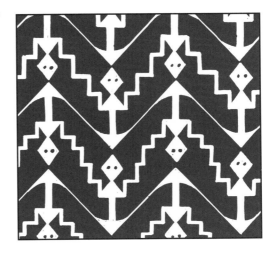

242

87

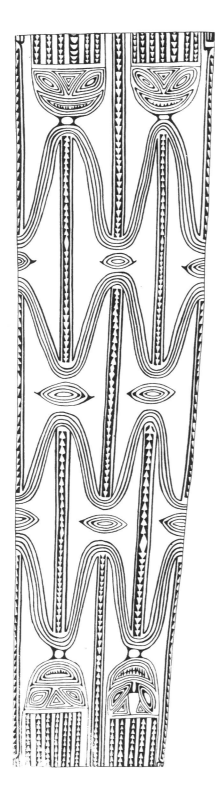

243

Type 2

The incised decoration on 243, a Melanesian club, consists of rows of quasi-human figures arranged arm-and-arm and leg-and-leg so their continuous limbs form undulating bands. An intermediate tier of figures is formed by inserting series of spinal columns between the knees of the upper & lower figures. The emphasis throughout is on *horizontal* continuity, but figures also share limbs, arm-and-leg, with figures *diagonally* above & below them.

In 243, heads are reduced to noseless, grinning skulls, ie skeletons or ghosts. Intermediate figures have token heads in the form of oval eyes. Each spinal column divides into two halves, with triangular vertebrae oriented in different directions and the navel in the center. This permits the design to be viewed equally well from either above or below.

Patterns 244, Melanesian; 245, Indonesian; 246, neolithic, southwest Russia; and 247, Cameroon, all encircled cylinders or bowls, while 248, also from Cameroon, was engraved on a flat surface.

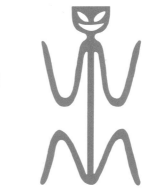

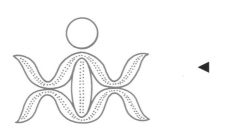

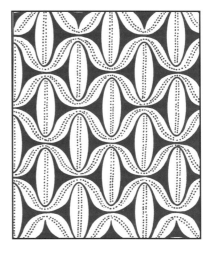

244

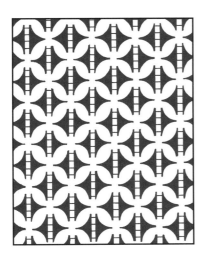

245

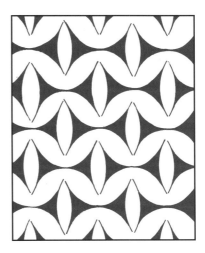

246

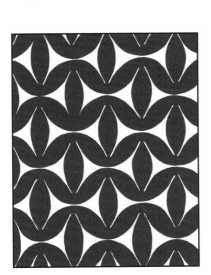

247

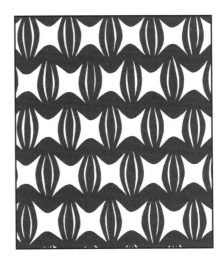

248

Hourglass Figures

Hourglass figures may abut, hip-to-shoulder, eg 249, an Apache Indian basket.

Or they may extend limbs out from their shoulders & hips, sharing those limbs (often multiple) with diagonally adjacent figures, eg 250, a Carajá vessel from Brazil.

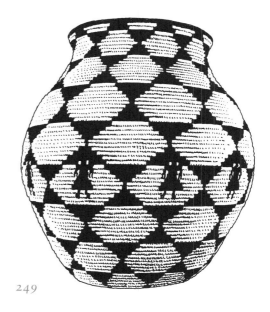

249

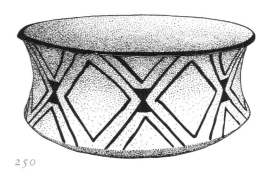

250

Reciprocal Hourglass Patterns

Appliqué techniques enjoy a wide distribution, especially across northern Eurasia. Most are based on leather or hide, as used by hunting peoples. But they are also used for felt, birchbark and, most recently cloth, though appliqué techniques antedate the invention of weaving.

A typical technique involves cutting a pattern simultaneously out of two or more layers of differently colored hides, then stitching these cut-outs together into a mosaic (often on a base of plain hide, to give the work body), in such a way that they form a reciprocal pattern.

light skin

dark skin

cutting line

mosaic

Here negative shapes enjoy the same importance as that of their positive counterparts.

A favorite motif of such reciprocal patterns consists of hourglass figures connected horizontally at their 'waists' by lateral bars: *251*, New Guinea woven bag; *252*, fibre bag from the Winnebago of Wisconsin; *253*, beaded apron from the Makusi Indians of Guiana; and *254*, engraved shell from Argentina.

In *256*, a vessel from northern Argentina, dated circa AD 500, the potter substituted stippling for color. Here stippling is functional, for the vessel is monochromatic. But in robe *255*, it's superfluous, since the color contrast is already sufficient to distinguish alternate bands. Originally, I think, potters copied two-color fur robes, substituting stippling for color. Later, robe-makers imitated these pottery designs, incorporating stippling into their patterns.

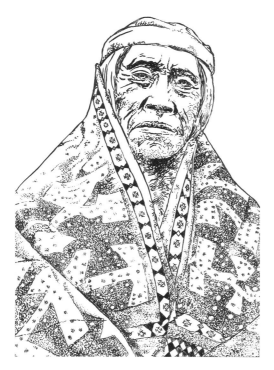

255

256

The robe in *255*, from the Tehuelche of Patagonia, has its fur turned inward, while its outer skins display painted hourglasses in alternate bands: dark hourglasses, having light dots, interlock with light hourglasses, having dark dots.

That this pattern is merely painted, not cut out of skins, then stitched together, is of less importance than its application to a robe—thus persisting in what I think was the design's original application, though the original technique had been abandoned.

The stencil for *257*, a petroglyph in New Mexico, was presumably folded twice, then cut *&* unfolded. The stencil for *258*, from New Guinea, required three folds; while that for *259*, from the Cuna of Panama, required four.

257

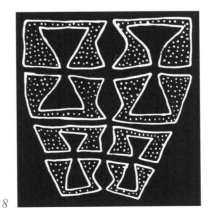

258

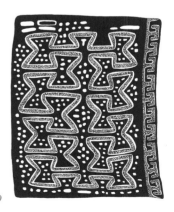

259

Types 1 & 2

Compare *Types 1 & 2* (undulating lines represent continuous limbs; zigzags represent spines):

Type 1

Type 2

Each scheme can be 'read' either vertically or horizontally, but the actual connection between figures is diagonal in *Type 1* and horizontal in *Type 2*.

In *Type 1*, the sides of each body extend to form continuous limbs with bodies diagonally above & below. Sides are thus indispensable. Spines, however, can be eliminated and often are. In *Type 2*, the sides of the body have no function and partly for this reason are sometimes eliminated.

Both schemes represent connections: *Type 1* emphasizes descent; *Type 2* emphasizes relationship within a single generation. How frequently the artists themselves had this in mind is uncertain. Perhaps rarely. Often they combined both schemes or muddied the distinction between them. Still, in deciphering design, it helps to keep this distinction in mind.

Compare *260* & *261*, two New Caledonian door-posts, *tale*, each said to represent the 'ancestors' (plural) of one side of the family. The large head spanning the top of each post belongs to all the headless bodies comprising its shaft.

Continuous limbs connect series of rudimentary human figures, the way undulating bands connect skeletal bodies in *243*. Diamonds formed between the zigzags (particularly star-shaped cut-outs within the diamonds of *261*) represent headless bodies. Each bank of zigzags (limbs) serves the bodies above & below.

These generations of headless figures are all 'animated' at the top by a single, large head symbolizing the ancestor from whom they all descend. Their multiplication was probably conceived as strengthening the posts symbolically. Shaft & capital together represented the inseparable, all-powerful unity of the tribe.

Vertical zigzags in *260* create a *Type 1* pattern; horizontal zigzags in *261* create a *Type 2* pattern.

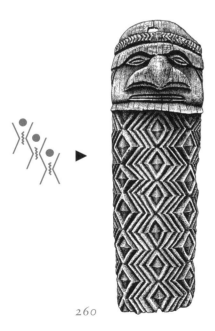

260

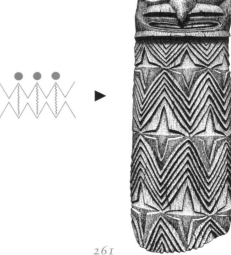

261

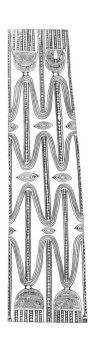

243

Shadow Systems

There is no significant difference between 262 & 263, two Caduevo arm-paintings, South America; 264, scratched-skin panel from an Australian robe; 265, Cambodian *sarong*; and 266, Yuma Indian beaded collar from California. Each exhibits duplicate, interlocking genealogical patterns. I call these systems, where two similar patterns overlap, *Shadow Systems*.

Precisely what is symbolized by interlocking two similar patterns, I don't know, but a complexity of rhythm seems inevitable in any graphic representation of genealogy. Compare 262 & 263 to 267, an anthropologist's diagram showing the effect of matrilineal moieties on patrilineal descent

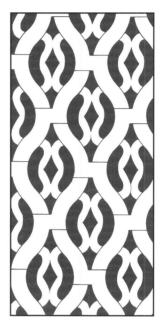

262

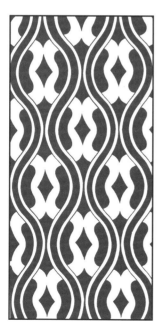

263

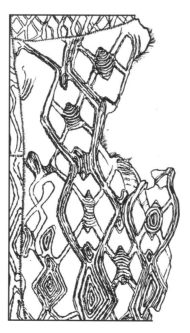

264

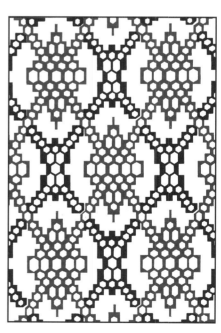

265

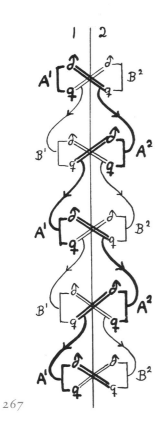

among the Malekulans in the New Hebrides. In 267, double lines indicate marriage; curved lines descent.

I'm not suggesting that 262 has precisely the same significance as 267, merely emphasizing how any attempt to illustrate kinship produces patterns like those used by tribesmen to illustrate genealogy in a less specific sense. The choice of crossed lines or 'strapwork' to represent marriage seems as natural as the use of graceful curves to represent lineage or descent. As if by 'instinct', modern anthropologists recreated what has long been a symbol among 'primitive' people.

Anthropologists also hit upon the idea of projecting kinship diagrams around a cylinder, 'such as a jam jar'. Thus they independently invented a method traditional among tribesmen who, for thousands of years, encircled their trunks & limbs with genealogical diagrams.

267

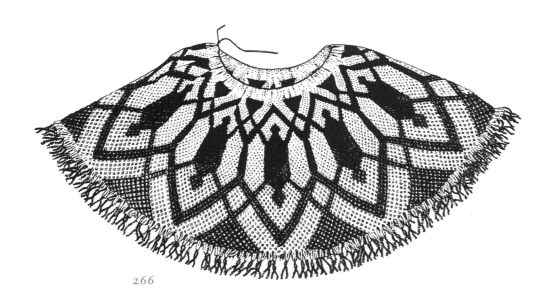

266

Biaxial System

The painted decoration of a Carajá paddle from Central Brazil, *268*, resembles the Melanesian design *244*. Both illustrate series of human bodies in the form of upright members, each member bisected by rows of dots representing vertebrae. Undulating bands, representing common limbs, connect these figures.

But *268* also includes zigzags for which *244* has no counterpart. If the dots of *268* represent vertebrae, what are the zigzags between the elbows & knees? Zigzags in genealogical patterns usually represent spines. So how can there be, in any one pattern of human figures, two series of spines disposed at right angles to each other?

The answer is that *268* contains 'crossed genealogies'. As a design, it presents the aspect of a puzzle. When the paddle is held vertically, as in *268*, its design conforms to *Type 2*, and the zigzags have no meaning. When turned on its side, however, the design conforms to *Type 1*, and the dots become meaningless.

The complexity of these interlocking or telescopic schemes is often matched by their obscurity: it's not easy to develop a repeating pattern comprehensible both horizontally & vertically. What is meaningful from one side often becomes meaningless from another. Yet each pattern yields its meaning to a simple test: turn it on its side.

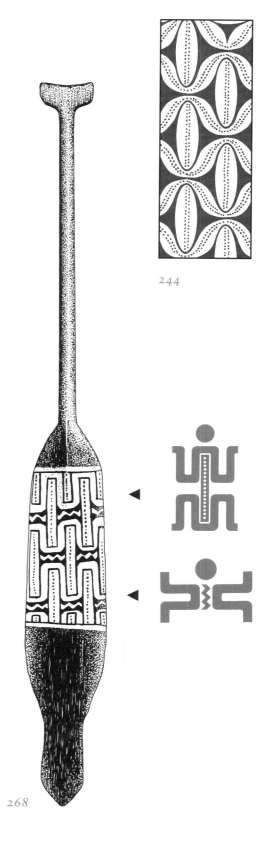

244

268

Rotation of 269, a prehistoric design from Marajó, Brazil, is made easy by heads at both ends of the bodies. Note the swastikas, a method sometimes used to link figures in *Biaxial Systems*.

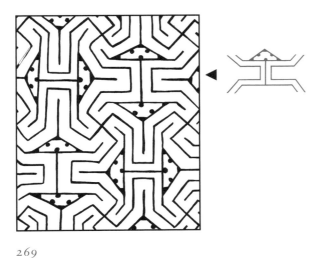

269

Design 270, engraved by Cocopa Indians of Baja California, shows a *Biaxial System* of hourglass figures, while pictograph 271, Patagonia, shows five linked figures from a *Biaxial System* of stepped figures.

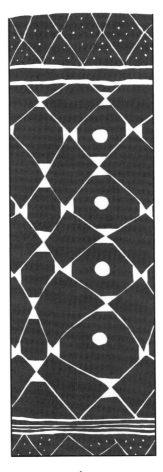

270

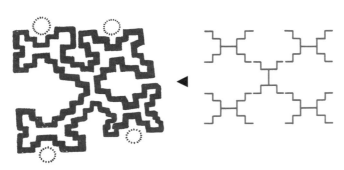

271

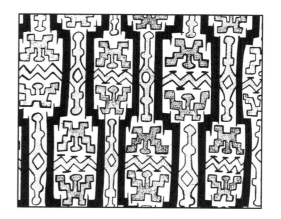

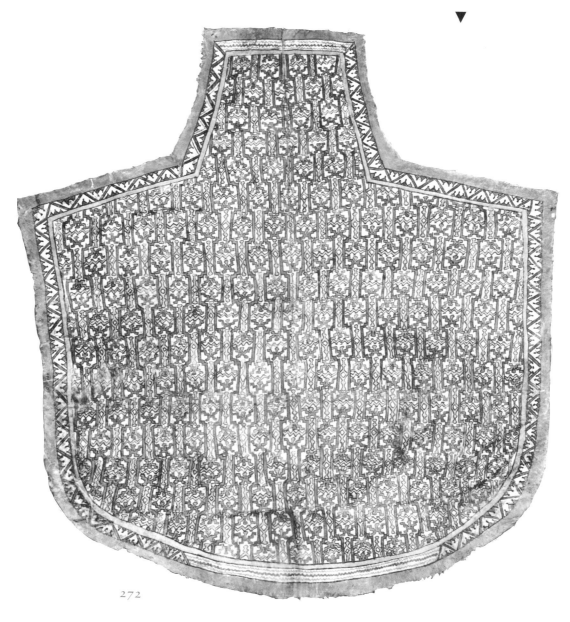

Triple Systems

Combining a *Shadow System* and a *Biaxial System* produces a *Triple System*. The painted skin in 272, made by a Tehuelche Indian of Patagonia, consists of three distinct patterns, with corresponding distinctions of coloring:

(*a*) Dark blue bands from a *Type 1* framework;

(*b*) Enclosed within the intervals of this primary pattern are pairs of little human figures, alternately red with green heads and green with red heads. This alternate coloring may symbolize a social differentiation, eg moiety or sex. The figures themselves originally belonged, I think, to a shadow pattern, shown here with hypothetical ligatures connecting their limbs;

(*c*) Yellow zigzags, representing spines, cross the primary network horizontally and at right angles with yellow vertical elements.

Compare 272, from South America, with 273, from Indonesia.

The precise role of the yellow vertical element in *c* eludes me. It has no apparent counterpart in 273, though the two designs are otherwise alike. Probably it's the primary figure's spine or body. But why, then, is it colored yellow, not blue? Conceivably it represents an unattached, whole figure, interchangeably upright *&* inverted. Or perhaps the color distinction doesn't matter.

Neither explanation wholly satisfies. No matter. *Triple Systems* require great conceptual *&* artistic organization. Understandably some parts remain obscure, at least to outsiders.

272a

272b

272c

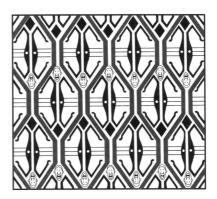

273

Multiple Limbs

Figures often have multiple, parallel limbs whose extensions connect with the limbs of adjoining figures, eg 274, a Formosan textile design.

Compare this to 275, a petroglyph in Guiana, shown here incorporated within a hypothetical reconstruction of the pattern from which it presumably derived. The figure has a head at one end and what looks like a corresponding vulva at the other.

Both 274 & 275 remind me of the widespread myth of children born from sinews drawn from their mother's limbs.

Design 276 appears on a bamboo pipe from New Guinea; 277 is engraved on a flute from the Yuma Indians of California.

The Mohave vessel in 278 has hourglass figures with multiple limbs. Neither 279, from Argentina, or 280, from Siberia, are multi-limbed, but both employ this same 'stutter' or 'outline' technique to illustrate multiplication.

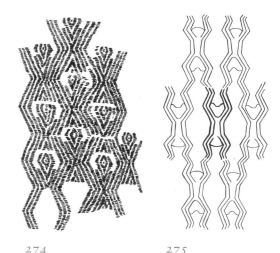

274

275

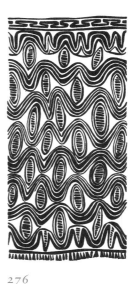
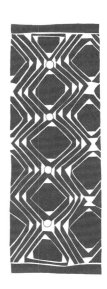

276

277

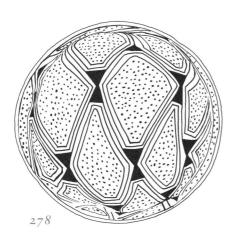

278

279

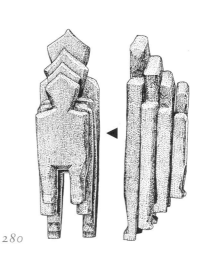

280

Count Systems

A tally or multiplication of generations may accompany a genealogical pattern.

Parallel lines, representing fingers and here conceived as counters, commonly alternate with hourglass figures:

Or a column of Λs, Vs, Ws, Μs or ⋜s, representing stacked torsos, appears beside or within a genealogical pattern: *281*, from the Aegean; and *237*, the Papuan pipe design. Each multiplies a lineage, magnifies a pedigree.

The Mohave remind us that this iconography was probably first designed to decorate the human body: *283*, a 'doll' with a pattern of hourglass figures on its back and a count of vertical bars on its chest. The Mohave vessel in *282* places the hourglass pattern inside, the count outside:

281

237

282

283

Excerpts

Seamstresses everywhere salvage scraps from worn-out clothing. In tribal societies, old garments decorated with genealogical patterns provide decorations for new garments. Single figures become medallions. Bands of linked figures become cuffs & borders. No symbol could be more appropriate: a chain of ancestors guarding a garment, vessel, house.

There's no mystery in any of this. It's simply a matter of re-using old clothing or copying old designs. Play grandmother: take an old garment worn beyond repair and cut out usable parts. Then incorporate these scraps into a new garment for your favorite grandchild. If the old decoration is a genealogical pattern, which is most likely, note how the cutting edge severs connecting limbs and retains extraneous heads. Straight-line cutting invariably violates connections.

Then, some time later, use those excerpts as models for new designs, perhaps as tattoos. These fresh tattoos will include all the excerpted mutilations—severed limbs, extra heads, etc.

Imitation without understanding often means that cut-out figures (with additions & omissions) serve as models for new figures. This is one key to understanding many variant genealogical motifs. Motifs which, at first glance, look unique or 'incoherent', usually turn out to be figures excerpted from conventional patterns, reused, then copied, and all this repeated innumerable times, with additions, omissions, errors, until the final figure no longer fits comfortably into the original pattern.

All this cutting & copying created complexity & confusion. If we had witnessed this process from the beginning, it might seem simple. But we arrive too late, by thousands of years. What we inherit was saved from total confusion by the efforts of rare artists who, millennium after millennium, continued to execute—often side-by-side with debased versions—complete, coherent, flawless patterns.

Which came first, body or clothing decoration? Logically, body decoration came first and was then transferred to clothing, conceived as an extension of the human body. Yet historically the reverse also occurs: body decorations sometimes imitate garment decorations, including designs cut from old clothing. This accounts for the severed limbs & spines of so many genealogical designs, including ones freshly tattooed or painted on human bodies. Artists copied the models before them, oblivious to meaning, and what they had before them was often imperfect.

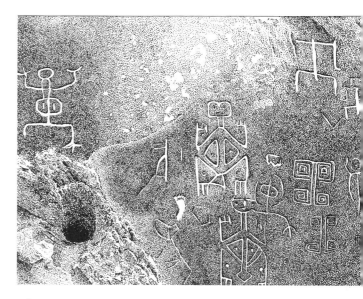

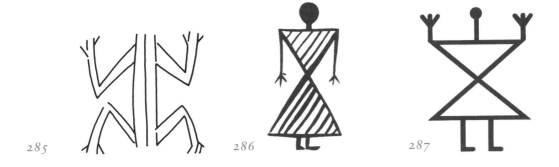

285 286 287

A wide range of excerpted figures grace the Venezuelan rock-face in 284.

Excerpted figures are often more explicitly anthropomorphic than their prototypes. The reason is simple: patterns impose design restraints. Artists enjoy greater freedom with isolated figures, adding details, even clothing: 285–287, from European neolithic vessels.

The Winnebago fibre bag in 288 has a classic reciprocal hourglass pattern. Bag 289 shows a horizontal band excerpted from such a pattern, plus two rows of hourglass females, some joined by limbs, and one row of males, a rare exception.

Tiny figures, explicitly human, were often slipped into genealogical patterns, presumably as a reminder that, no matter how abstract that pattern might appear, it was an assemblage of human figures. Figure 286 was tucked away in a pattern of spiral limbs.

288

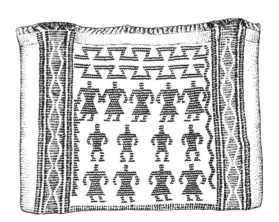

289

Joined Figures

Ikat 290 was presented to the Japanese court prior to AD 752, probably as a gift from the mainland, perhaps Indo-China or West Asia. Its two human figures, linked leg-and-arm, come from a *Type 1* pattern.

Design 291, engraved on a Guiana club, most likely takes its form from a *Variant Type 1* pattern, once common in neighboring areas of South America. The Siberian shaman's charm in 292, once attached to a drum or idol, may have enjoyed a similar background.

If I'm correct, the Nez Percé Indian motif in 293 shows ego in the center, with father & mother above, son & daughter below. Five-figure motifs in this combination appear again & again in tribal arts.

Design 294, on a Guiana club; and 295, from a Piro drum from Peru, show headless figures crossed at right angles. Let's assume that this crossing represents the union of a male & female from opposite moieties. We are sometimes told this is no ordinary marriage, but the union of the First Man and First Woman. This simple motif, at times no more than an outlined cross, may record the Creation of the World and the Origin of the Tribe.

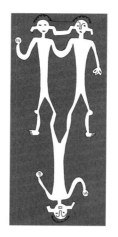

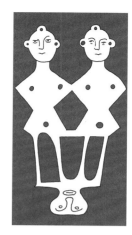

291

292

293

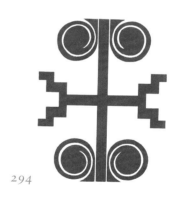

294

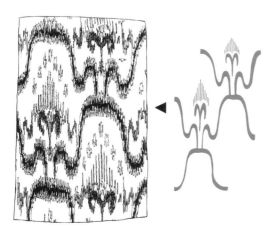

290

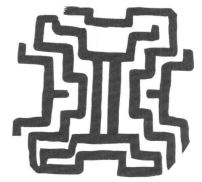

295

Certain neolithic sculptures from Cyprus, eg *296*, circa 3500–3000 BC, consist of crossed human figures, the upper figure with breasts, the sex of the lower figure hidden.

The larger figure in *297*, from Borneo, is said to be male; the smaller figure, female.

Merovingian bronze designs, representing crossed human figures, often have nucleated circles at their joints, *298*, and a 'checkerboard' at the shared navel, *299*. Most lack sexual features, though a few are clearly male-female pairs. Conceivably their interlocking limbs served as a prototype for the 'slung-leg' motif, an erotic motif in later Christian art.

Chalcolithic pottery designs from Iran often include the motif of crossed creatures, *300*. These creatures appear to be lizards, not people, but in this class of pottery the two are often distinguishable only by the presence or absence of tails. I think the form derives from the genealogical hocker.

'Checkerboards' formed by the crossing of two such creatures occur in the arts of many peoples: *301 & 302*, Ashanti, West Africa; and *303*, Batak, Sumatra. Whatever meaning the grid once had for the Ashanti is now lost, but until recently the Batak used *303* as a divinatory or horoscopic chart.

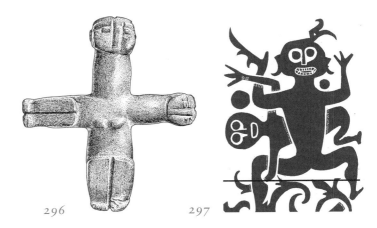

296 297

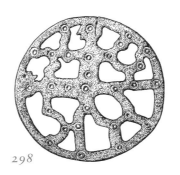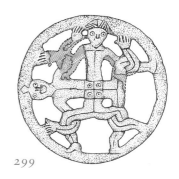

298 299

300

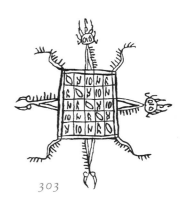

301 302 303

Inter-arthral Disks

A curious motif of a squatting human figure with a disk between each flexed elbow & knee is found on several continents. It has its origin in the process of excerpting a hocker from a genealogical pattern.

It's easy to *copy* a figure embedded in such a pattern. But *cutting* one out isn't so simple. Parts of other figures remain. Those at the extremities can be trimmed away, but heads locked between elbows & knees are difficult to extract, hence frequently retained.

Compare *304*, a carved paddle from Borneo; *305*, stela from Ecuador; *306*, prehistoric Mimbres design from Arizona, and *307*, Dogon granary door from West Africa.

304

305

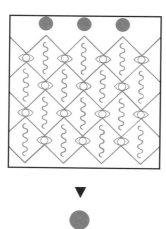

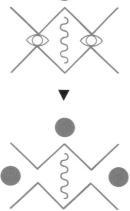

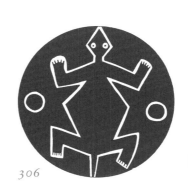

306

307

Design *308*, Cameroon Grasslands, encircles a beaded drum, while *309*, a New Guinea headrest, takes this motif into full sculpture.

Statues of crouching human figures from Indonesia, *310*, and Melanesia, *311*, often have their knees & elbows separated (or joined) by a ball or spindle. This is no local phenomenon. It occurs as well in several areas of South America, eg *313*, a pre-Columbian figure from Venezuela.

All these props lack anatomical justification. Their enigma yields best to one explanation: they preserve heads from a *Type 1* hocker pattern. That these props are not structural features can be seen in *312*, from New Guinea. Here elbow-marks & knee-marks have separate identities, like joint-marks, which they once were.

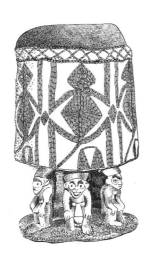

308

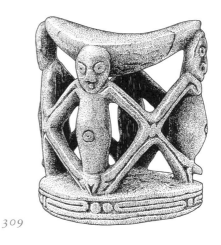

309

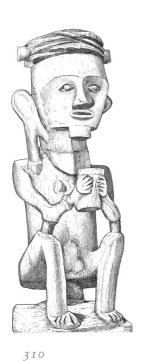

310

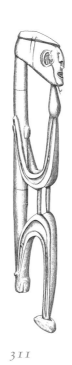

311

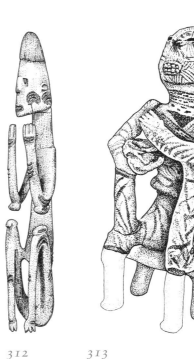

312　*313*

Horizontal Bands

It's easy to cut horizontal bands from hexagonal patterns without violating figures: cut just above the hands and just below the feet. Yet in practice, such bands often incorporate parts of figures above & below, as in *314*, a pictograph in the American Southwest Desert.

Or the cut may be made directly through the bodies: *315*, pictograph, Nevada; *316*, petroglyph, Norway; *317*, mesolithic clay figurine, Finland; and *318*, scarified Baamba, Central Africa.

Of course, even when a cut preserves the integrity of such figures, it still severs all limb connections and those connections are what these patterns are all about.

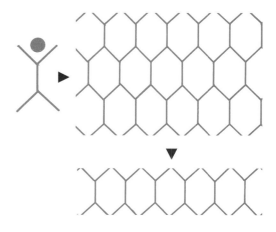

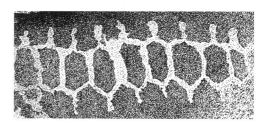

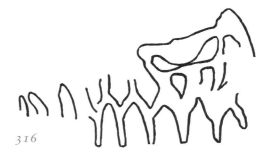

314

315

316

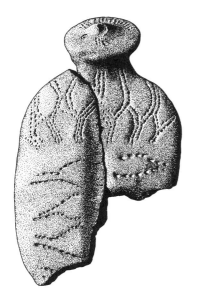

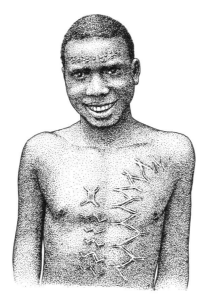

317

318

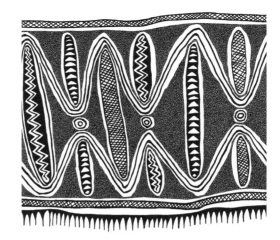

319

Similarly, horizontal bands, cut from *Type 1* patterns, sever leg-arm connections (depicting descent), but leave intact arm-arm & leg-leg connections (depicting a single generation).

Both 319, from Papua; and 320, from the Congo, were *copied* from excerpted bands. In 319, the extraneous spines were retained, though halved; in 320, they were eliminated.

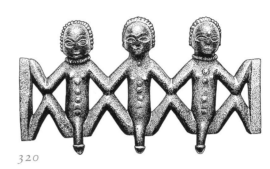

320

The design on 321, a pottery lime-container from modern Indonesia, duplicates the decorative band encircling 322, Jomon vessel, Japan. Both derive from genealogical patterns.

Though such designs appear to us as purely decorative, presumably they once represented limbs & spines and may continue to hold that meaning for some who still make them. Bands from such figures commonly decorate thresholds.

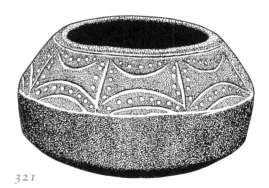

321

Clothing, metaphorically, is threshold: costume-change signals identity-change, always an occasion for anxiety. Let chains of ancestors guard cuffs & borders. Weapons, too, transform life. Drums transport shamans to the Land of Darkness; boats to other lands; tombs to other worlds. Let ancestors guard them all. And let ancestors form unbroken chains around the mouths of cooking vessels, for these, too, are places of magical transformation: whatever goes in raw, comes out cooked.

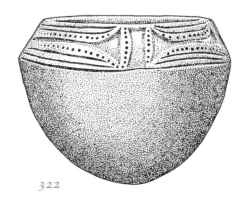

322

Vertical Bands

Shield *323*, from Irian Jaya, is shown here incorporated within a hypothetical reconstruction of the pattern from which it presumably derived. A vertical swathe, cut from this *Variant Type 1* pattern, severs arm-arm & leg-leg connections between diagonally adjacent figures. But leg-arm connections between vertically adjacent figures remain intact, leaving figures stacked like acrobats on one another's shoulders.

The wooden club or staff in *324* comes from pre-dynastic Egypt. Designs identical to that on its upper portion survive today in the Near East and North Africa on camel straps, while entire patterns of this type grace rugs in both areas.

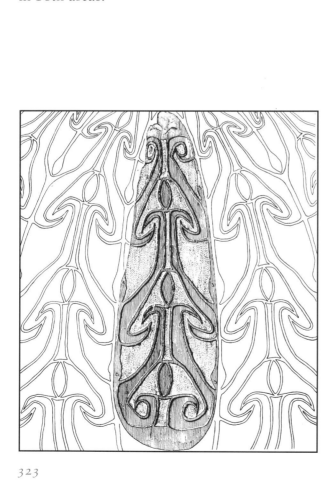

323

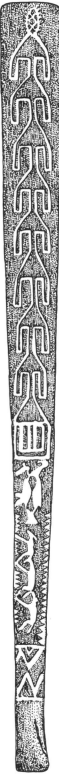

324

A vertical meander is simply a swathe cut vertically from a *Type 1* pattern. I assume *325* was excerpted from a pattern like *326*, both from New Guinea.

In classical times, meanders enjoyed great popularity as borders. But by then their original meaning & function—guardian ancestors—had probably long since faded. Still, some shadow may have lingered: in *327*, opposing meanders flank the 'spine' of a Mycenaean funeral stela.

The Asmat of Irian Jaya call hockers, *kavé*, *328*, and assign to them the names of deceased persons. Vertical bands of *kavé*, *329*, are popular on shields, *330*, and spears, *331*. Split vertically, *332*, each half *kavé* is called a *wènèt*, after the praying mantis which it resembles and with which humans are said to be interchangeable.

Wènèt may be linked, leg-and-arm, to form vertical chains. Two opposing chains, on either side of a spine, represent a lineage. The Asmat explain *333* as representing 'the family groups belonging to a particular ceremonial house'.

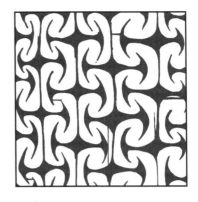

325 326

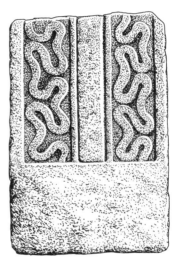

327

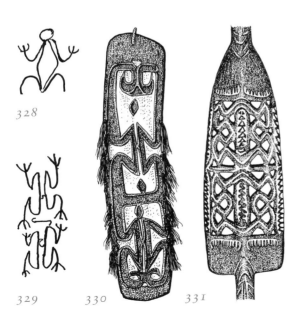

328 329 330 331

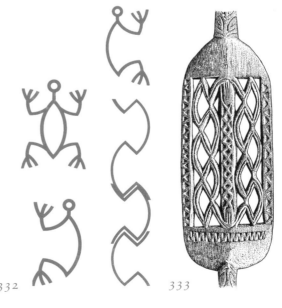

332 333

Huge Arm, Huge Leg

Cutting a horizontal band from a *Type 1* pattern severs all leg-arm connections. To retain those connections, start with a line of unattached figures:

Then enlarge one arm and the opposite leg of each figure, interlocking these spiral limbs with those of adjacent figures, as in *334*, from New Guinea.

Design problems explain why two, and only two, limbs expand. In adapting all-over patterns to pottery decorations, artists often pulled apart component figures to fit them into horizontal bands around vessels. This process everywhere gave rise to similar developments: connections between figures were disturbed; limbs were distorted and pairs of interlocking limbs were sometimes reduced to single spirals.

Figures on *335*, neolithic vessel, Ukraine, look like ramiforms with detached spiral limbs. Related examples from the same area collectively reveal a band of figures, each with one huge arm and one huge leg. The same form appears on *336*, a Ban Chiang vessel, Thailand; and *337*, a Tularosa design from Arizona; while *338*, an Arizona petroglyph, looks like a by-product of this motif.

This technique of preserving meaningful limb-connections is a simple solution to a problem created by excerpting. Was it independently reinvented in widely separated areas? Or was that solution already in place before the development of the various local styles in which we see it rendered? Either way, the artist's intention is clear: preserve the meaning of limb-linked figures.

334

335

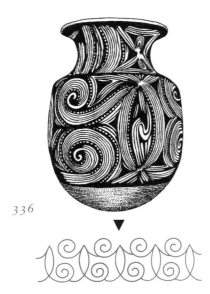

336

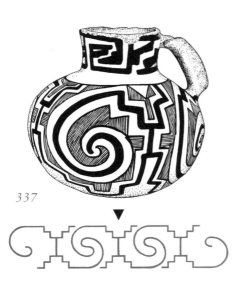

337

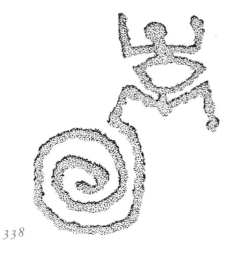

338

I think this figure with two, huge spiral limbs was a definite entity, and that these curious examples, both on pottery & stone, ultimately derived from Old World iconography and its clothing.

My feeling is that 'chronology', especially in art, is apt to be deceptive, and that archeology often yields a completely false impression of the course of events. I tend to relie more on the internal evidence of the designs themselves, using broad comparisons, which often lead back to symbolic origins.

Perhaps I'm foolish to say this. No doubt chronology is important. But if this motif reached the New World from the Old (as I believe it did), then the intra-American chronology will have to be coupled with a new dimension and, I suspect, a much older one, from Old World chronology.

Complete patterns of spiral-limbed figures no longer exist in the New World; conceivably they never existed here. And if they were present, presumably it was as body or clothing decorations, or on other perishable surfaces. Yet the figures themselves occur on both continents. I believe these figures (not necessarily all examples, but those used in certain systems of design) evolved from genealogical patterns. This evolution had already taken place, I think, by late paleolithic times, say roughly 10,000 BC. By neolithic times in South Russia (circa 3000 BC), the system was already 'old hat'.

Just how & when it came to the New World, I don't know, but I think it came early, via pre-pottery hunters, and that whatever they brought was already fragmentary, a *débris*, in which spiral limbs & stepped-frets were but fragments of a fragment.

Antiquity

Honeycomb or hexagonal patterns occur with some frequency on Magdalenian sites in western Russia, uniformly on ivory, *339 & 340*.

Note the 'spurred' lines on both sides of *340*. I see that motif as a conventional representation of stitching, presumably of a decorated skin garment. The spurred-line motif has a long history, especially among Eskimos who engrave it as garment seams on human effigies. The Okvik ivory cup in *341* is 'clothed' in a tailored garment. So is *342*, an early needlecase, also from Bering Strait.

If this interpretation of *340* is correct, then the whole plaque must represent a human figure clothed in a garment decorated with a conventional genealogical pattern.

Paleolithic art is often highly abstract. Two lines may define a steatypogous female; notches represent generations; bi-lobed beads represent women; etc. The hexagonal pattern fits comfortably into this sophisticated iconography. It's hard to imagine a more effective way to illustrate a genealogy. It could not be simpler. Yet that simplicity can mislead. Some writers believe hexagonal patterns represented nets. I think *all* paleolithic art was representational, but not limited to representations of physical objects. What was represented here was neither fishnet nor honeycomb, but genealogy.

339

340

341

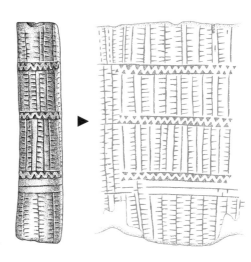

342

The engraved stag's horn in 52, perforated at the broken base, comes from Sjöholmen, a mesolithic site in Sweden. Its engraving includes horizontal bands of headless human figures with hatched spines. Each band comes from a classic genealogical pattern of double-walled hexagons.

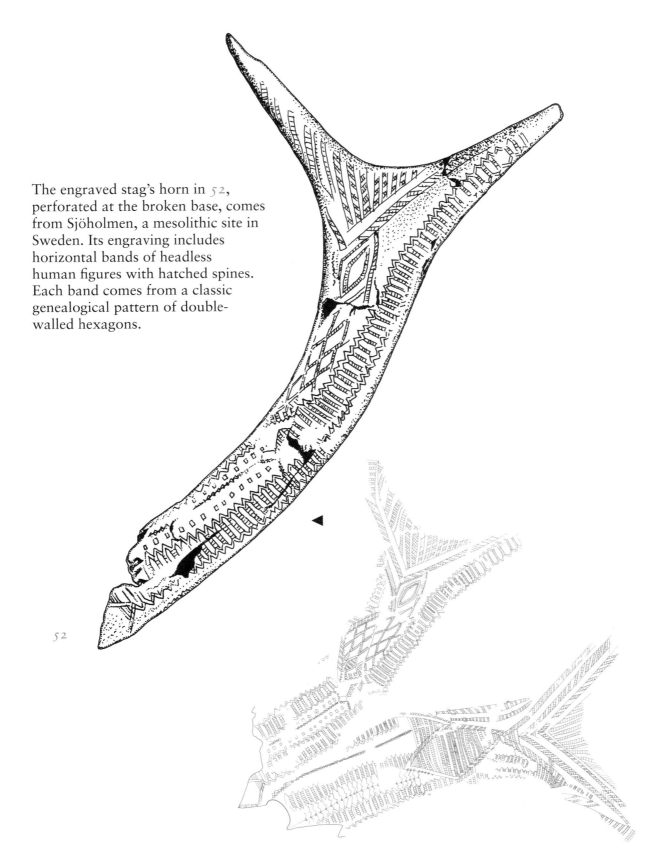

52

Many bone & antler objects of the Maglemose culture, which flourished in Denmark and the Baltic area between 8000–5000 BC, bear genealogical motifs engraved with a hexagonal or honeycomb pattern. In *343*, double lines define spinal columns and transverse gashes separate vertebrae.

In *344*, dotted figures join arm-and-leg to form hexagonal networks. The unfinished design in *345* is simply a double-walled hexagonal pattern.

Were artists always aware of the human identity of the elements comprising these patterns? Probably not. But the artist of *346* was. He isolated seven human figures at the beginning of his composition and followed his statement of the theme with a number of variations on it.

Most Maglemose hexagonal patterns envelop cylinders, or stop just short of doing so. This might be dismissed as the consequence of the nature of the objects decorated, chiefly bones & antlers. But the application of a genealogy to a cylinder aptly expresses the endlessness of the genetic process: I think cylinders were selected with this in mind.

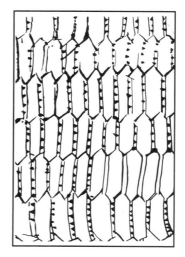

343

344

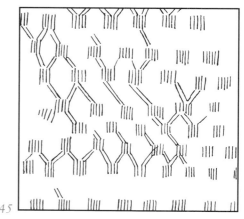

345

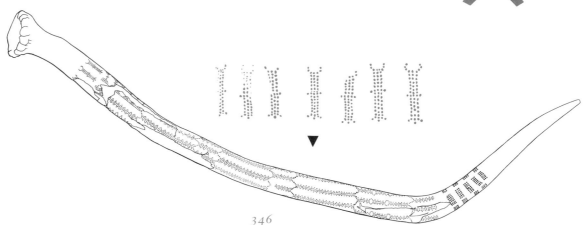

346

347

Ancient Count Systems

A Maglemosan engraving from Denmark, *347*, dated about 5000 BC, represents spines as columns of quasi-triangular or trapezoidal shapes. To the right of the hexagonal pattern rise columns of Λs or Vs.

This same association of pattern *&* count appears on an ostrich egg from predynastic Egypt, *348*, attributed to the Amratian period, circa 4000 BC. Each design is an excerpted band (hence the absence of closures at the top *&* bottom) from a *Type 1* pattern.

The Maglemosan engraving in *349* is chaotic *&* confusing, at least to us, but contains hourglasses and a column of stacked bars.

Spanish cave painting *350*, circa 4th millennium BC, shows a pattern of joined hourglasses, much like the Mohave example in *351*, though carelessly produced. To the right appear five attached figures in familiar combination; to the left, a column of stacked Ms. The distance between column *&* pattern is greater than shown here, and other motifs intervene. But the paint *&* condition of the column resemble those of the pattern: I think the two together constituted a *Count System*.

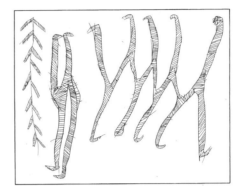

348

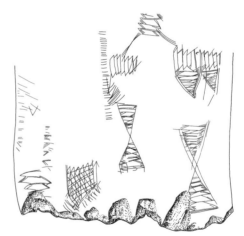

349

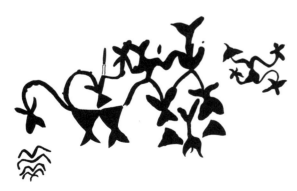

350

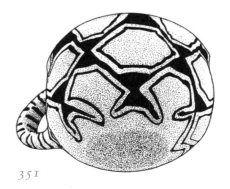

351

Exploded Systems

When a *Shadow System* falls apart, its secondary pattern goes first. But, even when its human figures lose their identity, it may still retain identifiable limbs, hands, vertebrae & heads, offered in total disorder.

I call designs 'debased' when bungled examples were copied. A significant portion of Asmat art in Irian Jaya belongs to this genre. Essentially the same process of bungling & debasement seems to have occurred widely, though independently, at other times.

Consider Asmat design *352*, carved around a bamboo tube. What first appears to be wild disorder resolves itself into a *Type 1* pattern of undulating limbs, with nucleated circles as joint-eyes or heads. A *mélange* of jagged elements fills the intervening spaces.

Comparison with *353*, another Asmat tube, suggests that the jagged elements are really products of the decorative dissolution of human bodies. Note the hands at the ends of the disjointed stalks resembling limbs.

These *membra disjecta* may be no more than *débris* stripped from bodies now reduced to curving bands. And/or they may belong to a collapsed, secondary pattern, originally inserted between the bands of the primary pattern. This same interpretation probably applies to many shield designs in this area, eg *354 & 355*.

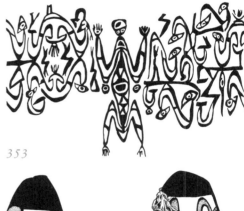

353

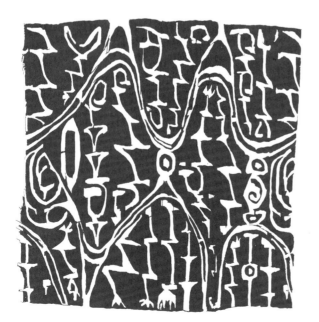

352

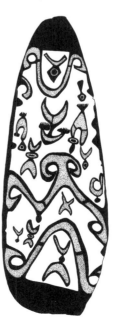

354

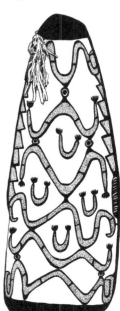

355

Consider a class of Magdalenian flat-relief carvings found in the French Pyrenees. In *356*, as in most of its class, the decoration comprises chiefly three elements, evenly spaced but irregularly disposed: nucleated circles, curving bands which tend toward spirals, and flower-like images. Eight such 'flowers', from four Pyrenean caves, appear in *357*.

Compare *356* with *358*, another Asmat bamboo pipe. Its nucleated circles have an ostensible counterpart in the nucleated heads of *352 & 358*. And the Magdalenian 'flowers' have a plausible equivalent in the unconnected *hands* of these same New Guinea designs.

Ideally, genealogical patterns encircle cylinders. Possibly *356* once did. Many, perhaps all, sub-cylindrical Magdalenian wands were roughened on the back, presumably to prepare them for the retention of resin, by which to fix them to a similarly carved counterpart, thus forming a cylinder encircled by the design.

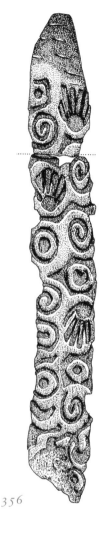

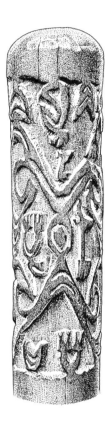

356 *358*

357

Paleolithic Meander

Figure *359* illustrates one of several engraved limestone plaques found together in Parpalló cave, in eastern Spain, and dated by stratigraphic evidence to Magdalenian 4, presumably before 10,000 BC.

359a *359*

Its most striking image represents the forepart of a horse: with superb economy of line, the artist conveyed the tension of this startled animal. A reindeer's muzzle, apparently by the same hand, overlies the horse's neck. Other animal parts appear at the lower right, jumbled together, as on an artist's sketch-pad. Finally, in front of the horse occurs a 'geometric' design, *359a*, with the same quality of lines as the other two drawings, again suggesting the same artist, yet possessing an entirely different character.

This strange association might be accidental. But naturalistic animals and 'geometric' designs co-existed in paleolithic art from beginning to end, and *359a* may be a relatively late manifestation of something far older. Aurignacian artists drew animals with great realism, sometimes with subtle appreciation of contour & movement, showing keen observation and technical mastery. Their schematic motifs, by contrast, reveal no such care or training.

These hastily executed designs recur in widely separated paleolithic sites. Presumably they reflect something so familiar to these communities that artists felt no need to lavish care upon their execution, but conveyed their intention, whatever it was, by hasty sketches, easily understood by contemporaries.

This association of naturalistic & schematic designs, sometimes side-by-side, continued sporadically into post-paleolithic times, after about 10,000 BC. Then schematic motifs, by themselves and apart from animals, played an increasingly important role in artistic traditions.

Naturalistic animals of upper paleolithic art have been widely studied and, in recent years, increasingly appreciated artistically. Schematic designs, falling as they do outside the range of what we generally call 'art', enjoy less attention. They are assumed to be 'diagrams' intended to convey ideas not capable of naturalistic representation. What those ideas were, we seem to have no way of knowing. Animal images we appreciate at a glance, but schematic designs require a key and that key seems to have been lost.

Personally I believe it was merely mislaid. We haven't known where to look for it, though it's been right before us. Schematic art of paleolithic times never ceased to exist: it survives today among various tribesmen. Compare *359a* with designs incised on three modern Australian boomerangs, *360–362*. The basic scheme of these Australian designs, especially *360*, is a meander of parallel lines, with zigzags between its loops. Meander *362*, like *359a*, is composed of parallel lines; its curves, which actually touch each other, 'break' at the points of contact; and its zigzags are discontinuous, in fact reduced to hastily executed 'zigs' & 'zags'.

If the Magdalenian artist of *359a* had in mind a design like those on *360–362*, why was he so sloppy? Perhaps careless. Yet elsewhere he wasn't careless. A more likely explanation is 'imperfect familiarity' with an iconography in which he had little interest. I suspect that this Magdalenian artist was a *man* who gave a man's impression of a design normally carried out by *women* in his society, and applied by them in its full form to skin clothing, now lost to us. As an artist trained in naturalistic representation, he may have looked down his nose at 'geometric' art, just as our modern artists look down their noses at what they call 'decoration'.

The complex at the lower left of *359a* is also composed of bundles of parallel lines, but associated here with oval or lentoid elements, not zigzags.

Certain mid-Magdalenian wands (*baguettes demi-rond*) from the French Pyrenees, *46 & 363*, share these same features. Two parallel lines (if we count grooves as lines) form conventional meanders. But, unlike most modern Melanesian examples, where ovals or circles *separate* undulating bands, here bands meet, and ovals or circles occur *between* their loops.

46 *363*

Four engraved pendants, *364*, from the Danish bronze age, circa 950–800 BC, have striated meanders. I see the perforated circles at their tops (and the nucleated circle at the bottom of one) as heads serving meander bodies. Note the horizontal zigzags in two, each possibly a count for the corresponding system as a whole.

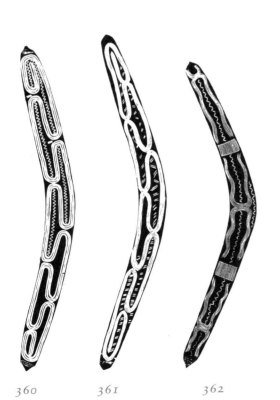

360 *361* *362*

364

Paleolithic Double Meander

The bone carving in *365*, excavated at Ahrensburg, Germany, belongs to the Hamburgian phase of the upper paleolithic. Radio-carbon analysis of associated material dates it at circa 11,000 BC.

Its largest motif is unfinished: five of its loops were never gouged out. Still, it can be recognized as a double meander of headless human figures representing a genealogy. I know of no paleolithic meander definitely accompanied by heads. It is a peculiarity of those paleolithic designs which have survived archeologically that they tend towards extreme simplification. Transition forms, which led to such extremes, are more likely to be found surviving in living traditions of the present day.

Note the human head carved at the bottom of *365*. Its *retroussé* nose, pointed chin and mouth cavity give it the appearance of an old man without teeth. Two fawn-like ears rise above its eyes, while a vermicular pattern is engraved on the back of its head.

Its discoverer speculated that this figure depicted a man wearing an animal's head, with the fur covering the back of his head. Many tribesmen wear such hoods ceremonially to demonstrate their professed ancestry from totemic progenitors.

Compare *365* to *366*, a modern Papuan mask. Note the quasi-human face below a meandroid design. Only the nose (or snout) and 'moustache' protrude in relief.

365

This is one of eight masks tradition-
ally worn in certain festivities in one
Papuan tribe. Structurally, all are the
same, though the heads of the other
seven represent animals or jaws, and
the 'forehead' motif varies from mask
to mask. Each motif was regarded by
the Papuans as the badge or emblem
of one of the lineal divisions of the
tribe which holds the dances in which
these masks are worn.

I see the forehead motif in *366* as a
debased meander originally composed
of human figures representing a ge-
nealogy—thus an ideal clan emblem.
This would then make the head at the
bottom a clan-ancestor, whose prog-
eny, the clan itself, is represented by
the meander of the human figures
above (arising from) this head.

I think *365* is simply a miniature im-
age of a life-size mask worn in pale-
olithic times by an imposter of the
clan-ancestor. If such a life-size ver-
sion once existed, its meander may
have been cut out of the fur of the
animal whose head served as a hood.

I don't know why the head on *365*
faces in the opposite direction from
the meander. But I offer a Papuan
counterpart: the modeled face at the
bottom of *367* looks forward, while
the flat face at the top looks back-
wards. F. E. Williams (our authority
on these masks) offers no explanation
for this backward-looking face.

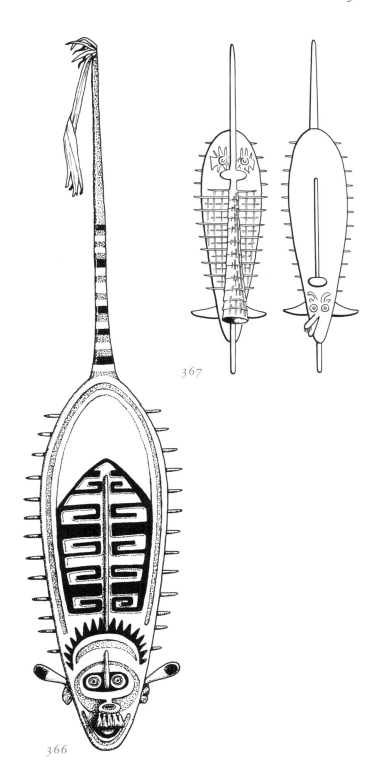

367

366

In *365*, the face, 'fur' (d), and mean-der (a) were all deeply carved, pre-sumably at the same time. But a fourth motif (b-c) must be older, for (a) was carved directly over it and, even then, (b-c) was almost effaced by wear.

Designs (b-c) and (d) are identical, save that (b-c) is smaller, finer and in-terrupted at least twice by blank bands. 'Interrupting' blank bands characterize many genealogical patterns, ancient & modern.

The choice of (d) to represent animal fur may have been prompted by the prior presence of (b-c), without thought for its symbolism, but more likely this genealogical pattern was deliberately chosen as a suitable motif for 'hair'.

Figure *368* shows a shield from north-ern New Guinea. Beneath its large, three-dimensional head, single mean-ders border either side. A double me-ander, also in flat relief, runs down its center.

This front meander joins the tip of the beard, symbolizing, I believe, the con-nection of the tribe to its mythical an-cestor, with the tribe mystically con-ceived as an extension of his beard, each hair representing one descen-dant. Such ancient, widespread beliefs could apply to *365*, with its meander (a) conceived as an extension of the ancestor's hair, or an extension of the animal's fur replacing that hair.

Again we see, in *368*, headless human bodies sharing a common head: a symbol of tribal unity. As in all such arrangements, these headless individu-als are joined by their limbs, in token of genealogical connection, to a myth-ical common ancestor, whose head dominates the group. Bodies are con-ventionalized, as if to indicate loss of individuality, while the head is treated with the utmost realism, as if it were a communal personality.

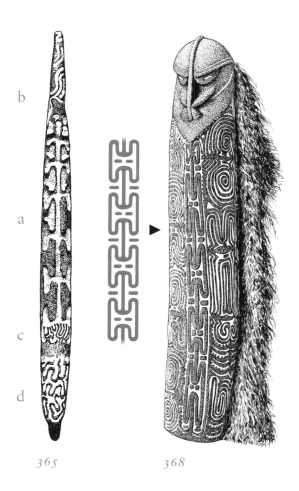

b

a

c

d

365 *368*

Modern New Guinea also provides a possible explanation for the function of *46 & 363*, even for *365*. Until yesterday, sacred bags remained a common feature in traditional New Guinea life, worn by men, especially warriors & hunters. Contents varied, but not greatly, and usually included tiny, stylized images of ancestors, carved of wood or, more rarely, of bone. Many of these images look much older than the bags which hold them. When asked, owners often identified them as coming from earlier generations.

The contents of *369* are typical of such bags: a pig's tooth; a single human finger (not shown); and two wooden carvings, one a highly stylized representation of a human figure and the other a meander representing genealogical descent.

In 1969, I collected several dozen such bags from various parts of New Guinea. Most contained carvings resembling those in *369*, and a number contained miniature likenesses of large ancestral figures. I've never seen any New Guinea examples with *precisely* the same designs as those on *46 & 363*, nor have I ever seen any mounted on both sides of a stick, a suggestion made about *baguettes*. Still, my guess is that *46 & 363*, even *365*, were once carried in sacred bags.

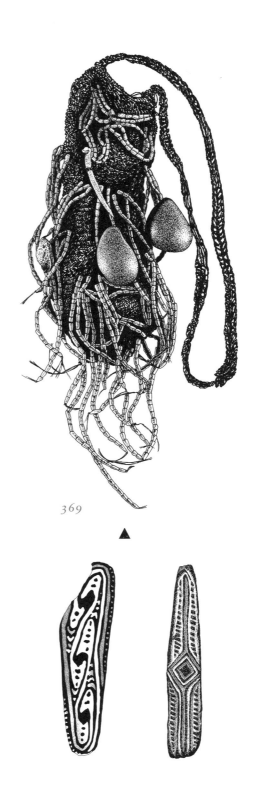

369

▲

46 *363*

Genealogical Iconography

Birth & marriage are the two basic considerations in kinship & genealogy. But kinship systems and genealogical patterns should not be confused.

Tribesmen rarely draw kinship charts, except perhaps at the request of visiting ethnologists. They express their notions of kinship verbally, with wide range of statement. Kinship systems vary from culture to culture.

Genealogical patterns, by contrast, are everywhere basically alike and far less complex. Tribesmen use them to illustrate what they declare to be their place within the great genetic chain of being. These simple diagrams enable them to trace their ancestry back to their Tribal Founder and forward to witness their own contributions to life.

Rules, rights, roles—the very stuff of kinship—lie beyond the capacity of even the most sophisticated genealogical patterns. What genealogical patterns do best is to record origins and display pedigrees. They also map ways to achieve rebirth.

I cannot imagine a simpler, more elegant way to illustrate a genealogy. A great invention. A marvel.

This should not surprise us. People everywhere are pattern-makers & pattern-perceivers. No matter how naked some may be, no matter how tormented their situation, all live in symbolic worlds of their own creation.

Of the many symbolic systems invented in history, surely none, save language itself, survived longer than this iconography. It lasted over ten thousand years, conceivably much longer. It crossed continents. Art styles that illustrated it came & went. The most diverse cultures sheltered it without destroying it. It outlived most of them. It reveals itself best through broad comparative study.

Self-contained, independent, everywhere the same, this iconography is free of the binding power of culture, save in the broadest terms of history. So when I juxtapose examples from Siberia & Papua, Africa & Australia, I'm not 'taking them out of context': the context to which they belong is the iconography they illustrate.

We confuse the matter when we see these examples as products of a given culture: pots & shields made by certain tribesmen in local styles with local explanations. Such details are incidental. In this iconography, culture, era, style, matter little.

Compare this to Euclidean geometry or chess. Chess-sets differ artistically, but the rules governing chess are basically everywhere alike. And the rules governing genealogical patterns are also everywhere alike. The same 'intelligence' lies behind examples from ancient Europe and modern Melanesia. This makes them easy to decode, once those rules are understood.

This analogy with chess isn't arbitrary. Both systems arrange stylized human figures spatially, according to set rules. Meaning lies in the relationship of figures to one another.

Chess may actually have developed out of genealogical iconography, specifically out of rebirth gaming-boards: eg a pawn, reaching the far side, Heaven, is auspiciously reborn a Queen, while the rival King is killed by 'dis-membering' his social body, a kingdom made up of bishops, knights, etc. Genealogical games reverse this: rebirth is achieved by 're-membering' a deceased ('dis-membered') body.

I don't want to push this analogy too far. Chess was invented (refined, actually) in northwest India, after the close of the Hun domination, probably around AD 570, and diffused from there, rapidly, culture to culture.

By contrast, this genealogical iconography was invented much earlier and transmitted internally, mother-to-daughter, father-to-son. Genealogical statements were tattooed on bodies, painted on clothing, engraved on weapons, and carried wherever their makers went. Dispersal of peoples, not diffusion of alien ideas, accounts for the worldwide, though not universal, occurrence of this system.

Bodies & Hands as
Kinship Charts

3

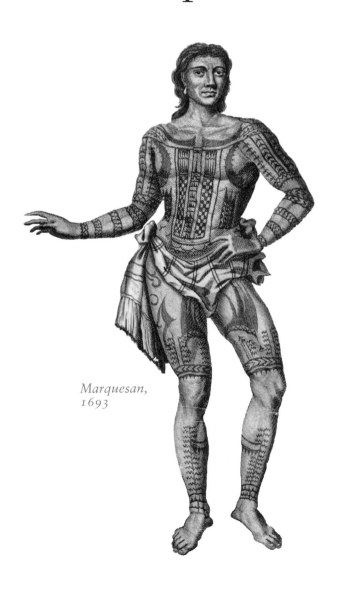

*Marquesan,
1693*

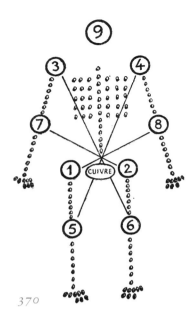

370

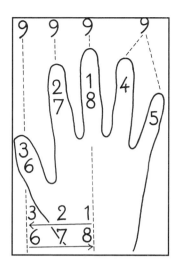

371

Dogon Kinship Chart

The Dogon of West Africa lay out a scheme of a man on the ground, *370*, with stones to illustrate the marital relationship of the ancestors of the eight clans composing their society. Large stones mark the four primary joints on each side of the body (shoulders, elbows, hips, knees), here numbered by the anthropologist to indicate the relative social rank assigned to them by the Dogon.

We are informed that the males & females of 'opposite' clans intermarry according to the lines connecting the joints diagonally across the center of the diagram. The ninth stone, marking the head of the figure, represents the chieftainship of each clan. The eight stones of the joints are explained as 'tokens of affection' left by the original ancestors of their respective clans, and as 'receptacles of their vital energy, which they wished to keep in circulation among their descendants'.

This diagram, which lives in the memories of Dogon elders versed in the lore of their tribe, was said to have originally been 'vomited' on the floor of a tomb in the place of the body of the first mortal by a primordial serpent who swallowed him after his death. The diagram is thus a symbol of regeneration, as well as a genealogical chart; and we are told that a similar chart, representing 'the human soul', is projected by the same serpent at every birth.

Of particular interest to us in *370* is the fact that it symbolizes genealogy not only by means of the major joints of the body, but also, as in the *Sachsenspiegel* diagram, *112*, by means of finger-joints. In *370*, stones represent long bones, ribs & spine, but cowrie shells, said to symbolize nails, represent fingers & toes. Joints or finger-sections are assigned numerical values corresponding with those of the eight major joints of the body, *371*. Thus the fingers represent a system of marriage, each pair of marital partners being coupled on two adjoining sections of a finger (with the exception of the last two fingers, which 'intermarry' with each other).

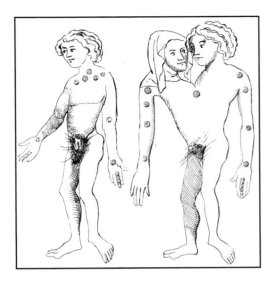

112

Medieval Kinship Chart

In Teutonic customs, *wergild*—the indemnity required when one person killed another—was paid by the killer and his sib to the victim's sib. Theoretically, duties & claims extended as far as sixth cousins on both sides (ie to all of the joints, but not to the nails in 112); practically, they extended only as far as fourth cousins. Rules fixed the total amount of *wergild*, as well as the share of each class of kinsfolk. The nearer the kin, the greater the sum.

Wergild was paid to those who possessed rights over the victim. These rights were held by the victim's cognatic relatives in a system similar to partnership: each relative held a share, and the share of any claim for indemnity depended on the nearness of the relation, eg second cousins claimed twice as much as third cousins claimed.

A man's kin were divided into those of the spear side (his paternal kin) and those of the spindle side (his maternal kin). In some Teutonic systems, relatives on the father's side paid or received twice as much as those on the mother's side, since a father's sister's son was judged a nearer relative than a mother's sister's son.

Drawings such as 112 illustrate the sequence of relationship governing the rights of inheritance: 'The father and mother stand in the head, full brothers and sisters in the neck, first cousins at the shoulders, second cousins at the elbows, third cousins at the wrists, fourth, fifth and sixth cousins at the joints of the fingers. Finally come the nails, at which would stand the seventh cousins . . .'.

Here remoteness of relationship increases with the distance from the head, and finger-joints represent the remotest relatives. Though this sequence appears logical, it may invert the earliest historical development: finger-joints may first have been used to count relationship and this count was subsequently extended to joints of the major limbs.

Nevertheless, I doubt that medieval jurists invented this kinship chart. I think they merely codified an image from earlier times. Among the Germans, at least, the 'primitive' idea of the whole body as a chart of relationship is deeply embedded in linguistic usage. Grimm brought together from various Germanic languages a series of kinship terms, both specific & general, derived from the names for head, nose, cheek, bosom, stomach, lap or womb, side, back, elbow, femur, knee, ankle & nails. Joints are included here on a par with other body features.

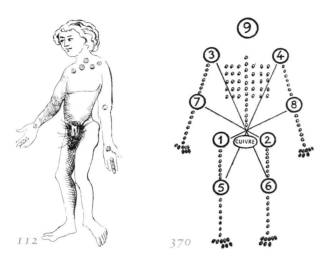

112 *370*

Though image *112* reveals its archaism especially in the fact that it makes use of the fingers in reckoning relationship, it becomes obvious in light of these Germanic terms that the body as a whole must once have been conceived as a kinship chart, even though only the joints are specified in legal practice. The fact that *112* makes no use of the joints of the lower limbs, which linguistic evidence shows to have been of at least equal importance with the upper limbs, supports my impression that the original symbolism has here been abbreviated for practical purposes. In most respects the symbolism of *112* survives better in *370*.

The human body may serve as an image of human society in more than its joints. It must always have been obvious that joints are nothing more than locations where bones connect and that they disappear with the dissolution of the flesh, while bones remain. I presume that joints were first conceived as symbolizing marital unions between 'members' of the social order, as represented by bones.

Ultimate priority in the development of the genealogical concept may belong, logically, to the fingers because of their natural suitability for numeration. But early man may have passed easily from counting relatives on fingers to outright identification of fingers with relatives, as implied by the custom of amputating fingers in mourning. This identification could then have been extended to the larger members, and to other parts of the body.

Ammassalik Eskimo say that in every part of the human body (particularly in every joint, and especially in every finger-joint), there resides a little soul. How natural to express this idea by using the human body as a kinship chart, just as Eskimo do.

Lucien Lévy-Bruhl cites instances of counting in Australia & Papua which begin with the fingers of the left hand (taken as units, not by knuckles or phalanges), hence proceeding to the left wrist, elbow & shoulder, followed by the neck and sometimes features of the face or head, and continuing downward successively by the corresponding joints of the right side, to the fingers of the right hand.

Similar examples are scattered through the literature. Certain native Australians count relationship on their bodies, using not only joints, but other body features. Stanner writes: 'A number of tribes use signs to designate certain relatives. The usual method is to touch various parts of the body, each relative being represented by a different part. This is commonly done when silent communication is for some reason necessary, but often it simply accompanies the mention of a relative, much as many aborigines when counting on their fingers raise each finger to their lips as the numerals are ticked off. Doubtless the concept has a reflection in the belief that twitchings or strange sensations in parts of the body mean that certain relatives will soon appear. The Nangiomeri say that twitchings of the thigh mean that mother's brother is likely to appear or that something is happening to him. One informant from this tribe gave me the following list of bodily signs for relatives: right shin, brother; left shin, classificatory brother; groin, mother's brother and sister's son; shoulder, father, father's sister and son; stomach, cross-cousin and father's mother; breast, sister's son; knee, father's father and son's son; buttocks or hips, mother's father; eye, wife's uncle. The lists vary between tribes'.

I don't know whether the Nangiomeri actually project their system in a diagram, like those of the Dogon or Germans. Yet I see a psychological analogy between the Nangiomeri custom and the Dogon idea. The Dogon elder who communicated the idea of *370* to an anthropologist was blind and thus unable to trace it on the ground. So he indicated the position of the various ancestors and the social groups descended from them by tapping the corresponding parts of his own body. He did so exactly as Stanner saw the Nangiomeri do, and as a medieval German lawyer may have done when arguing a case of inheritance in court. In each, kinship is designated by means of the human body.

The Nangiomeri designation of father's father and son's son by the knee has a certain parallel in the Philippines, where the Tagalog designate a great grandchild as 'grandchild of the knee'; and a great great grandchild as 'grandchild of the sole of the foot'. Iloko-speakers of Luzon locate ego at the waist, ascending generations at the shoulders & head, and descending generations at the knees & soles, thus mirroring the bilateral kinship group as it exists in reality.

The preceding comments suggest that the structure of society may be indicated by the joints of a single figure (in a human kinship chart), as well as by the multiplicity of figures joined by common limbs (in a genealogical pattern). Again, the relation between the individual & society is the relationship between microcosm & macrocosm: each an image of the other.

In genealogical patterns, each individual appears as a member of society; but conversely, in human kinship charts, society may be symbolized by the 'members' of each individual. The synthetic & analytic images of the social order are thus reconciled in the generic symbolism of the limbs.

All this may help explain 'joint-marks', a tradition firmly established among many people. On the simplest level, joint-marks are notches on the trunk of anthropomorphic posts, eg *372*, shaman's grave in Siberia. Post notches = tree knots = human joints.

In more explicit versions, human faces, skulls or eyes, representing ancestors or relatives, are painted or tattooed on human bodies, at the joints, according to descent or relationship. An individual, usually during initiation, is 'clothed' in his tribal ancestry and thereby converted into a living genealogical chart.

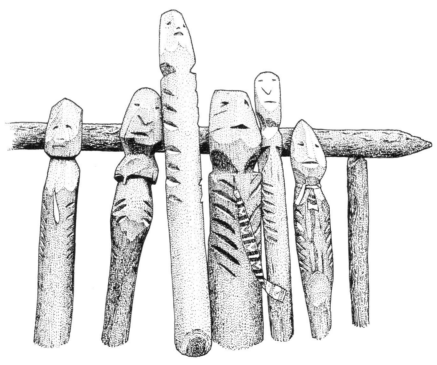

372

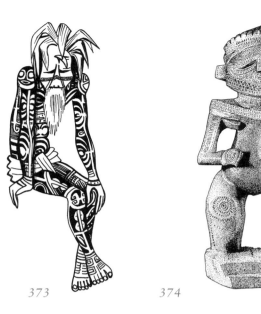

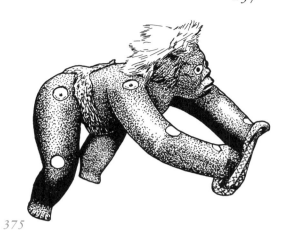

373 374

375

Figure *373* shows a Marquesan male with skull-like faces tattooed on his shoulders *&* knees.

An Austral Island 'goddess', *374*, has a joint-mark on each shoulder, wrist, hip, knee, ankle. Hawaiian figure *375* has shell-inlaid 'eyes' at all twelve primary joints.

Melanesia (New Guinea in particular) offers many examples. The ancestral image in *376*, from West Irian, has joint-eyes (some even have eyebrows) at the twelve primary joints. Spatula *377*, from the Massim area, has joint-eyes at the shoulders, elbows, hips and possibly hands *&* feet. A skull hangs from each elbow *&* knee of figure *378*, carved on a club from Milne Bay, with additional 'eyes' at each shoulder, hand, foot.

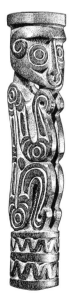

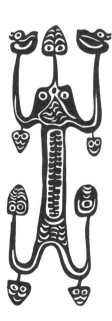

376 377 378

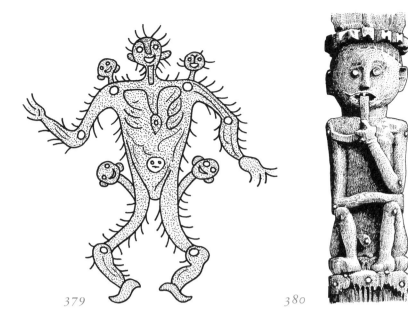

379

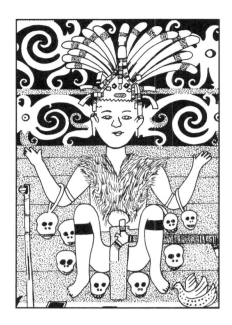

380

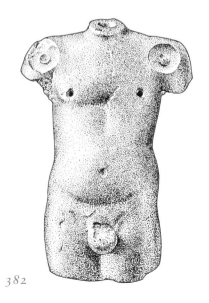

381

Joint-marks were common in Indonesia, especially in Borneo. Figure *379*, with joint-marks at its shoulders, elbows & knees, plus heads at the shoulders, hips & navel, appears in a drawing of a spirit-ship allegedly manned by ancestors. A Kenyah sculpture, *380*, also from Borneo, has porcelain inlays at the eyes, shoulders, elbows, knees, ankles, penis. In *381*, a Kenyah painting, an initiate takes 'the highest degree of all', with human skulls at his elbows, knees, hips, ankles.

A miniature stone sculpture from India, *382*, 4th century BC, in pseudo-Greek style, has a cavity in each front shoulder, presumably to hold a precious inlay. A bronze figurine from Mongolia or North China, *383*, has disks at its elbows, wrists, knees and possibly genitals. The terra cotta figurine in *384*, late Jomon culture, Japan, circa 2500–1000 BC, has markings at all twelve primary joints.

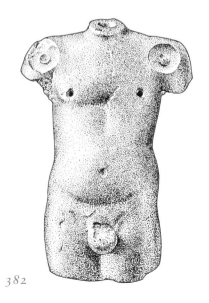

382

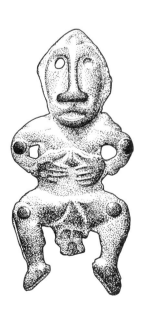

383

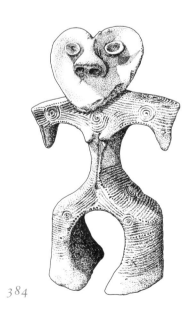

384

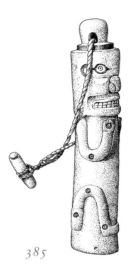

385

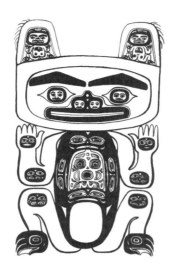

386

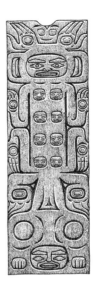

387

Joint-faces or joint-eyes had a special function in Northwest Coast art. The bone container in *385*, from British Columbia, is carved in the shape of a man with nucleated circles at his wrists, elbows, hips, knees, ankles. A Tlingit house-screen figure, *386*, shows faces at its knees, elbows & wrists; eye-motifs at its feet, and faces on its ears, eyes, nostrils, stomach. House-post *387* has eye-motifs on its hands & feet, as well as faces adjacent to its shoulders, elbows, knees, hips.

Tablet *388*, from the pre-Columbian Adena culture of Ohio, bears the engraving of a figure with nucleated circles at its twelve primary joints. Figure *389*, engraved on a shell gorget from a prehistoric mound in Alabama, is similarly marked. Disks mark the elbows & knees of *390*, a California pictograph.

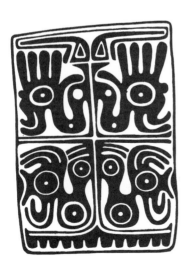

388

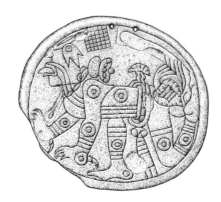

389

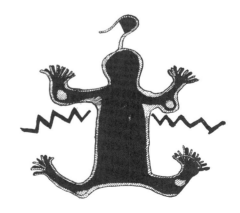

390

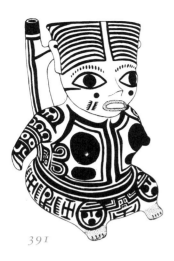

391

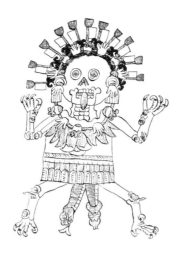

392

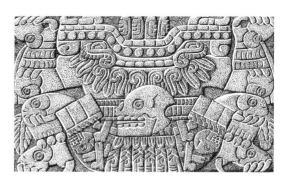

393

Joint-faces occur in ancient Mexico in at least two distinct cultural phases. The painted vessel in *391*, from the Huastec culture of the gulf coast, has a face on each knee & shoulder, and at the genitals, the whole design presumably imitating tattoos or painted designs.

Joint-marks occur in later Aztec art in the Central Mexican plateau, chiefly as an attribute of both the earth goddess, *392*, and the mythic earth-toad, *393*.

The Costa Rican figure in *394* displays prominent joint-marks at its shoulders, knees & navel(?); while vessel *395*, from Puerto Rico, displays a complete set of twelve.

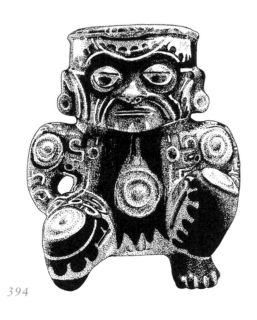

394

395

396

397

398

Faces appear on the elbows & knees of 396, a figure painted on a pre-Columbian vessel from Peru; as well as on a popular type of Nazca pot, 397, which also has a face at the genitals. In 398, a vessel from northeastern South America, two animals merge in one creature whose body coincides with the body of the vessel, and whose double head and double tail protrude at opposite ends. Eye-motifs mark the shoulders, hips, elbows & knees.

The decoration of vase 399, possibly from the Paracas area, presumably imitates body-painting or tattooing or clothing. Eye-motifs appear at the shoulders, hips, knees. Vessel 400, from Brazil, has joint-eyes at the shoulders & knees; while the pottery figurine in 401, from Venezuela, has two nucleated circles (pairs of eyes?) stamped on each shoulder, wrist & knee, as well as the genital region.

399

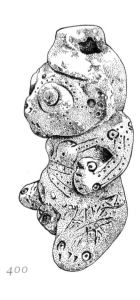

400

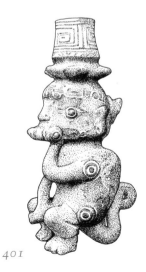

401

402 403 404 405

In the decorative arts of northeastern South America, the same types of joint-marks found on human figures also occur on animal figures, especially reptilian creatures with flexed limbs. Crater-like protuberances mark the shoulders, hips, elbows & knees of *402*, a lizard modeled on an urn from Marajo. Stamped-rings mark the hands & feet of *403*, one of two confronting frogs modeled on a Venezuelan bowl.

This arrangement of joint-marked frogs as a confronting pair may be very ancient, while the 'frog' or hocker motif itself is probably even older. Compare *402* & *403* with *404* & *405*, the latter two from Melanesia. Then compare all four with *406*, a decorated neolithic sherd from Europe.

406

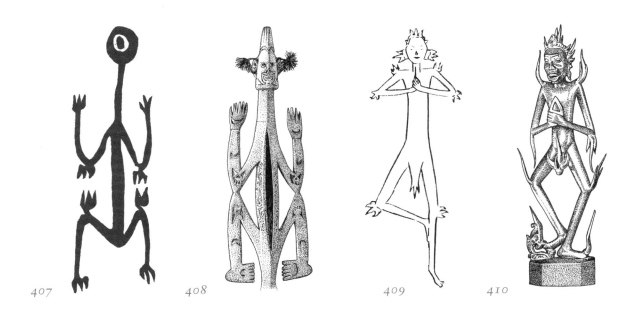

407 408 409 410

Sprouts?

Joint-marks resemble sprouts (fingers,
flames?) on *407 & 408*, from Irian
Jaya; *409 & 410*, Tintiya, Supreme
Being in Balinese cosmography; *411*,
neolithic vessel, Ma Chang period,
China; and *115*, German, 14th century.

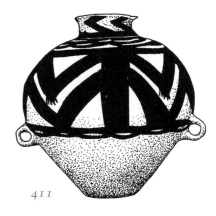

411

115

Eyes & Whorls

Why do joint-eyes so often substitute for joint-faces? Eyes serve as heads in *243*, permitting the design to be viewed from either end. A single figure excerpted from such a pattern retains the heads (eyes) of adjoining figures at its hands, elbow-knees, feet *&* genitals.

Shoulder-rosettes tattooed on the Kenyah man in *412*, Borneo, have parallels elsewhere in Oceania. They may survive from an ancient custom of placing whorl-motifs on the joints, especially the shoulder-joints of deities and those who claim descent from them. Similar whorls were placed on the joints of mythic animal images.

Whorl-joints appear on some of the earliest Sanskrit inscriptions in Java, eg *413* (shoulders, nipples, elbows, wrists, knees). They appear, as well, as far away as Mildenhall, England, where a Roman silver plate shows a Gorgon, *414*, with whorls at his shoulders *&* nipples.

European lore tells of the child lost by chance or treachery, then rediscovered —recognized from a royal cross, 'redder than the rose of summer', on his right shoulder. In medieval romances, those who discover this fateful mark, even before they can assign the predestined hero a precise genealogy, don't hesitate to exclaim, like the countess who rescues Richard le Bleu, abandoned in the forest soon after birth, 'O God, he shall be king!'

243

412

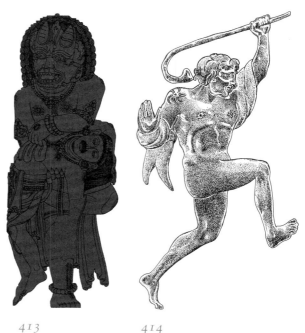

413 *414*

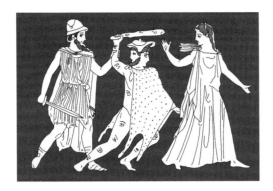

415

416

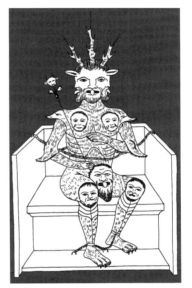

417

Vestiges

Scene 415, from classical Greece, shows
Hermes killing Argos whose many
eyes are distributed over his entire
body.

Renaissance armor, especially that
of kings, sometimes had faces at the
joints, 416, with lion-like faces at the
shoulders, elbows, wrists (also knees
& feet, not shown). Armorers sought
to recreate what they imagined was
a Roman model. Often wildmen in
European folk festivals were similarly
adorned.

Gradually, joint-marks lost dignity.
Knee-faces became animal heads or
devil faces. The three-faced devil in
417, a 15th century miniature, has
faces at its shoulders & knees and,
most prominently, at its genitals (a
penis is still jocularly called 'a joint'
—a euphemism of some antiquity).

Woodcut 418 shows a misshapen
child, variously reported to have been
born in Cracow or the Nederlands in
1541.

Language & lore preserve other oddi-
ties: the handshake, as social contract;
the raised fist, as symbol of unity;
the gesture of clenching the right fist
while slapping the flexed elbow with
the opposite palm, once a warning
of kin support, now reduced to an
obscenity.

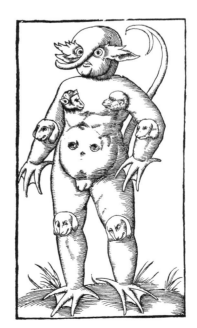

418

Potency of Fingers

The genetic potency of fingers comes to light in a Papuan story of the culture hero who was dismembered & eaten, except for one finger: the next morning he reappeared alive. This seems to imply that the survival of a single finger is sufficient to assure the regeneration of the whole body, in much the same way as a plant may spring from a cutting.

Of the myths that are told by Eskimos from Greenland to Siberia, none is more important than the myth of Sedna. Sedna is variously a daughter, orphan or mother sacrificed to save the community. In this sacrifice, her first, second & third finger-joints are cut off. These fall into the sea to become the seal, walrus & whale upon whom the Eskimo depend for survival. Sedna controls these sea mammals and thus holds the power of life & death over the living. Since these animals derive from her, hunting them is a holy occupation and eating them is a communion tantamount to eating the First One.

Fingers, of course, are ideally suited for numeration, especially the numeration of relatives when each phalange represents a relative.

In Taiwan & Borneo, human images are tattooed on fingers, 419 & 420. The Haida of British Columbia tattooed mythic figures on lower phalanges, 421. Eye-like motifs on a Tlingit charm from Alaska, 422, represent 'spirits emerging from the knuckles'. That same motif appears on 423, from prehistoric Oklahoma.

The 15th century German hand-chart in 424 presumably served as a mnemonic device for reciting the Twelve Articles of the Christian Credo, shown at the right. Christ & Mary appear on the thumb and the Twelve Apostles on the finger-joints of an inner left hand.

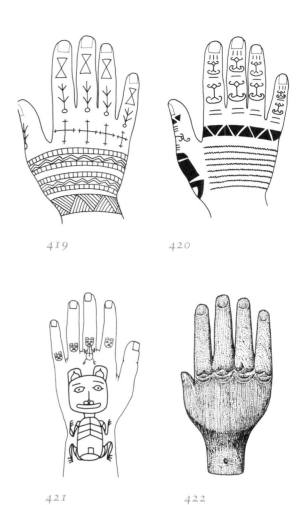

419 420

421 422

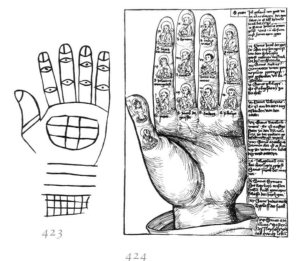

423

424

The idea that a special potency resides in the fingers is merely a specialization of the genetic role of limbs. But it may have been the other way around: perhaps social significance was first imputed to fingers, and only later were limbs conceived as symbols of social organization & relationship.

The reason for this inference lies in the custom of finger-mutilation—specifically, the amputation of one or more phalanges of a living person. Many tribes practice this custom. Its practitioners offer various explanations, the most common being sorrow for the death of a close relative, or an attempt to preserve the life of a sick or dying person. The basic notion seems to be: 'For each joint, a relative; for each relative, a joint'.

In other words, fingers are so closely associated with relatives that they become identified with them. This sacrifice is, as it were, a partial death of the individual, by which he partakes in the death of a close relative.

The Dani of New Guinea, following a funeral, remove a phalange from each of several girls, 425: 'Each knows that what happened had to happen, and that it will happen again. When they were infants, their own mothers had held them and played with them using hands that were mostly thumbs.'

Trophies composed of human fingers occurred among a number of American Indian tribes. Example 426 was one of two removed from a Cheyenne village destroyed by cavalry in 1876. It was said to consist of left-hand, middle fingers of Indians of hostile tribes, killed by High Wolf, a Cheyenne warrior. John Bourke, who published this example, cited examples from many parts of the world.

425

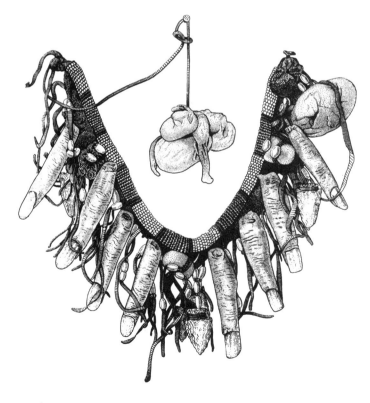

426

In 1969, in southern Papua, I saw a long necklace composed of human finger phalanges. It was intended to be worn, I was told, and though it wasn't then in use, it showed much wear from handling.

A custom occurring so widely suggests an ancient origin. And we have evidence of its antiquity. Silhouettes of hands with missing fingers, eg *427 & 428*, were projected on cave walls in France *&* Spain in the Aurignacian period, some 30,000 years ago. Similar motifs occur in Texas, *429*, and in the caves of southern Patagonia, *430–432*. New World examples remain undated, perhaps undatable, but I think the custom of finger-mutilation reached both Americas long ago.

Those who practiced this custom until recently often said they did so to mourn dead relatives. If this same motive prevailed in ancient times, then it follows that some 30,000 years ago fingers were already conceived as representing relatives or degrees of relationship.

427

428

429

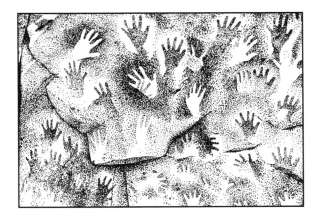

430

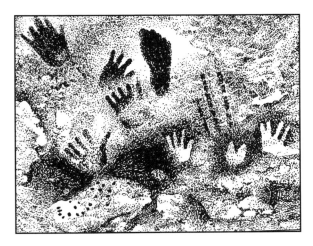

431

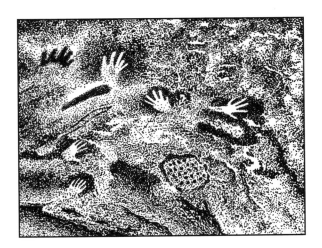

432

Fingers & Digits

Associating relatives with finger-joints presumably arose through the use of the fingers as digits in counting relatives for purposes of social classification. I assume this numerative function led, at very early times, to the actual identification of fingers with particular relatives or classes of relatives.

Among peoples with limited interest in numerary abstraction, counting may have first taken place on the fingers as units. But probably from early times the counting was done on knuckles or phalanges, as some Australian aborigines counted until recently. Degrees of relationship were probably symbolized progressively from the distal to the proximal joint of each finger.

We don't know, of course, precisely what relationships were assigned to various parts of the fingers in Aurignacian times. Presumably modes of counting varied from one people to another. Since it is impossible to amputate the second or third phalange of a finger without amputating the tip, the choice of phalange to be amputated probably was not always strictly determined by the classificatory position of the mourned relative in the hand, but reflected only a generalized association between relatives & fingers.

Nevertheless, the best explanation for this custom of amputating fingers as a sign of mourning for deceased relatives begins by assuming that the fingers were first used for classifying relatives, and then were identified with them.

Hand-prints

The hand-print has been popular in tribal art from very early times. Among recent tribesmen, it was often painted or stamped directly on the human body.

In Patagonia, Tehuelche men, at festivals & dances, used white paint or powdered gypsum, moistened & rubbed in the hand, to make five white finger-marks over their chest, arms & legs. Among the Mohave, both sexes drew designs with wet, white paint on the palm of the hand, then pressed or stamped these designs repeatedly over the body or hair. In 1907, a Pima Indian in California, 433, was marked with hand-prints of powdered soapstone, in preparation for a curing rite.

The painted, or more probably impressed, image of a hand upon the left breast of a Mandan chief, 434, was said to indicate he had taken no captives. A contemporary description, as well as the illustration itself, suggest that the hand was dipped in yellow pigment, then stamped *over* a pattern of alternately brown & unpigmented stripes covering the whole upper body, thus creating a silhouette effect.

In the same way, a number of yellow bars, said to represent a tally of brave deeds, were drawn by the fingers (*nota bene!*) across the brown striping on the arms.

If the hand is essentially a social symbol, by virtue of the function of the fingers in counting relationships (and perhaps the resemblance of the outstretched fingers to genealogical 'branching'), then its association with an hourglass on the sternum of the Sioux warrior in 435 becomes clear: the hand appears as a numerary adjunct or tally of the human figure represented by the hourglass.

In other words, the hand, because of its fingers, has the value of a multiplication mark: it suggests the multiplicity of the associated human figure, in the sense of an impressive ancestry.

Among Plains Indians, few body decorations were more important than the human hand-motif, painted or tattooed on the chest.

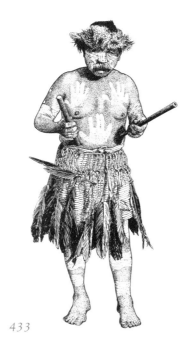

433

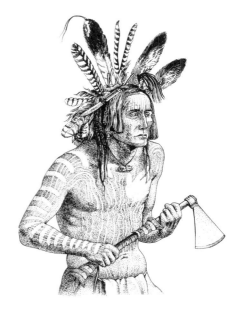

434

This custom of impressing hand-images on the human body enjoys such a wide modern distribution, I wonder if it doesn't survive from paleolithic times. Hand-silhouettes and imprints of pigmented hands on cave walls may represent a transfer of this decoration from body to stone surfaces — perhaps to commemorate the presence of the respective individuals at some ceremony held in or near the caves. Examples are common in both Old & New Worlds, eg *436*, Canyon de Chelly, Arizona; as well as in Oceania, eg *437*. In Australia, hand images were painted on, and carved into, rock surfaces, eg *438*, showing hand & vulva motifs commingled.

Hand-silhouettes in *436* have Old World Aurignacian antecedents. A similar 'air-brush' technique of splattering paint from the mouth was employed in Patagonia, Australia, Oceania & elsewhere to produce 'hand-negatives' on rock-facings, as well as on certain classes of Pueblo pottery. I assume all of these examples perpetuate an old tradition.

436

437

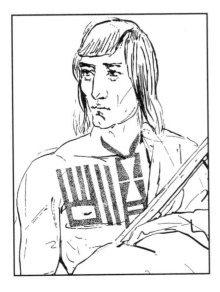

435

438

4

Social Bodies

Polynesian,
1817

All genealogical patterns rest on the premise that each person is composed of two halves, derived respectively from the corresponding halves of each parent. In most cases, the right side is declared male, the left side female. Link such figures in all directions and you have a familiar genealogical pattern:

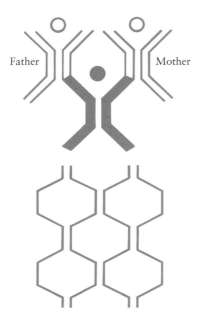

Father Mother

Single figures excerpted from genealogical patterns often emphasize this split, eg *439*, from New Guinea; and *440*, from Puerto Rico. So do certain patterns, eg *441*, Polynesian tattoo; and *442*, Patagonian painted robe.

This division symbolizes the composition of any offspring from the union of a male & female from exogamous moieties. On a social level, it illustrates the tribe's dualistic nature.

439

440

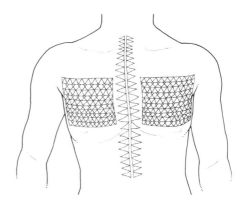

441

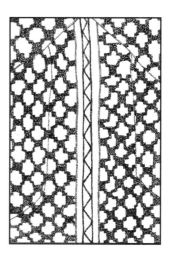

442

It's easy to transfer this duality from individual to tribe because the transfer originally went the other way. The two opposing parts, male *&* female, which together form the individual, become the two extraneous moieties which together form the 'social body' of the tribe, personified by the body of the First One.

This symbolism of opposites united in One, with its related myth of tribal origin from a Primordial Body, figure in the myths *&* arts of many people. Posts, even entire houses, may be clothed in these symbols. The reverse also occurs: dancers dress like posts, even like houses, while individuals declare themselves 'members' of a house.

The most diverse tribesmen liken their houses *&* temples to the body of the First One, conceived anthropomorphically. Spaces within are equated with the limbs *&* organs of this primordial figure. Activities performed at these locations often relate to those body parts.

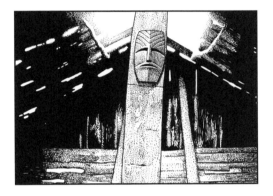

443

Many temples divide down their centers, with opposite sexes or opposing moieties facing each other. In the symbolism of the Delaware Indian ceremonial house, east is male, associated with red, life, day and the right-hand side; west is female, associated with black, death, night and the left-hand side. On the center-post of this Big House appears an image of the Great Spirit; one side red, the other black, *443.*

The Winnebago of Wisconsin, the Bororo of Brazil, and many other peoples divided their villages in half, separating the lodges of one moiety from the lodges of the other moiety. In Taiwan, an elaborately constructed stone path, *444*, separated the houses of the two primary social groups in each village.

444

Symbolically, the human body is further divided, this time horizontally through the navel. The resulting quarters are then identified with the four clans which together constitute the two exogamous moieties.

A New Guinea myth tells of a god whose body is divided at the navel into four parts, from which all humanity descends. That myth enjoys many variations. So does the custom of impersonating such a god in a quartered costume, eg *445*, a Cariyaos dancer, Brazil.

Ceremonial posts, dance costumes, even entire villages, may reflect this tetrad. The Malekulans of Vanautu said of Pete-hul, one of their villages that its internal organization was 'perfect'. Typographically, it illustrated their four-clan system, *446*. Ta-ghar, their creator-deity, allegedly founded this village by causing a certain fruit to fall which, splitting, gave rise to the first man & woman. From them issued four brothers, regarded as the ancestors respectively of the inhabitants of these four quarters.

One observer was sufficiently struck by Pete-hul's geographical divisions to say they resembled the 'quarters' of a town. That term, used nowadays in Europe in a purely figurative sense, recalls the fact that such quarters were once actualities there, too.

445

446

We don't know the kinship systems of prehistoric peoples. But, on the basis of observed changes in known systems, it seems likely that cross-cousin marriage, at least among sedentary, neolithic peoples, was once more common than today.

'With cross-cousin marriage', writes Anthony Jackson, 'the pattern most often found is to intermarry in groups of four lineages or clans. It may be that to intermarry in threes is not quite so symmetrical in appearance. Whatever the reason for the pattern, the grouping of lineages in four for this kind of marriage is what is most often found in practice, and sometimes appears in creation myths where peoples speak of their emergence from four founding ancestors'.

Cross-cousin marriage permits a man to marry either: 1) his mother's brother's daughter (MBD); 2) his father's sister's daughter (FZD); or 3) a stranger.

Diagram 447 illustrates FZD cross-cousin marriage in a four-clan system: women go clockwise as wives from lineage P to Q, Q to R, etc, in the first generation, then reverse direction in the second generation, with a corresponding reversal of the power structure.

The Solomon Islands *kapkap* in 448 shows four skeletons linked to headless figures in a circular genealogical pattern. Not all *kapkaps* show four such figures, but a disproportionately large number do. Does 448 illustrate 447?

It may not be that simple. Genealogical patterns aren't kinship diagrams. They could never have remained uniform for so long if linked to anything as varied as kinship. Yet at points these two systems touch. Images & tales of four clan founders may be one point of contact.

447

448

Genealogical patterns can be extended —at least potentially—endlessly in all directions. This makes them ideally suited for portraying the endless repetition of the genetic process. Even when the design is reduced to a band encircling a cylinder, as in *449*, an ancient vessel from India, the sense of continuity remains unbroken, for the rotation of a circle is potentially endless.

This applies equally to disks. The space is different, but continuity is preserved as long as the chain of linked figures remains unbroken. But this new space requires modifications. If you arrange a chain of human figures, eg *449*, in a circle, legs overlap in confusion. The simplest solution is to delete alternate bodies, while retaining their heads.

Examples include *450*, Solomon Islands *kapkap*; *451*, Navaho ceremonial design; *452*, West African threshold design; and *453*, 12th century European wind chart.

Extra heads are sometimes interpreted as trophy skulls, but trophy skulls are unknown in many areas where this motif is common. I see them as solutions to a design problem. But the selection of four primary figures was hardly fortuitous.

449

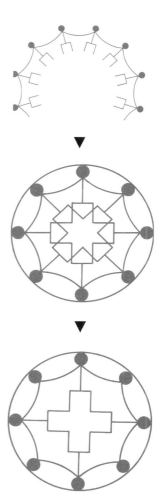

450

▲

451

▲

452

▲

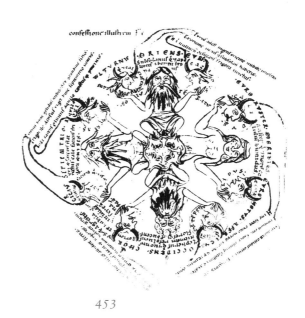

453

454

455

456

Among modern tribesmen, a single ramiform often represents a clan, while radiating ramiforms (most frequently four in number), represent a tribe. How far we can extend this symbolism into prehistory is uncertain, but there is no shortage of examples, modern & ancient.

Compare 454, Manihiki, Polynesia; 455, Antandroy, Madagascar; 456, ceramic vessel from Algerian megalithic tomb; 457, neolithic vessel, Bohemia; and 458, two mesolithic, painted pebbles from Mas d'Azil, France.

457

458

459

460

461

Pottery vessels with horizontal bands of genealogical patterns often had four primary figures surmounting headless progeny.

We don't know what prehistoric potters had in mind, but we do know that a disproportionately large number favored four figures: 459, prehistoric Iroquois, New York; 460 & 461, Ryukus; and 462, pre-Columbian sherd, Ecuador (the last two designs, uniformly extended, represent four linked figures).

Did such figures, like so many of their modern counterparts, symbolize four clan founders? I suspect that many did. I think this particular motif and this particular myth were long linked.

Similarly, when two reptilian hockers, surmounting genealogical patterns, confront each other across the mouth of a vessel, as occurs so widely, so often, this suggests to me representatives of opposing moieties.

462

The primary division, in all tribal societies, remains the division between exogamous moieties. From that division comes a dualistic view of the universe, separating everything into two opposing but complementary halves: men/women, good/bad, light/dark, left/right, etc.

Most societies associate men with all that is 'right': right side, life, dominance, sun, light, goodness. Women are linked with all that is opposite: left side, moon, darkness, evil. There are exceptions & variations, of course, but this general symbolism remains widespread & basic.

The symbolism of quartering is equally elaborate. Many people speak of the 'four quarters' of the universe and 'four seasons' of the year, neither of which exists except as metaphor, and assign to each direction & season a different color & humor, even a sub-deity or ancestor, conceived as an immediate descendant of the First Ancestor and intermediate between this Primordial Being and living people.

They employ this symbolism especially in games & rituals in which organized groups, sometimes affiliated with moieties or clans, compete in games of state or destiny. Examples of this appear in the last chapter.

Here let me offer three examples. In 463 & 464, two Mimbres vessels from Arizona, circa AD 1100, four players throw dice on a blanket, wagering untipped arrows. In the past, according to the modern Pueblo, dice sometimes determined important decisions. Gaming, they say, was sanctioned by the supernatural example of the Twins, who wore warrior caps similar to those in 464. Presumably the stakes in 464 related to war or peace, either in this world or another.

At first glance, design 465, on a Bidahochi jar, Arizona, circa AD 1350, looks purely decorative, but soon we realize it's a gaming diagram for four players, each with his own logo.

463

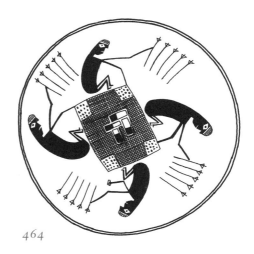

464

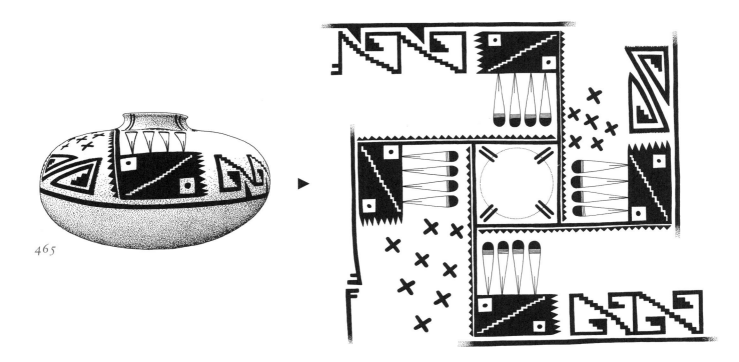

465

466

Posts, Houses, Dancers

The painted housepost in *466*, was made by Tukanoan-speaking Indians of the northwestern Amazon basin. Its large head surmounts a spinal column bisected at the navel by a narrower bar. Human figures with linked, outstretched limbs, fill each quarter. Essentially the same genealogical pattern, but with heads & spines, appears on the Guiana pottery vessel, *234*.

Individual heads & spines, missing from the greatly simplified figures in *466*, are represented collectively by the single head at the top and by the dividing spinal column.

If we regard each conventionalized body in *466* as representing an individual, then these bodies collectively form the body of the tribe, for which there can logically be but one head— that of the tribal ancestor at the top of the pattern, through whom all individuals of the tribe are ultimately related. So design *466* is far more than mere decoration: it symbolically represents the tribe as a whole.

Beyond this, the very application of a genealogical design to a housepost is in itself significant. When we speak of an outstanding individual as a 'pillar of society', and when we speak of a family as a 'house', we are perpetuating metaphors that may go back ultimately to literal usage.

Surely *466* represents such a usage, surviving in the traditions of a people closer to symbolic origins than ourselves. Not only figuratively, but also literally, the tribal ancestor is here the pillar of the house, its physical strength being metaphorically reinforced by the strength of all the individuals forming the collective body of the tribe.

234

▼

Genealogical patterns often emphasize spinal columns. But in *466*, spinal columns are extracted from their places in the repeating pattern and magnified into a single feature of dominant importance. The chevrons representing the vertabrae in this broad column run in opposite directions from a central point, determined by a transverse bar and evidently conceived as an umbilicus.

If the repeating pattern represents the tribe, its divisions by this means into four equal sections can only refer to social divisions within the tribal body. Among the Cubeo, and presumably among other Tukanoan tribes, this would probably mean exogamous phraties or sibs. The spinal column thus appears to be a symbol of cleavage, not so much within the body of each individual, as within the body of the tribal ancestor, and thus coterminus within the body of the tribe.

The crossing of the spinal column by a horizontal bar suggests that the body of the tribal ancestor was conceived as having been actually divided into four parts, which must be forever reunited by individual marriages between members of the exogamous divisions in order to perpetuate the social fabric of the tribe.

Here the umbilicus was probably conceived as an omphalos or cosmic navel, by which the bodily divisions of the ancestor were aligned with the cardinal directions—an alignment ideally perpetuated in the relative geographical locations of the sibs or phratries comprising the tribe.

The post embodying the ancestor is then simultaneously *&* necessarily the World Pillar supporting the firmament, as represented in microcosm by the roof.

Tupinamba Warrior

A document of prime importance for this phase of our study is the tattooing on a Tupinamba warrior, 467, as recorded by Claude d'Abbeville, a Capuchin missionary in the 17th century. This design differs from that of 468, a Tukanoan housepost, only in the absence of bars and the multiplication of stepped lines.

According to d'Abbeville, 467 represented to its wearer, and to his compeers, a record of twenty-four enemies who he killed in battle and whose names he acquired. The Tupinamba, then, recognized the elements composing this pattern as human figures. Since the basic meaning of all such patterns is genealogical, is there a connection between Tupinamba ritual homicide and the idea of tribal continuity which might explain the use of this pattern as a record of human sacrifices?

I think there is. In Tupinamba ritual, the body of the slain captive was first quartered, and its parts assigned to various individuals to be eaten. For participants, this assignment was a matter of great social importance. This suggests the ritual re-enactment of a widespread creation myth, according to which the human race is descended from the dismembered parts of a primordial body, with certain peoples, tribes or sibs descended from certain parts, in geographical alignment with the four quarters.

When the captive proclaimed his 'honor' at being dismembered & eaten, this was not only an expression of bravado, but also reflected the knowledge, or at least some vague memory, that in this grim drama he was impersonating the ultimate ancestor, and thus virtually a god or God himself, whose body was to be consumed in a primitive communion.

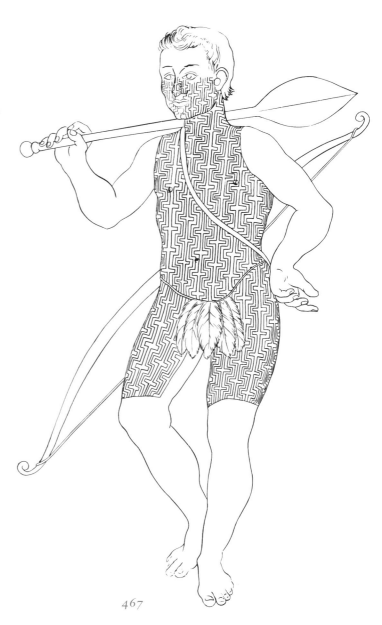

467

This idea may be read between the lines of a remarkable speech made by a captive warrior before his execution. In accordance with a formula customary on such occasions, he taunted his tormentors by claiming that in eating him they would eat their own relatives & ancestors, since he had earlier eaten of these when they fell captive to his own people.

This diatribe should be considered in conjunction with the fact that not only the executioner but all of the male & female relatives of his generation changed their names when the victim was executed. His death thus symbolized a whole generation's rebirth, and his sacrifice was somehow associated with the tribe's perpetuation.

That the Tupinamba executioner (who was often the son of the victim's captor) did not himself partake of the victim's body may be explained in the light of a Mexican practice, according to which captor & captive acknowledge their relationship to be symbolically that of father & son, and the captor abstains from eating of the sacrificed captive specifically for this reason.

The general relation between Tupinamba & Mexican cycles of captive-sacrifice and cannibalism was pointed out by Paul Radin, who also noted that the Tupinamba regard each captive enemy as a substitute for one of their own dead. Like the Mexican captive, the Tupinamba captive was treated, until his sacrifice, as a god; but also as the equivalent of an ancestor in the sense of a dead relative.

In applying a genealogical pattern to his body to commemorate the slaying of captives, the Tupinamba warrior also commemorated his own genealogy in terms of ritual sacrifices. Note that he was tattooed only on the torso, exclusive of his arms & legs, which would be cut away if he were captured.

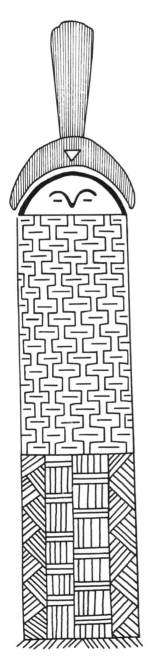

468

The human form assigned to posts, houses & dancers is often that of the Ultimate Ancestor. Whether this ancestor is represented by a living dancer or an immobile housepost or even by the house itself, matters little: the symbolism is the same. Society and the human body are conceived as mirrors of each other: the Ultimate Ancestor incorporates all of his descendants, who are the tribe; and his body parts, in turn, represent the divisions of the tribe.

A creation myth from the Society Islands explains how the architecture of a house literally 'embodies' Ta'aroa, the First Ancestor, who was dismembered to create the world: 'Ta'aro was a god's house; his back-bone was the ridge-pole, his ribs were the support'.

To the residents of such a house, the meaning of the ancestral housepost is often primarily *social*. But where the ultimate ancestor is conceived as God, that function becomes *cosmic*. Thus the Tikopia of Polynesia regard the housepost as a demi-god who provides communication between this world and the macrocosm.

Both as First Ancestor and as Cosmic Pole the center-post serves as a means of communication with forces beyond. Not all such posts bear genealogical patterns, but among those that do, some are said to provide a means of rebirth, permitting the soul to ascend through successive generations until reunion is achieved with the First Ancestor. This basic notion underlies 'heavenly ladders', as well as cosmic games played on the body of a primordial giant. It applies particularly to sacrificial posts where captives, forced to impersonate ancestors, are sacrificed & buried. More remotely,

it appears in the myth of the virgin who embraces a center-post or Tree of Life, and thereby conceives a son destined to found a tribe or perform miracles.

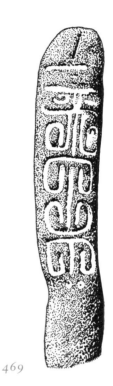

469

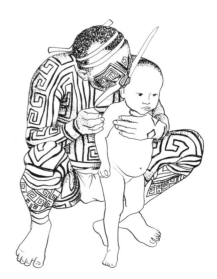

470

Lévi-Strauss describes Northwest Coast Indian houseposts as 'less things than living beings' who, in days of doubt & torment, guide the inhabitants, comfort them and indicate the path out of their difficulties. A 'refinement' of such ideas may exist in the Athenian Erechtheum.

Each clan in a Papuan men's house has an assigned section. It regards the anthropomorphic post or posts of that section as belonging to the clan. But the central post relates to the whole house & tribe.

471

In a Sumba house in Indonesia, one pillar, called the 'oracle post', stands out as 'exceptionally important'. Ancestral spirits, believed to come from Heaven to listen to appeals, are consulted here daily. Like the roof, this post is carved & sacred. Both are closely associated with spirits.

A stone column, 469, at Tafí, Argentina, conforms to this formula of post with human head at the top and genealogical pattern on the trunk. That design, simplified in 469, finds an analogy in the living arts of tropical Indians far to the north: 470 & 471, two Kashinawa, Peru; and 472, Carajá dancer, Brazil.

A pattern of headless human figures makes sense only if these figures are animated by the head of a living person who wears the pattern. And conversely, the only type of pattern which really makes sense as a body decoration is one composed of headless bodies.

472

Not all patterns used by South American Indians for body decoration necessarily derive from series of linked human figures. But some do, and a considerable number may ultimately be explained in terms of genealogical symbolism.

Tukanoan architecture symbolizes social ideas in a variety of ways. Each rectangle in the checkerboard facade of *473* represents a dancing costume with fringes at the bottom, similar to the typical Tukanoan housepost, *466*. The heads of the wearers of these costumes (perhaps conceived as masks) are represented in a frieze of alternately dark & light faces at the top, just under the overhanging roof.

I see this facade as a genealogy representing the enlarged family which figuratively constitutes the 'house'. I assume the reciprocal coloring of heads & bodies refers to the warp & weft of the tribe's social fabric. If so, these alternately dark & light heads may simply represent male & female partners in the family structure—or, by extension, exogamous clans.

When Koch-Grünberg photographed *473*, the inmates of the house posed before it in two groups: men & boys on one side of the door, women (and presumably a girl-child) on the other side. Koch doesn't tell us whether he asked them to pose in this way. It seems more likely they simply acted in accordance with custom.

466

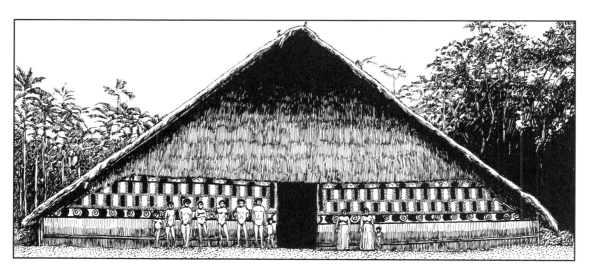

473

The Dogon of West Africa liken the house facade in 474 to a pair of hands spread out, with niches in two series of five columns each. Niches are said to be the homes of ancestors, who occupy them in the order of birth, beginning with the highest row. The Dogon reckon ancestry on their fingers, beginning with the first joints.

Each pilaster in certain tombs in the Cauca valley of Colombia has a head for a capital, as well as a genealogical pattern on its shaft, 475. Enough is left of the original limbs to indicate the design's derivation from series of interlocking human bodies, here highly simplified.

How accurately this tomb decoration reflects the domestic architecture of the people buried there, I don't know. Even if these decorations imitate beams & matting, this doesn't exclude a symbolic explanation; the two reinforce each other. I regard these pilasters as genealogical in the same sense as the Tukanoan houseposts and dancing costumes.

474

475

Dancers

Speaking of the Tikopia of Polynesia, Raymond Firth tells of seeing several women during a ceremonial cycle and being told, 'The Atua Fafine (chief Goddess), it is she'. For all of his efforts, he fails to make this sound logical to Westerners who regard several as plural and 'she' as singular. But, in genealogical patterns, One is Many; Many, One.

Tikopian houseposts are sometimes conceived, though not represented, as deified ancestors. In particular, the central post of a temple is controlled by the main deity of the temple—'it obeys him'. It is spoken of as his post and treated as his 'body'. His descendants are known collectively by the name of the ancestor's 'house'. In a periodic rite of renewal, a 'dancing skirt' is tied around the 'body' of this post-god.

Dancing skirts & scarves are tied around many posts in many lands on festive occasions. Presumably the ancestor-god of such a post was once conceived as the first dancer or the initiator of the dance.

Posts & houses imitate body decorations & clothing, and body decorations & clothing imitate posts & houses.

Where patterns used in body decoration & tattooing are themselves composed of series of conventionalized bodies, their application to the body makes the wearer into a living image of his tribe. This corresponds to the conception of the anthropomorphic housepost as a composite tribal spirit. Whether the body decoration was copied from the housepost or the other way around need not concern us: in either case the design is a 'tribal' pattern in the sense it represents the tribe as a composite of all of its members.

Bacairí dancers in Brazil wear grass costumes sometimes so large they look like thatched roofs, 476, and are, in fact, called 'houses'. The dancer is thus, so to speak, an animated housepost, or the housepost is an immobilized dancer. Here the dancer, like the housepost, represents the First Ancestor, who introduced the dance.

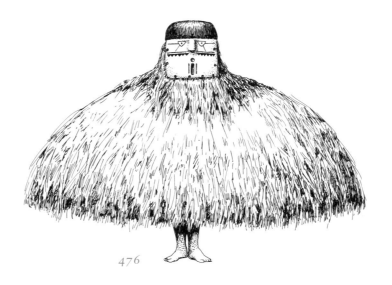

476

▼

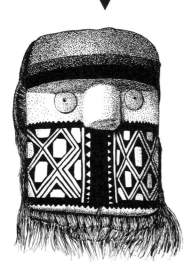

477

Bacairí dance masks, and those of the neighboring tribes of the upper Xingú River, 477, are sometimes decorated with a genealogical pattern extending just up to the level of the eyes. Though this design looks merely decorative, it is a classic *Biaxial System* composed of crossed hourglass figures with extended limbs. Normally such a system was placed on the torso. Here it was transferred to the face or mask because the body, in dancing, was covered by a grass costume.

Precisely that same genealogical pattern was placed by the Mehinacú Indians of the upper Xingú on anthropomorphic posts, 478, each capped by a human head and each decorated with two dancing scarves. The neighboring Camayura erected similar posts to represent the four original ancestors, as well as ancestors deceased during the previous year. Posts were cut from the sacred *camuva* tree, out of which the first ancestors allegedly came and whose wood was otherwise reserved for ritual objects and center-posts.

All these designs are but variants of a single type, evolved from series of human figures joined by their outstretched limbs and symbolizing the principle of descent or pedigree. Their use for body decoration expresses the wearer's pride in his tribal connections.

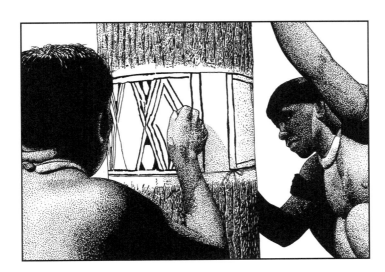

478

Australian Creation Myth

What distinguishes genealogical patterns from mere representation of human figures is the continuous limbs. These can only be symbolic; nothing like them exists in nature. And what they symbolize can only be familial & social connections.

Direct evidence confirms the great antiquity of genealogical patterns. The ideas behind these ancient patterns are more elusive. But there are indirect means of penetrating the barrier closed by history: in the customs, beliefs & rituals surviving among the Australian aborigines lie plausible solutions for some of the enigmas posed by the art of our earliest ancestors.

Figures *479* & *480* show the outlines of earthworks prepared for an initiation ceremony in 1894 by the Kamilaroi tribe in New South Wales. R. H. Mathews reports that the 'life-size' men in *479* 'were formed by cutting a nick or groove in the ground along the outline of each'; and that 'all of the figures were joined together, the hands and feet of one joining the hands and feet of the others'.

The Kamilaroi told Mathews that *479* 'represented the young men who were with Baiamai at his first camp'. Baiamai, the Creator of the Kamilaroi, was

himself shown, not as part of the connected group, but separately, as an earthen figure of heroic proportions (about 4.5 meters long), opposite his consort, Gunnanbeely, carved in life-size, *480*.

Mathews continues: 'They say that Baiamai created them (the Kamilaroi) and gave them the country and all that was in it for their use, after which he and Gunnanbeely went away. A short distance from [*480*], a figure of a man and a woman were formed on the ground behind a tree and were partly hidden. The blacks said that these represented their original parents, whom they called Boobardy and Numbardy—meaning father and mother respectively'. (This pair of figures is not reproduced by Mathews. Perhaps they were represented *in coitus*.)

What do we make of these explanations? All seek to explain a complex of ideas centering around the theme of *creation*. This theme is represented first, by the images of the Creator-pair, *480*; second, by the pair of figures called 'father' & 'mother', whom the Kamilaroi evidently regarded as their more immediate ancestors; and third, by the composition which chiefly concerns us, that 'of the young men at Baiamai's first camp', *479*.

The relation of *479* to the other figures is somewhat obscure. Yet I suppose that 'the young men who were with Baiamai at his first camp' were the first figment of his creation or the first human beings, and thus ancestors of the Kamilaroi. Perhaps they were the progenitors of various tribal subdivisions.

Mathews wasn't told why the figures of *479* were joined together by their limbs. But the meaning of connected limbs in general emerges in the light of another ritual observed & recorded elsewhere in Australia some forty years later.

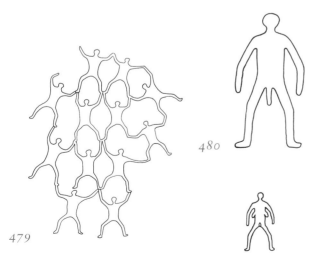

479

480

Cape York Ritual

In 1935 Ursula McConnel described
& photographed a ritual she observed
among the Wikmunkan & Wiknatara
aborigines on the western side of Cape
York Peninsula, in northwestern Aus-
tralia, *481* & *482*. This ritual was per-
formed by 'a line of men lying on the
ground . . . with hands clasped. One
in the middle represented a woman
with a baby [made of beeswax] lying
on her abdomen. Those on the left of
the "woman" are men who are grow-
ing old. Then came woman and birth.
Those on the right are the children
who came after the result of sex and
birth. At the end of the line stands a
man who swings the *moipaka* [female
bullroarer]. The ritual symbolizes the
continuity of life by means of sex and
birth'. The author adds: 'It must be
realized that the spiritual power
behind this ritual is believed to be
invoked by its performance and
to bring about the desired continuity
of life. Hence its sacred character'.

There are differences between *481* &
479: in *481*, men in a single line join
hands; in *479*, figures spread in all di-
rections, joined leg-and-arm. Yet both
arrangements illustrate essentially the
same idea: creation & procreation.
What the Kamilaroi represent stati-
cally in art, the Cape York aborigines
enact in ritual.

If clasped hands symbolize genetic
continuity in *481*, does this same
meaning apply to the common limbs
of *264*, one panel from a painted skin
robe from this same part of Australia?
Note its *Shadow System* of two inter-
locking *Type 1* patterns. Both patterns
are composed of reptile-like human
figures, a familiar motif for represent-
ing ancestors. Unfortunately, no
record survives of the artist's intent.

481

482

264

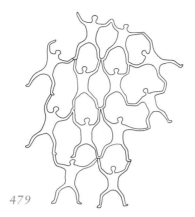

479

350

351

481

The importance of the Kamilaroi pattern, 479, is that it came to the attention of observers able to transmit to us at least an inkling of its ritual meaning. I assume such a ritual is also depicted in 350, the Spanish cave painting, circa 4th millennium BC. Both arrangements are noteworthy for their irregularity: in neither are the figures joined in a rigidly repeating pattern.

The Australian figures are connected by their limbs, but in one case a leg rests on the head of another figure (lower left, 479). This may be the exception that proves the rule of ligature by limbs. I suspect that ligature by the head, which also occurs in 350, is the result of accident or carelessness, and that the correct connection is by limbs, shown accurately in 351, the Mohave vessel.

The Australian figures in 479 represent males. The Spanish figures in 350 probably represent females, with the exception of the male figure at the lower right. In 481 all of the performers are men; even the central parturient woman is impersonated by a man. This may simply be a consequence a male monopoly of ritual. Or this all-maleness could be associated with the *couvade*. Female impersonation could explain the single male figure in 350.

A 'female' bullroarer, 482, is swung in this ritual as a symbolization of the generic process and as a prayer for continuation.

Today in Arnhem Land, initiates still wear painted genealogical patterns, 483; and during their initiation, still lie side-by-side, 484. Note the joints rendered as black dots. Spines are rendered as columns of white dots in 484 (second figure from the bottom), and in 485, a painted figure from this same area.

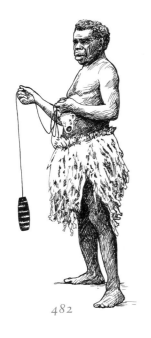

482

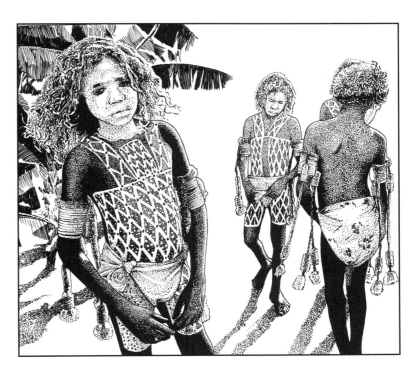

483

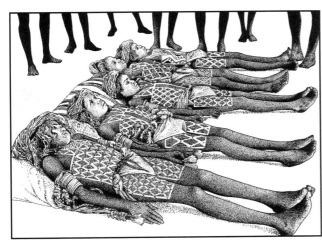

484

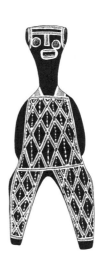

485

Mohave Creation Ritual

Remarkably similar rituals occurred among a desert people in southwestern North America. In the late 19th century, John Bourke described a dance which the Mohave said represented their myth of creation. As part of this ceremony, they traced on the ground an image of the Creator and beside it an image whose meaning Bourke was unable to learn, but we recognize as three hourglass figures from a reciprocal pattern, *486*. Like the Kamilaroi images, they were explicitly associated with a creation ritual. Bourke made no mention of any Creator-pair or parental-pair comparable to the Kamilaroi images. But such earth images exist in this general area.

On both sides of the Arizona-Sonora border, monumental sculptures were made in prehistoric and possibly protohistoric times by scraping surface stones away to outline effigies and other forms. Two male figures, *487*, lie near Fort Mohave, Arizona: below the 'right' elbow of the man with the head occurs a third, smaller figure, lacking sex features.

486

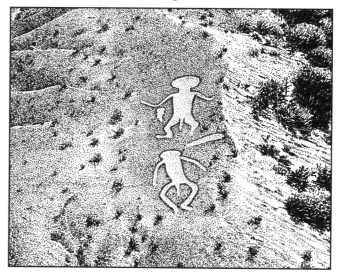

487

Near Sacaton, Arizona, a human form (54 meters long) lies beside a second figure (4.5 meters long), *488*.

Paired earth figures, one large, the other small, have a wide distribution in the Old & New Worlds. Where distinct sexual differences are absent, their 'male' & 'female' natures can usually be inferred from their relative sizes.

Perhaps only among Australian tribes is their original conception, as 'the first man and his wife', still alive or was alive until recently. Descendants of American Indians who constructed paired earth-figures don't speak of them in precisely these terms. Yet their ancestors may have done so. I suspect that in America, as in Australia, such male-female earth-monuments represented the original tribal ancestors in 'primordial copulation', the monument being the point of origin of the tribe and, by extension, the beginning of the world.

488

Plants & Limbs

The analogy between the branching of plants and birth from limbs probably played a role, from the beginning, in furthering this belief in the potency of limbs. In Indo-European and many other languages, it survives today in that community of words shared by men & plants: trunk, limb, branch, sprout, bud, etc, as well as in the identical nomenclature for human joints and joints of the stalks of plants.

It also survives in legends explaining human generation in terms of the propagation of plants. Thus the Hawaiian goddess Haumea, described as having 'a breadfruit body, trunk and leaves', allegedly produced the tribe of Pele from her dismembered parts.

The Batak drawing in *489* shows a tree with a 'human trunk'. Presumably it depicts the sacrifice (by means of blow-guns) of a human victim tied to a pole—a sacrifice undertaken in the interests of fertility, the idea being that a 'cosmic tree' would sprout from the limbs & head of a buried corpse, eg *490*, another Batak drawing.

Drawing *491*, 'the old man from Bekut', from the Solomons, illustrates the origin of trees and cultivated plants, as well as the origin of the social order: those growing to the right belong to the paternal parents; those growing to the left, to the maternal parents.

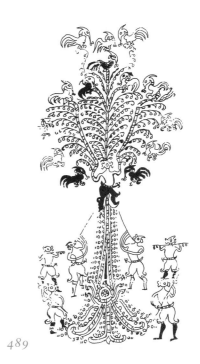

489

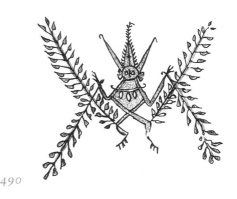

490

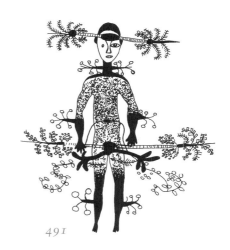

491

The Vanautuan figures in *492* are specifically identified by their makers as ancestral figures and the growths at their shoulders are said to be more immediate ancestors.

A myth current along the north shore of New Guinea relates how two heroes, apparently conceived as 'the first man' and his nephew, built a canoe carrying 'all the animals' to sea. They used for lashing the 'drawn-out sinews of blood vessels of the arms and legs of his [the nephew's] mother'. Then, somehow, 'men and women sprang from the cut off ends of these lashings' and proceeded to populate certain islands, which are duly enumerated.

Thus the woman's progeny sprang from her limbs, the way plants spring from the cuttings of a parent stalk. In fact, earlier in this story, her arms & legs are described as having the thickness of a tree and producing yams.

Certain South American pictographs & petroglyphs, eg *493*, represent a figure (sometimes clearly female) presumably excerpted from a repeating pattern. Its limbs end in a multiplicity of lines, like the genetically potent 'drawn-out sinews and blood vessels of the arms and legs' of a procreative mother.

The unpleasant mechanics of this gruesome and apparently nonsensical story makes sense in terms of genealogical figures joined by their arms & legs. The 'mother' in this story is, as it were, excerpted from such a pattern.

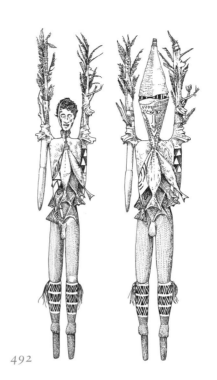

492

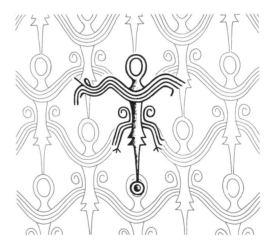

493

Birth from Limbs

Common-limbs & clasped-hands serve as bonds between generations, not only in art & ritual, but in other traditions as well. Widespread myths tell of human beings born from arms or fingers, more commonly from legs, and most commonly from knees. Those born in this way are generally described as 'the first people'; and the limbs from which they spring are said to be those of the 'Ultimate Ancestors'.

African myths referring to birth from knees or legs range from east-central Africa southward to the Hottentot. The Masai, for example, tell of a man who awoke to find his knee swollen. After eight months, he lanced it and out came two children.

Association of the knees with genealogy occurs in many tribal myths, in the Finnish epic *Kalevala* and in Indo-European cosmogonic legend, not to mention the Greek myth of the birth of Dionysos, god of fertility, from the thigh of Zeus.

An Indonesian account tells of a man & woman sealed in a tree trunk, which lands at Gunung Lubunut. There the woman gives birth to twins: a boy from her right calf, a girl from her left calf. Their offspring are forbidden to marry.

The most diverse ethnic groups tell of birth from swollen knees, fingers, thighs, calves, heels. However much these myths vary in details, they have a basic relation to each other: birth from knees or legs is generally preceded by swelling of the afflicted parts, analogous to normal pregnancy. Sometimes a male child springs from the right knee and a female from the left knee, or different races or social subdivisions spring from the two knees, or from inside & outside of the knees.

These stories often appear grotesque to the point of absurdity: yet their vast distribution, perhaps throughout every continent, makes them impossible to dismiss as meaningless.

The Australian ritual at Cape York, together with genealogical patterns generally, explain these stories and are, at the same time, explained by them. The conception of limbs as bonds connecting generations goes back thousands of years in art. It should hardly surprise us to encounter this idea in tales & legends all over the world, especially in those purporting to explain the origins of humans. The vagaries of these legends might be likened to the conventionalization of genealogical patterns.

Which came first: the idea or the image? Perhaps they came together, for man thinks in images. Often it's hard to explain the idea of 'genetic potency of limbs' except by reference to a genealogical pattern. Conversely, it's hard to explain a genealogical pattern except by reference to the basic idea behind it.

Legends about birth from limbs can be explained as fragments of a cosmogonic myth, according to which the world in general and mankind in particular originated from the parts of a primordial giant. Myths of this type are found among tribal peoples in many parts of the world, though not necessarily among the same people who tell stories about birth from limbs.

Austral Islanders in Polynesia depict their god Tangarora, 494, in the 'act of creating the other gods and man'.

A Vedic hymn explains the origin of the world and of man from parts of a cosmic being sacrificed and presumably dismembered for that purpose. The four primary castes of the Indian social system are said to derive from the body of this being.

Poem on the Profound Book of Mysteries, from the oral literature of Russia, explains various features of the physical world as parts of the body of the primordial Cosmic Being. In some versions, man is said to be descended from the various parts of the body of 'Adam' (obviously a Christian substitute for this more abstract figure): the tsars from his head, the boyar-princes from other, unspecified parts of his body, and the peasantry or common people 'from the holy knee of Adam'.

The generative function of the knee in this Russian poem is presumably an archaic trait, inherent in the prototype from which all of these legends descend. I think it likely that these stories about birth from knees or legs, found in widely separated parts of the world, all ultimately relate to such a cosmogonic myth as fragments of a whole. This basic myth of creation by dismemberment is certainly much older than any of the literatures in which it was first recorded, and lies at the bottom, or very near the bottom, of all of the phenomena studied here.

In formal literary traditions, this cosmic being appears as an abstraction; among tribesmen, it is simply a deified ancestor.

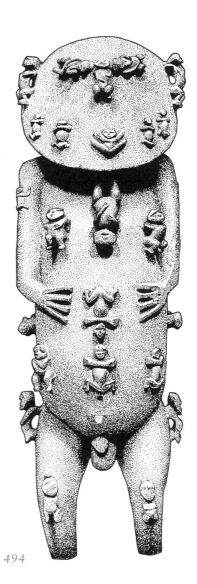

494

Dismemberment

Creation of the human race from the *membra disjecta* of a prototypic human being implies human sacrifice. The allusion to such a sacrifice in the Vedic hymn of a sacrificial cosmic being seems merely allegorical, but reality probably preceded allegory. Presumably in pre-Vedic times, human beings were sacrificed, perhaps periodically, to symbolize the creation, or periodic re-creation of the world and of mankind.

A human sacrifice, symbolizing the Creation, is *ipso facto* the archetypal sacrifice. If such ritual recapitulate Creation and the dismembered parts of the victim are associated with divisions of the social body which he symbolizes, is there a special disposition of the limbs?

Cannibal practices vary enormously, and it's difficult to disengage symbolic motives from savagery and eating habits. Still, we often find an emphasis upon arms & legs, or hands & feet, which may be due to something more than a gourmet's interest in a 'joint' of meat.

When Hans Staden, in 16th century Brazil, depicted four Tupinamba women racing around the huts of their camp, *495*, each carrying one of the freshly dismembered limbs of the victim, this may be more than an expression of cannibal joy pure & simple. I believe this association of the four 'quarters' of the victim with the four geographical & social quarters of the camp symbolizes that the sacrifice recreates the Tupinamba world.

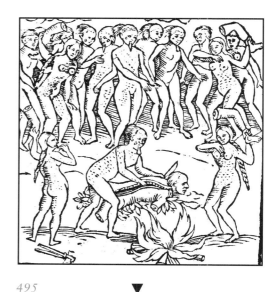

495

▼

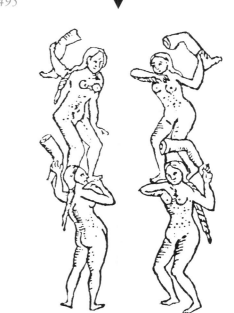

A predilection for the arms, legs & feet of the victim as cannibal tidbits may stem ultimately from the recognition of the importance of these parts of the body in terms of this same concept. Aztec kings and Nicaro nobles reserved victims' thighs for consumption. I doubt that this choice was dictated by purely epicurean considerations. Though its original motivation may have been forgotten, that choice was probably rooted in the same idea as the Tupinamba treatment of the four limbs.

Perhaps for this reason victims' arms & legs, hands & feet, even fingers & toes, were widely regarded as special cannibal delicacies or reserved as perquisites of chiefs & nobles.

Ewald Volhard cites evidence of this preference in Australia, Melanesia, Africa & Madagascar. He cites, as well, two African instances of *avoidance* of eating the tips of the fingers & toes in cases where the the victim had been diseased, on the grounds that the disease was concentrated after death in these extremities. Perhaps this idea—that disease concentrates in the finger-tips—rationalizes the myth that offspring bud from limbs and that a special *potency* attaches to the fingers: a potency so great it could harm, rather than strengthen, the eater. I suspect this same motivation for the Kwakiutl avoidance of eating hands & feet, though they valued & preserved severed hands, offered them in trade and, symbolically at least, gnawed on the finger-joints.

Among the Tupinamba, the victim's finger-tips were assigned as a special treat to distinguished guests. This takes on significance in the light of an episode in the creation myth of the Bacairi according to which 'the first woman' (who was herself killed, dismembered & eaten), became pregnant by swallowing the finger-bones of dead Bacairi Indians.

The Guarani (southern Tupi) cut off the right thumb of the sacrificial victim before dismembering his body for the cooking pot. Underlying this absention from finger-eating is probably fear of the great potency of fingers. The Guarani say this amputation prevents the victim's ghost from drawing a bow in vengeance. The real motivation, I suspect, has been forgotten.

My guess is that the Guarani amputation was undertaken in order to complete the 'killing' of the victim by inhibiting his procreative power: if the amputated right finger had been eaten, as among the Tupinamba & Bacairi, the object would have been to acquire, rather than merely destroy, the victim's potency. Thus the behavior differs, but the basic idea underlying that behavior remains the same.

In each case, if I am correct, a primary association of the fingers with relatives was extended to the *principle* of relationship, hence to the closely associated idea of procreation, and finally to that of potency (perhaps with the help of phallic illusion).

Dis-membering & Re-membering

Earlier I suggested that the classification of relatives probably first began on the fingers or finger joints and was later transferred to the body as a whole. Is there a similar relation between finger mutilation and dismembering the body as a whole?

Such ideas appear to be related conceptually, but I don't know how they relate historically. What is important here is the co-existence of mutually supportive ideas & practices: identical kinship charts on the bodies of men & deities; rites of rebirth involving passage through the successive parts of a Primordial Ancestor; human sacrifice & dismemberment; and myths of re-creation involving the reassembly of dis-membered parts.

The Nangiomeri list includes bodily parts besides joints. This provides an ideal condition for the development of a myth of creation by dismemberment, analogous to the Dogon story of the primordial serpent. There a serpent with a human upper body enters the first ancestor's tomb, swallows his body part by part, then creates him anew by spewing

370

forth the swallowed parts in the same order, so as to form the diagram of *370*, thus prefiguring a typical rite of initiation.

I don't know if the Nangiomeri or any other Australian tribe actually have such a creation myth; but other tribes of southeastern Australia observe a custom which may be regarded as prerequisite for such a myth. Thus Alfred Howitt describes the cannibalism practiced by the Dieri as part of a burial custom:

'When the body is lowered into the grave, an old man who is the nearest relative to the deceased present, cuts off all the fat adhering to the face, thighs, arms and stomach, and passes it around to be swallowed by the relatives. The order in which they partake of it is as follows: the mother eats of her children, and the children of their mother; a man eats of his sister's husband and of his brother's wife; mother's brothers, mother's sisters, sister's children, mother's parents, or daughter's children are also eaten of; but the father does not eat of his child nor the children of their sire. The relatives eat of the fat in order that they may be no longer sad'.

The parts of the deceased relative devoured by the Dieri may not agree precisely with the parts of the body associated with relatives by the Nangiomeri. But Dieri mourners partake of specific parts and identify themselves with the relative whom they eat. Assuming the deceased has 'gone to join his ancestors', and thus become one of them, eating the deceased was tantamount to eating the ancestor, and this rite was a re-enactment of the Creation by the dismemberment of a primordial human being, the ideal Ancestor of the tribe or race.

The communal eating of parts of a dead relative by the Dieri probably represents the survival of an immensely ancient custom which lies at the bottom of all myths of creation. Eating the dismembered parts of a more immediate ancestor is essential to this rite.

Among the Biami of Papua, the dead are exposed on raised platforms. Relatives touch that part of the rotting body prescibed by their relationship to the deceased, then lick the oil from their fingers.

Substituting an image, or substituting a sacrificial captive, is probably a later development. In both, the intention of the 'endocannibalistic' rite is really defeated, insofar as the ancestor can be properly impersonated only by a dead captive. The importance of this inference will appear in a moment.

The idea implicit in Dieri ritual cannibalism also underlies the many initiation ceremonies in which neophytes are ritually 'swallowed' by a mythic monster as a prelude to ritual rebirth. If Nangiomeri nomenclature is related to the familial cannibalism of the Dieri, then the bodily parts by which the Nangiomeri name their relatives presumably were conceived also as bodily parts of their ultimate ancestor. The Nangiomeri simply enumerate these parts. The Dieri eat them. And the Dogon have them eaten by a semi-human monster.

If the Dieri custom of eating parts of dead relatives symbolizes the creation of mankind, and if Tupinamba & Aztec customs of human sacrifice recapitulate that creation, we might expect to find some evidence of inner relation between the Australian & American customs.

In fact, there is such a relation; and it is so intimate that certain features of the American Indian custom are hardly to be explained except in the light of those of the Dieri. The specific prohibition of the Dieri against the father's eating of his child and the child's eating of his father has its close, if not precise, counterpart in the fact that after a captive of the Aztecs has been sacrificed, the man who captures him must abstain from eating him, *because of a simulated parental relationship.*

This is announced ritually at the moment of the capture, when the captor says to the captive: 'You are as my son', and the captive responds: 'You are as my father'. The captor may eat of the other sacrified captives, but not of his own: 'for', he says, 'should I then eat of myself?'

This correspondence with the Dieri custom can only mean that the basic motivation of the Aztec (and Tupinamba) sacrifice is really ritual cannibalism, in which the parts of the body devoured are regarded as parts of a reincarnated ancestor whose dismemberment is prerequisite for the creation of the race and whose parts must be swallowed for its perpetuation. In short: each sacrifice, and more specifically each act of cannibalism, recapitulates the Creation.

The motive which deters the Aztec captor from eating his captive is the same as that which deters the Tupinamba executioner from eating his victim; and the paternal solicitude shown by the Tupinamba for their prisoners (who often became the temporary sons-in-law of their captors) supports this interpretation. In Australia, relatives were ritually eaten when they died; in America, relatives by proxy were created for that purpose.

If the importance of the prohibition against cannibalism in the direct male line didn't strike us in the Dieri custom, it's forced upon our attention by its conspicuous survival in a ritual like that of the Aztecs, which seems to be otherwise characterized by secondary elaboration. What is the significance of this prohibition? Why does the Aztec warrior justify his abstention from the flesh of his 'son' with the argument that this would be like eating of himself?

Apparently there is something special in the relationship between father & child which precludes their eating of each other. Why is this relationship different from all others enumerated in the account of the Dieri ritual?

Perhaps there is a clue in the naming of relatives by bodily parts among the Nangiomeri. Stanner gives only the list of parts which he encountered among one particular tribe, and tells us that these lists are variable. Still, I wonder if there isn't special significance in the fact that the Nangiomeri assign the 'father's father and son's son' just to the knees—since knees play such an important role in creation myths throughout the world.

In such myths, the ultimate ancestor from whose knees the first human beings were born is almost invariably a male, and in most instances we are given to understand that this birth takes place spontaneously, without the intervention of a female womb.

In other words, the first birth is exclusively in the male line. Evidently because of its exceptional character, the relation between all fathers & children is different from all other relationships, which are traced through the participation of females in the procreative act. This in itself might explain the prohibition against eating of the real son (and father) among the Dieri and of the fictive son among the Aztec & Tupinamba.

Both Nangiomeri nomenclature and Dieri cannibalism imply the creation of a society by dismemberment: ideally the dismemberment of the ultimate ancestor, and ritually that of the individual who stands for him. Cannibalism may have developed out of, or in close relation to, this conception.

It's noteworthy that the motive of cannibalism persists in association with the Dogon diagram, insofar as the 'first man' represented in *370* is eaten by a mythic half-human serpent. Among the Germans, at least in the immediate legal context of the *Sachsenspiegel*, the theme of cannibalism has disappeared.

Human sacrifice emphasizing joints occurred in rituals of regeneration in India. A 19th century account of human sacrifice among the Khnoistan tribesmen of eastern India states that participants take hair from the victim's head & saliva from his mouth to anoint their own heads; that his head & neck are introduced into the reft of a strong, split bamboo, its ends secured & held by the sacrificer; the presiding priest then breaks the victim's arm & leg *joints* with an axe; after which his flesh is stripped and 'each man, having secured a piece, carries the quivering and bloody morsel to his fields, and there buries it.

'When it is remembered with what care the victims are fed, fostered and cherished until the hour of the sacrifice arrives, even at that supreme moment being regarded as something more than mortal, it will hardly surprise anyone to learn that, so far from being grateful to us for having saved them from a cruel death, the majority appeared almost indifferent. . . .'

In Paris, in 1613, the assassin of Henri IV was drawn & quartered by four horses in the Palais de l'Hotel de Ville. On the Isle of Man, in 1442, for striking any of Lord Stanley's men, the deemster gave this sentence: 'That they be drawn by wild horses, hanged and after that their heads were to be cut off, and set upon the castle, another quartered at Peel, a third at Ramsey and the fourth at Castletown.'

Generally the victim, sentenced to be drawn & quartered, was hanged by the neck, but cut down before dead; his entrails burned before his face; his head cut off; his body quartered. In 1814, fifteen Canadians, convicted of treason, suffered this fate.

Emblems of the Arma Christi, common from the mid-15th century, show Christ's dismembered & stigmatized hands & feet in the four quarters of the field. Medieval Christianity, like the Bible, contains many involuntary descriptions of ancient images & customs.

Legitimation: Return to the Male Womb

The word for 'knee' is used in kinship terminology throughout many languages, including all or most Indo-European languages. Many Indo-European terms for 'knee' are used alternately for ideas like 'degree of kinship' or 'generation'. Though the semantic connection is expressed variously in these different languages, all such variations can be traced back to the homonymy of two Indo-European roots: the nominal root *g'en* for 'knee' and the verbal root *g'en-*, which seems to mean 'beget'.

The homonymy of these roots leads to such correspondences as that between Latin *genu* for 'knee' and *genus* for 'descent'; Russian *kolieno* for 'knee' and the plural & distributive forms *koliena* & *pokolienie* for 'race', line, branch, stem, generation, degree of kinship; and the Irish use of *glún* for both 'knee' & 'generation'. There are similar correspondences in Germanic, Armenian, Persian, Sanskrit.

In Greek the name for 'knee' appears to be cognate and sometimes interchangeable with 'generation'. Euripides refers to knees as 'generative members' and the knee is commonly referred to as the seat of paternity.

This knee-generation nexus seems basic in Indo-European languages. It occurs, as well, in Lapp and various Finno-Ungarian tongues. Thus Finnish *polvi* means both 'knee' & 'generation' and in the Finnish epic *Kalevala*, the sky-god Ukko generates three cloud-maidens when he presses his knee-cap. For the Assyrians & Babylonians, whose language was unrelated to Greek or Latin, the word *birku* signified the knee or the male organ of generation.

Grasping the knees is the classic form of entreaty in Homer.

The Indo-European verbal root *g'en-*, meaning 'beget' (Latin *gignó*) is used to designate exclusively the parental role of the father, not that of the mother. This has been explained in terms of what appears to be a third homonymous root, *g'en-*, meaning 'know' (Latin *gnosco*). Meillet concluded that there was originally but one verbal root, meaning 'know' and that this came to mean 'beget' by being used in a special juridical sense: 'to know as one's own' or 'to recognize as legitimate', with a child as the implied object.

The Hebrew word for 'blessing' derives from the Hebrew for 'knee', in *Jeremiah* 1,5, 'Before I formed thee in the belly I knew thee . . .'; the speaker is God and the word 'knew' is followed by 'sanctified' & 'ordained'.

From consideration of the Latin *genuinus*, meaning 'legitimate' (the u-stem of which marks it clearly as derived from the root for 'knee' and not from that for 'beget' or 'know'), Meillet & other linguists concluded that the homonymy of the roots for 'knee' & 'beget' rests, in the final analysis, upon the early existence of a rite of *legitimation* or *filation* performed by the father, in which he recognized the new-born infant as his own by placing it upon his *knee*.

According to *Genesis* 48,12, Joseph considered his two sons, Ephraim & Manasseh, as his own and 'brought them out from between his knees'. 'And the children also of Machir, son of Manasseh, were brought forth [borne] on Joseph's knees' (50.23).

Job, cursing the day of his birth, bewails the fact that he found two knees to receive him (3,12). From this, according to de Vaux, some authors concluded that childbirth sometimes took place on the knees of another person. 'But there is a simpler explanation: the text . . . must be referring to adoption'.

Reminiscences of this custom persist at various levels of linguistic evolution in the Italo-Celtic & Indo-Iranian branches of the Indo-European family: in Germanic rites of adoption, which apparently involved placing the child upon the knee of its adoptive parent (presumably & properly its adoptive father); and in certain artistic traditions of early Christianity, *496*.

496

This custom is specifically alluded to in Homer's *Iliad* (IX,455) and *Odyssey* (XIX,401). In Hesiod's *Theogony* (460) we're told that Kronos swallowed his children 'as soon as they came forth from the womb of their mother on to the knees'.

There is no pronoun in the original specifying whose knees are meant, and this passage is generally translated with 'her' (ie the mother's) knees. But Benveniste convincingly supplies the masculine pronoun 'his', and infers that the children eaten by Kronos had been placed on his knees for the purpose of legitimation.

The tale of the father who devours each of his children as it is placed on his knee, seems to be a mythical projection of what *might happen* to children in the remote contingency that their father didn't 'recognize' them as his own, as sometimes happens under primitive economic conditions in Australia.

The Tupinamba custom of the father's (or natural uncle's) lifting the newborn from the earth has a precise parallel in the Latin rite of *sublatio*, which, according to Loth, was the father's first act of recognition of the infant as his own: the father then placed the infant on his knees and named it, thus indicating that the child was not to be destroyed, but 'raised'.

Loth adds: 'The custom of placing the child on the ground seems to have been at first a type of homage to Mother Earth. It is on the ground as well that, among Latins and Germans, the dying were placed. The earth is the mother of men . . . : they come from her womb and they return there. The *sublatio* consequently appears to be a most general act involving the recognition of the child by the father'.

But the act of legitimation by lifting the child from the earth and placing it upon the father's knee was really *a symbolic return of the child to the place of its prior conception in the male*, and thus a repudiation of the conceptive role of the earth-womb.

Myths about the birth of the first human beings from the knees or, less specifically, from the legs of an Ultimate Ancestor occur in Africa, Asia & America, as well as in the 'Indo-European cosmology'. So the rite of legitimation may itself be rooted in a broad and presumably still more ancient mythical substratum. This rite, in which the father takes the new-born child upon his knee, then appears to be a re-enactment of the creation of the first human beings.

The Greek myth about the birth of Dionysos from the thigh of Zeus belongs to this class of legends, but it is far from 'primitive'. We are told that Dionysos was first conceived normally by a woman, Semele or Ge (probably 'Earth'), who thus appears as a partner in a typical 'marriage of Heaven & Earth', but that the half-formed foetus, delivered prematurely from the mother's womb, was sewn by Zeus into his own thigh, where it remained until Zeus himself, upon its maturity, cut the binding threads and released the child. A Greek vase, 497, circa 410 BC, illustrates this event.

As fantastic as the fiction of the male 'womb' may seem to us, it must be admitted that it is based on simple observation. The observed world would not appear differently to us if the earth really was flat, circled by the sun, just as tribesmen everywhere assert. Nor would our observations of conception change if, as tribesmen also assert, mothers really were gardens planted by men.

This wholly rational conclusion was not easily displaced. James Boswell defended 'the opinion of some distinguished naturalists, that our species is transmitted through males only, the female being all along no more than a *nidus*, or nurse, as Mother Earth is to plants of every sort; which notion seems to be confirmed in the text of the scripture, "He was yet *in the loins of his* FATHER when Melchisedeck met him" (*Heb.* 7,10); and consequently, that a man's grandson by a daughter, instead of being his *surest* descendant as is vulgarly said, has in reality no connection whatever with his blood'.

Faces on Knees

The Tlingit of Alaska favor faces or eyes on various joints on various figures, but on spirit figures (*yakes*), guarding shamans' graves, they carve faces only on the knees, eg *498 & 499*. This was equally true, until recently, in the Yuat area of New Guinea: joint-marks were common, but on large ceremonial figures generally confined to knees, eg *500*.

Compare the knee-faces on *501*, a shaman's figure from Siberia, with the knee-faces engraved on *502*, a pottery figurine from the Theiss culture, Hungary. The larger design on this figure resembles a mosaic garment. Perhaps knee-faces decorated high boots.

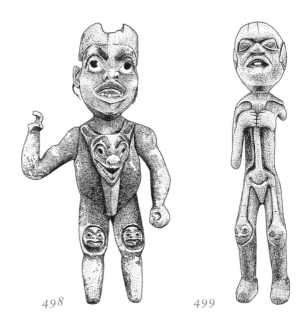

498 *499*

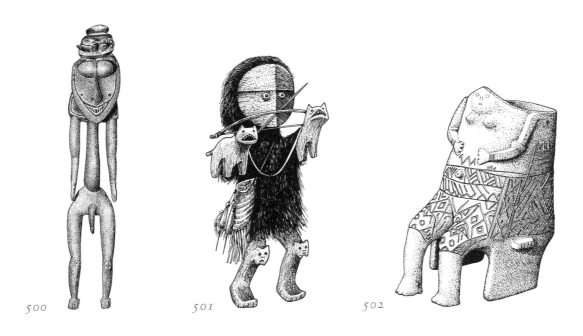

500 *501* *502*

Couvade

Birth from limbs, legitimation, dismemberment & cannibalism all figure in this Greek myth of Dionysos. In Euripides' version, Pentheus is dressed up to impersonate Dionysos, then ritually dismembered & eaten, in particular by his female relatives.

The Greeks, I assume, recognized the relationship between this tale and the *couvade*, known to them as a custom of their barbarian neighbors, for they poke fun at the Jovian childbed in their later comedies.

Undoubtedly there was such a relation. Yet the Greek myth hardly proves the best explanation of the *couvade*. It is atypical. No other myth about birth from legs mentions prior conception of the foetus in a woman's womb, or in fact makes any mention of normal birth whatever.

A better explanation of the *couvade* was given to a Portuguese voyager who visited the coast of Brazil in the 16th century. When Soares de Spisa asked a Tupinamba husband why he observed dietary & other typical restrictions of the *couvade* during the pregnancy & parturition of his wife, the man replied: 'because the child came out of his loins (*lombos*), and because all the woman can do is to guard the seed in the womb where the child grows'.

The distinction here is between planting & breeding. And it is this distinction which underlies the myth of the first birth from the 'legs' of a male ancestor. For the 'loins' of the Tupinamba male are functionally the same as the 'thigh' of Zeus.

The Greeks, by having Dionysos born first in a woman, were rationalizing an ancient legend, according to which Dionysos should have been born only from the leg of Zeus, and not from a woman at all. The Greek version violates the original conception.

This same tendency to rationalize the apparently irrational theme of first birth from the legs of a male ancestor may be seen in an African tale about a hero who 'slipped out of his mother's womb into her leg and was immediately full grown'.

What I regard as a rationalistic transfer from the knee to the vagina appears in a legend of one of the hill-tribes of India. According to this legend, 'originally the vagina was situated below the knee of the left leg. One day a chicken pecked at it, and it jumped up to a place between the thighs, where it has remained ever since. But it was wounded, and blood flows from it every month'.

The epithets διμήτωρ & διссοτόκος, meaning twice-born, applied to Dionysos, have their exact counterpart in the Sanskrit term, *dvijá*. This was applied to a man of any of the first three classes, *Rigveda X*, who has been 'reborn' through investiture with the sacred thread. Was this thread equivalent to that with which Zeus sewed the immature foetus of Dionysos into his thigh in preparation for its 'second birth'?

The fantastic character of all such myths lies in the displacement of the supposed source of the 'seed' from the penis to the knee. The explanation may lie in the structure of certain genealogical patterns, eg 3. Here the heads of progeny occur 'on' the knees of their progenitors. As we have seen, a single figure, excerpted from such a pattern, often retains, between its knees & elbows, the heads of its two immediate descendants. Since such genealogical patterns were once the common property of much of mankind, this seems to me the most plausible explanation for the fact that, in widespread myths, the most commonly designated source of the 'first' children is the knees.

It is, after all, nothing but the actual physiology of procreation which many tribal peoples apprehend and then project symbolically in their tale of the 'first' birth from the legs of the male ancestor. Perhaps displacement of the 'seed' from a plausible penis to an implausible knee is felt to be appropriate to the supernatural character of this event.

3

The generative function of the knees is reflected in many myths & languages. The Yami of Botel Tobago say the penes of their progenitors were joined to their knees. The Assyrians & Babylonians used a single word meaning both 'knee' & 'penis'. This was also true in pseudo-Hittite. These correspondences may be of the same order as the dual use of Latin *membrum* and German *Glied*, and the more recent jocular euphemisms for the penis such as 'joint', 'third leg', 'short arm' & 'eleventh finger', the last recorded in Grimm.

This displacement from penis to knees hardly prevents us from recognizing that such myths attempt to explain an actual physiological process. 'Male birth' may strike us as a fantastic inversion of nature, and so it appeared to the rational Greeks who tried to set it right. But it is nothing but a figurative elaboration of one of the 'facts of life': the generation of semen in the male.

The Tupinamba's statement that 'the child came out of his loins', explains very well this myth about the birth of the first human beings from the 'legs' of a male ancestor. It also brings us as near as we shall probably ever get (and that is near enough) to the idea underlying the *couvade*. For this statement implicitly combines custom & myth in what must be their original & logical relation.

According to a Palaung tale from Burma, 'long, long ago . . . it was the man and not the woman who bore the children. The man carried the unborn child in the calf of his leg until the time when it was large enough to be born. . . . The man said . . . "Take the body and keep it warm in thy stomach. . . . " Then he saw that the woman had taken good care of the child . . . ; so, after that time, he gave over to the woman the care of the children.'

Note the explicit priority of male over female birth, paralleling the Tupinamba explanation: the mother merely nourishes the child in her womb. This story also includes details (omitted from the above quotation) of an accompanying, and clearly symbolic transfer of the labors of fruit-gathering from the female to the male in exchange for her role in child-bearing. In the light of this tale, the *couvade* appears as a reversion of the original state of affairs, when men labored in child-birth and women in the production of food.

So much has been written, back & forth, about the custom of the *couvade* that it takes courage to attempt another generalization. Yet it seems to me that the statement of Tautain—remarkably brief for a communication on this subject—comes nearest the mark. He says that the basic motivation of the *couvade* must be the principle of *filation* or *legitimation*: in other words, the recognition by the father that the child is really his, and an affirmation of his paternity.

The physiological relation of the child to its mother is proved by its birth from her body, but its relation to its father is not capable of equally ineluctable proof—a circumstance which has led to countless tragedies & comedies in real life & invention. To correct this inequity of nature, man provided his own means of establishing his paternity; and it is only natural, as Tautain says, that the rite by which he sought to establish it should be an imitation, or insofar as possible a counterpart, not to say an exaggeration, of the act by which woman gives birth.

This impulse adequately accounts for the drama surrounding the simulated parturition of the male, which has long fascinated scholars. All this drama is nothing but byplay to this basic idea, which is lost like the cloth under an elaborate embroidery.

Alfred Métraux doubted that the *couvade*, in South America, imitated childbirth. I question this. The idea that the first 'womb' of mankind lay in the lap of a mythical male ancestor—an idea closely associated with the *couvade*—has an enormous distribution, including South America. And the common South American custom of the husband's 'keeping to his hammock' before, during or after his wife's parturition, surely imitates the woman's confinement. The same applies to food & other taboos observed by the husband, and sometimes by the wife.

Ultimately the idea expressed in the *couvade* is the priority of the male in the procreative process. On this priority is based the special relation between a father and his children not only often manifested in the *couvade*, but also in the prohibition against the father's & children's eating each other in the 'creative' cannibalism of the Dieri & Aztecs. The Aztec formula justifying this abstention, 'Should I eat then of myself?', clearly derives from the idea that the child is 'born' first in the father.

The source of all these phenomena is the observation that the seed is generated in the male and only secondarily 'planted' in the female. What springs from such 'planting' is obviously that of the *sower*, the father. Undoubtedly it was a widespread sentiment which the Mundurucu expressed when they described the role of the mother as being that of the earth: the seedbed.

Surely this explanation of the procreative process, with its analogy to the propagation of plants from seeds, accounts for the elaborate repudiation of the mother's role in the *couvade*. At the same time, it explains why the father & child are considered as one, regardless of the woman's intrusion. The mythological motif of the man's midwifery, practiced on his own leg or knee, is encountered not only in the Greek myth, but also in the myths of the African Masai, the Antillean Caribs and the Brazilian Umutina. Each asserts the spontaneity of the male procreative act—and of necessity symbolizes it in terms of childbirth from a woman.

This mythical midwifery is neither more nor less ridiculous than the man's behavior in the *couvade*; for the two are one. It is hardly surprising that this widespread idea crystallized in a special rite of filiation or legitimation, in which a father asserts his parentage by taking a new-born child upon his knee, as if it were the real 'womb' from which the child had come originally. Nor is it surprising that a memory of this rite is embodied in the very base of the Indo-European linguistic tree, in the homonymous roots for 'knee' & 'beget', which brings forth analogous fruits on various branches of that tree.

Couvade, myth, cannibalism, legitimation & language all perpetuate this one idea: an obsessive preoccupation with the special relation between father & child, based upon the prior activity of the father in the procreative process, and generally symbolized in a fictive male 'womb'. Perhaps even the exclusion of women from the ritual life so commonly observed among tribal peoples throughout long phases of their social development is itself a reflection of this sentiment.

Mosaic Garments

*Koryak parka,
Siberia*

Evidence

Among hunting peoples, especially in cold climates, skin garments become prime vehicles for the transmission of traditional designs. Often they constitute the chief, even the only, decorated objects. Clothing is very personal, and designs applied to it, once established within a tribe, serve as emblems of tribal identity and become themselves marks of identity.

Designs tattooed or painted on the human body often resemble designs applied to skin garments. Human skin is thus tantamount to animal skin as a medium for human designs. Choice of motif is probably seldom, if ever, arbitrary. I assume all this was equally true in the past.

I think the earliest art medium was the human body and that early peoples wore their art wherever they wandered. Many modern tribal designs derive, ultimately, from these first models.

So I begin by comparing appropriate classes of traditional artistic expression. I do so with less deference to academically-established boundaries between artistic provinces & periods than to the internal character of the designs themselves. This isn't an academically popular route, but it does illuminate dark areas of prehistory, accessible by no other means.

Perishability deprived us of direct evidence of ancient clothing. Indifference deprived us of much modern evidence. Those given the opportunity to collect traditional clothing before it was too late generally failed to do so, regarding such specimens as trivial. Even the few specimens collected were often damaged or lost before, even after, reaching museums.

Still, there is evidence. A handful of traditional robes survive. Many bear scratched or painted designs identical to designs early men scratched or painted on pebbles. These 'dressed' pebbles bear witness to what I believe was women's earliest art.

Until recently Plains Indian women prepared & decorated hides with traditional designs of a highly schematic character. Men, if they expressed themselves artistically at all, did so in an entirely different mode, involving naturalistic representations of the chase or warfare. Both men & women painted on hide, but their work was utterly different, and men rarely dabbled in women's designs, nor knew how to execute them properly. I suspect that a similar distinction was widespread in ancient times.

The artistic work of paleolithic women, applied to perishable materials, perhaps exclusively to skins, is totally lost. What survives is men's art, applied by men to imperishable materials. Only when a man introduced a suggestion of women's designs among his own naturalistic representations do we get a glimpse of women's schematic art.

These rare exceptions are important. Crude, fragmentary sketches of women's designs, introduced among carefully executed representations of animals in paleolithic cave art, convey casual impressions of otherwise well-organized women's designs. I see them as evidence of men dabbling in women's matters, about which they knew little and were customarily indifferent.

Fortunately, such designs survive in full in certain modern tribes, although not necessarily with this sexual difference. Modern genealogical iconography—for that is what schematic art is really all about—thus becomes the key for reconstructing its paleolithic prototype.

Beginning in late paleolithic or mesolithic times, naturalistic representations of animals became few in number and poor in quality, while schematic art came to the fore. This is especially evident in the Maglemose culture of northwestern Europe. But Maglemose schematic art hardly represents an innovation. Its efflorescence probably reflects some social change, connected with economic change, whereby art traditionally applied by women to perishable materials, such as hides, was now engraved by men on bone & antler. These engravings provide immediate insight into the schematic art of the preceding paleolithic period.

The original character of neolithic designs is more difficult to recognize, perhaps because of the relative ease with which designs were applied to pottery and the enormous increase of artistic activity that pottery facilitated. In the rapidly multiplying 'schools' of pottery decoration, many liberties were taken with motifs inherited from the past.

No known paleolithic garments survive. However, neolithic schematic designs, especially continuous-patterns encircling pottery, provide clues to those earlier garment designs that later artists used so loosely. Conversely, these varied neolithic designs begin to make sense when we understand their derivation from the more significant forms of a still remoter past.

Even in paleolithic times, schematic designs were only rarely applied to imperishable materials. The few examples surviving today on stone & ivory can only be an infinitesimal fraction of what originally existed on skins. Conceivably, whole artistic traditions, once widely prevalent in paleolithic times, left no trace, for they were never committed to ivory or stone. Our impression of paleolithic art, based necessarily upon surviving evidence, may be very one-sided and highly erroneous.

Many years ago I was descending the Sepik when a sudden downpour raised the river, making it impossible to land. Finally, in darkness, we lashed the dugout to an overhanging trunk. In the morning I discovered we had moored beside a clearing. I went ashore. In the center of cultivated fields stood a large structure, superbly constructed. There was no one about. All the baskets & bags, platters & hooks, mats & utensils, were made of jungle materials. So were tools stored in the rafters. All were well-made; most were decorated. Everything this tiny community needed was there, but the only object I observed that would survive more than a few years was a flashlight battery that had already burst from dampness. Even the post-holes would not have survived long, for the Sepik meanders.

Restricting archeological evidence to imperishables can produce a very biased view. If Nukuoro atoll, in Micronesia, had been unoccupied at the time of European contact, we would unhesitatingly classify its former inhabitants, on the basis of excavated evidence, as Micronesian. Excavated specimens of stone & shell, bone & ivory, parallel those on the nearest Micronesian islands. Yet surviving Nukuorans spoke a Polynesian language. Their social organization, architecture, music, lore, art, etc, were Polynesian. Traditions expressed in stone & bone proved less constant than those expressed in words & wood.

I'm not suggesting that archeologists abandon what they do best. I'm merely noting that some of the best evidence is still alive and that much excavated material can best be understood in comparison with this living evidence.

Fur Mosaics

Fur mosaics are formed either by stitching together entire pelts or by cutting fanciful patterns out of rectangles cut from pelts of contrasting colors.

Dichromatic examples of the first type probably once existed, but we can't be certain: I know of no surviving example.

Composite robes of similar pelts do survive. Robe *503*, made by Tehuelche Indians, southern Patagonia, is composed of the skins of twelve guanacos, a local species of small llama with soft, dense fur. Ten skins were trimmed to fit into each other in alternately upright & inverted columns of two skins each. Two skins were split along the animals' backbones, and the resulting halves faced outward to form the straight sides of the rectangular robe.

Although all of the pelts of *503* are identical, their lighter-colored underbodies form a pattern corresponding roughly to the seams visible on the skin side. Each natural pelt looks like a human figure and the resulting design resembles a genealogical pattern of alternately upright & inverted figures joined limb-to-limb.

The skin side, *503a*, is painted with: 1) a system of borders; 2) a minute pattern repeated endlessly over the central surface, possibly a debased Shadow System; and 3) a pair of vertical bands. These bands bisect the vertical skins. Thus they simulate the actual splitting of the inverted skins at the side of the garment.

If (2) is a debased Shadow System, then the robe as a whole contains two distinct genealogical patterns: one implicit in the interlocking skins themselves, the other painted upon them, and both dissected by simulated splitting.

The social symbolism of split furs may also underlie simulated splits. Moreover, the outlines of pelts may in themselves have suggested human figures. If so, then each robe, composed of many skins, appears as a pattern of interlocking human figures. Such a composition would in itself suggest social implications.

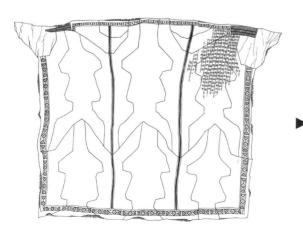

503a

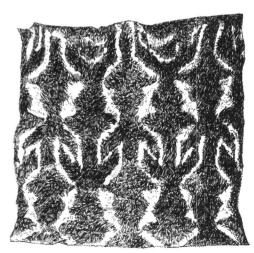

503

Since some skins of this basic type were split in half, this splitting would be tantamount to splitting the 'human figures' visualized on them, and that, in turn, would imply, symbolically, splitting the social fabric.

No matter which came first, moieties or robes, the symbolism is as striking as it is natural; and I find it easy to believe that it occurred to people who, surely for many millennia in remote prehistoric times, made & wore such robes.

The counterpart of simulated skins exists among Plains Indians in North America. Instead of stitching robes together out of small skins, they made them from the integral hides of large animals, such as bison. One hide equalled one robe.

In preparing such a hide, the Indian woman cut out a long, natural strip from the part that covered the animal's spinal column. Being tougher than the rest, this strip would have made the garment unsuitable for wear. So it was removed and used for other purposes, such as straps and moccasin soles.

504

The two halves of the hide, thus split, were then stitched together, and the resulting seam covered with a specially ornamental pattern, sometimes painted, sometimes embroidered with beads or porcupine quills, *504*. The effect is that of an enhanced seam, called by ethnologists a 'blanket strip'.

Such strips might be removed from a robe and hung separately in a tepee, *505*. They played a prominent role in marriage ceremonies, and were actually called 'marriage belts'. In their original function as decoration down the spinal column of a fur robe, they joined the two halves of the robe, with each half representing one moiety. Thus they came to symbolize the actual union, in marriage, of two societies. Even when removed from the robe, this marital symbolism was maintained.

Splitting bison robes is practical and bisects no pattern of human figures. Still, the fact that it runs along the spine of the animal might explain the simulated splitting of smaller skins, no doubt along their spines. Since no practical reason exists for splitting these small, soft furs, did the ancestors of those who split them once hunt larger game? In other words, did simulated splitting of small hides merely commemorate this earlier custom?

505

Traditional designs obviously persisted despite changes in the materials to which they were applied. But the picture is surely more complicated than that. Certain designs may have been associated with certain furs. And garment decorations must have influenced one another in the past, just as they do today. It probably makes no sense to try to differentiate between real & simulated splitting when ancient examples are known to us only through stone & ivory engravings.

It may also be unimportant. Although splitting skins into halves apparently had its ultimate origin in technical requirements (rectangularization of a robe, or removal of tough hide along the spine), the widespread practice of simulated splitting suggests splitting was also symbolic, and that its symbolism related to anthropomorphism.

Insight into this symbolism is provided by certain modern peoples of East Africa among whom splitting a sacrificed animal along its spine was explicitly associated with the conception of social alignments within a tribe, or with political truces between tribes. This former function was reflected, for example, in splitting a sacrificed animal to neutralize the bad effects of real or supposed incest, ie of a contravention of marriage regulations.

The reason for this usage becomes clear in light of a number of East African myths of tribal origin in which the 'split' between exogamous moieties is symbolized by the splitting of sacrificial animals, with the two halves assigned to the progenitors of the two main marriage classes within the tribe.

Such myths are variants of that widespread creation myth in which the world in general, and the two moieties in particular, are created from the body of the Ultimate Ancestor. The sacrificial animal (or human) then impersonates this Ancestor, and the two halves of the victim correspondingly represent the principal social body 'split' into two intermarrying moieties.

According to *Genesis* (15:9–10), Abram, following God's direction, divided a heifer, goat & ram 'in the midst, and laid each piece one against the other'. That evening, after a burning lamp 'passed between these pieces', the Lord made a covenant with Abram, saying 'Unto thy seed have I given this land' (15:17–18). Later he spoke of this 'covenant which they made before me, when they cut the calf in twain, and passed between the parts thereof' (*Jeremiah*, 34:18).

These Biblical references attest to the antiquity of this practice and reflect the importance of the split as symbolizing the sanctity of a contract which binds, or reunites, two parties. But sacramental symbolism may be secondary. The true origin of this custom is more accurately reflected in modern African usages where parties to the contract are bound in marriage.

Let's assume this cluster of East African traditions represents the survival of an ancient system of social symbolism, the sacrifice of domestic animals being, presumably, an extension into a grazing economy of the killing of hunted animals. What, then, is the relation of these African sacrificial practices, and their associated legends & ideas, to the presumed or latent symbolism of the robes?

Consider *506*, a cowhide with scratched design presented by an Arbore bridegroom of Ethiopia to his bride as a cover of their wedding bed. Paired lines, paralleling the animal's spine, represent the bride & groom respectively. Native opinion differs about the other elements of this decoration, but the tenor of the symbolism is clearly genealogical: the two central bars explicitly represent partners in the marriage contract. Each half of the skin is thus associated with a separate marriage class. Here these classes are reunited by the marriage of these individuals.

It then follows that the skin as a whole represents the tribe as a whole, or, rephrasing the same concept, the skin as a whole represents the Ultimate Ancestor from whose parts the tribe was created.

Hide *506* wasn't actually cut in two. But the marital concept associated with simulated cleavage is probably the same as concepts associated with actual cleavage of sacrificed animals in other East African usages.

As a corollary of these associations, stitching together of the cleft halves of Plains Indian bison skins, though originally purely practical, came to symbolize the actual union, by marriage, of moieties. The sexual analogy of stitching itself may have reinforced that idea.

What is the relation between these hides and the social fabric or (more basically) between animals and the groups or classes of human beings represented upon them? Inscribing diagrams of social relationship on animal skins implies a totemistic identification of that social group with that animal.

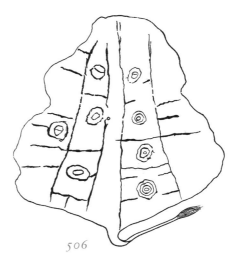

506

The very outline of the skins in a robe like *503* suggests human figures, joined by their limbs in a familiar genealogical pattern. Each skin (presumably totemic) can be split, actually or symbolically, and half of those in *503* are. This means that each 'human figure' can be vertically divided in half. Perhaps these individuals are conceived as being themselves 'split', or both split & joined, in the sense that each is the product of the marital union, or reunion, of representatives of two social sections.

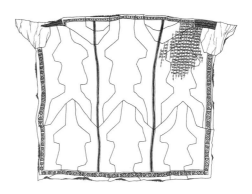

503

Mosaic Technique

Using the sharp point of a knife, a Samoyed woman in northern Siberia, *507*, makes mosaics out of reindeer hide. She has placed a light-colored hide on top of a dark-colored hide, stitched them together to prevent shifting, cut a 'toothed' line down the center of both, and next will sew the resulting four strips together so that the 'teeth' of one engage the cut-outs of the other.

The Obugrian Voguls of western Siberia employ this same technique. Sewing-bag *508* illustrates their simplest, most characteristic cut-out pattern. Note the zigzag band with a lozenge attached to each angle on one side. They call these lozenges 'heads' or 'skulls' and *509*, which resembles a human figure, 'half-man' or 'stump-man'. Clearly *508* is composed of series of 'half-men' simplified for the purpose of serial connection by dropping their arm-stumps and feet.

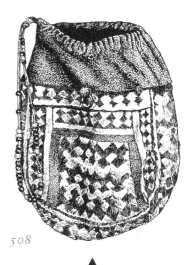

508

▲

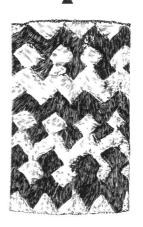

507

▲

509

Most native names for designs are simply popular etymologies, guesses about meanings whose origins have been forgotten. If original meanings can be recovered at all, it is chiefly through comparisons with related phenomena in other cultures, where meanings of analogous designs happen to be more apparent. But there are exceptions: sometimes native nomenclature has diagnostic value.

The idea that *509* represents the 'half' or stump of a man seems appropriate in several ways. The name may allude to the inherent incompleteness of the elements in a diachromatic mosaic, which depend upon contrast with adjoining areas for completion. Moreover, where anthropomorphic elements, alternately upright & inverted, are connected diagonally by common 'arms' & 'legs', as in *508*, cutting this connection vertically produces 'half a man'.

In terms of a dichromatic mosaic, the term 'half-man' could also be interpreted in other than purely technical terms. If such mosaics convey, as I think they do, a significant social symbolism, then each 'half-man' is not really complete even if he appears so. Completion occurs when, after being cut out of skin, he is united or 're-united' with his marital partner, in the form of an identical figure of the opposite color.

Such an interpretation should not be overlooked in seeking to understand the 'complementary' character of dichromatic mosaics. Marital symbolism may well have played a conscious, decisive role in the development of dichromatic patterns—even if it was later forgotten and the design reduced to mere decoration. The term 'half-man' fits just as well all 'split' genealogical figures. For every pattern composed of anthropomorphic elements split into panels or bands produces 'half-men'. And these 'half-men' find a satisfactory explanation only in terms of social symbolism: the splitting of the social fabric into exogamous moieties.

Each 'half-man' in *508* is designed so that the head of the 'half-man' below him fits precisely into the space between his legs. This is the same interlocking arrangement of many neolithic pottery designs, which are simply excerpts or swathes cut through endlessly repeating patterns of little 'half-men'.

Compare *508* with *510*, five potsherds from three neolithic cultures in central & eastern Europe. In three, to preserve the dichromatic effect of the original mosaic, the potters stippled or banded alternate elements. In the others, no attempt was made to suggest color contrast, unless some fugitive paint has disappeared, which seems unlikely. Here potters represented only the 'cutting lines' of the mosaic with which, obviously, they were thoroughly familiar.

510

In *511*, an Ostyak fur hood from western Siberia, the lozenge is also called a 'skull' or 'head'. Compare *511* with *512*, a Bükk vessel of the Hungarian neolithic. Their total compositions are analogous: each surface is a hemisphere divided into panels like the gores of a melon, radiating from a basal 'cap' and separated from that base, as well as from each other, by fascicules of parallel lines.

Moreover, the designs enclosed within the gore-like panels are strikingly similar. True, they aren't precisely identical, but you can satisfy yourself that *512* is as much a 'mosaic' as *511* by performing the familiar 'cut-out' experiment: following the lines of *512*, cut out the pattern with scissors simultaneously from two differently colored sheets of paper, then recompose. If you simultaneously cut four instead of two sheets, you have enough cut-outs to compose all four of the panels surrounding *511*.

Conceivably *512* evolved by some other procedure, but I doubt it. Repetition of the design in a succession of identical panels (perhaps originally with reversed coloring in alternate panels, as in *511*) is an automatic consequence of the mosaic technique.

Even if the differentiation in coloring in the original mosaic wasn't maintained in *512*, the potter (presumably a woman) was so familiar with the traditional cutting lines of this mosaic that she reproduced them in clay as easily as on skin—or even more easily.

511

512

▲

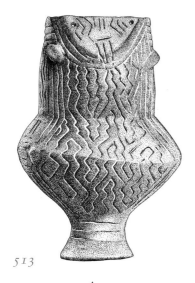

513

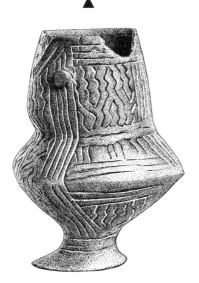

▲

The decoration of *513*, a Bükk vase-figure from Hungary, represents, I think, a garment of rectangular panels strongly emphasized by multiple bands. Such compartmentation is inseparable from the mosaic technique, eg *514*, a Samoyed parka or kaftan. Perhaps parts of *513* represent fringes cut out of skin, like those so conspicuous in *514*. If the typical Bükk 'meander' is anthropomorphic, then the bands of *514* may also be anthropomorphic.

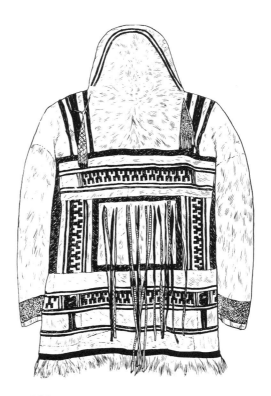

514

One striking pecularity characterizes all of these neolithic designs and almost all of the mosaic designs studied so far—namely, the splitting of an essentially diagonal, 'complementary' pattern into rectangular panels or bands by strongly-marked vertical and/or horizontal demarcations. These are the 'splits' already familiar to us in many mosaics. Ultimately they go back to the splitting of the whole animal skins to form the outsides of rectangular garments.

When mosaic designs were transferred to pottery, habits associated with the mosaic technique persisted. The vertical split in *515*, a neolithic vessel base from Moldavia, cannot be expained technically, eg aligning the design with the vessel's rim. Splitting the painted pattern in *515* is best explained as a retention, by cultural inertia, of a mosaic trait. It was this feature the potter copied, or reproduced from memory, when clothing *515* in a mosaic garment.

Note the similarly 'split' meander or pseudo-meander in *516*, a Bandkeramik vessel-base from East Slovakia.

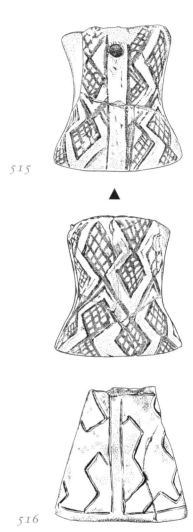

515

516

Consider the kilt-like garment incised on *517*, a tiny figurine from Vinca, Serbia. To make the garment recognizable in this tiny effigy, its maker emphasized the upper seam or girdle, the diagonally meandering pattern and the two vertical 'splits' that interrupt it. How essential were those splits!

Possibly the original pattern was no longer rendered as a mosaic: it may even have been merely painted or woven. Even so, the stitching together of loom-widths of diagonally-patterned cloth to make a tubular skirt produced the same effect as the 'splitting' of a mosaic panel.

And the source of the 'meandering line'? Hardly, I think, from the pre-classical Mediterranean world, but surely from a mosaic. The equal widths of the spaces between the lines of *517* would be achieved automatically by interlocking pieces cut simultaneously from two differently colored layers of skin.

All these designs are essentially the same; and so, I think, are their explanations. All reproduce mosaics and for this reason consistently display a technical peculiarity of mosaics; the splitting of 'complementary' patterns into bands or panels.

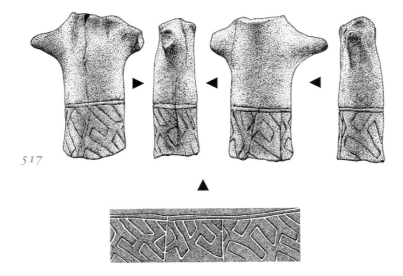

517

Iberian Stela

Design *518* is painted on an upright slab of a bronze-age dolmen, Côta, Portugal. Breuil plausibly identified its two upper elements as 'Almerian idols', familiar motifs among Iberian pictographs. Each female body is reduced to hourglass shape, with triangular head, triangular skirt, and lateral protrusions evidently conceived as the bust.

Breuil further identified the columns of telescoped triangles as ramiforms: stacked torsos of ancestors forming family trees. He called them 'pine-tree men'.

I believe *518* represented a clothed human figure wearing a mosaic garment. I assume that the man so honored was of special consequence in his community, and that the garment painted on his mortuary monument—presumably a replica of a robe he wore in life—was itself a mark of distinction.

To duplicate *518*, take two rectangular sheets of paper, of equal size but differing colors; lay the lighter over the darker, cut out full-motifs *&* half-motifs of telescoped triangles; then interchange the light *&* dark cut-outs and recompose as a two-color mosaic.

This simple procedure is basic to all mosaics. It utilizes, without waste, all parts of both pieces of skin. It also permits considerable variation in patterns. Such patterns form compartmented compositions, with vertical *&* horizontal divisions between compartments or panels—except where cut-outs are made from long, narrow strips, for use as borders, eg the right side of *518*.

518

The technique is simple. Yet *518* is a mess. Perhaps approximation sufficed on a mortuary monument. Or the reason may be more fundamental. I assume the painter of *518* was a man, reproducing patterns more familiar to women, for surely it was women in this society who cut skins and stitched those cut-outs together to form a mosaic, then stitched the whole to a foundation or lining. I doubt that any skilled seamstress, with cutting edges literally at her fingertips, would be so careless.

The dotted lines of *518* aren't dotted in the original, but rendered as black lines, in contrast to the rest of the decoration which is red. However, a dolmen just north of *518* has actual rows of black dots outlining certain motifs, some of which are surely cognate to the ramiforms of *518*.

In describing these black dots, Breuil used the expression *ourlé*, 'hemmed'. Presumably he meant this figuratively, but the expression may be literally true, at least for those parts of the design with a surface broad enough to hem or stitch to a foundation-layer of skin.

The modern Kilim rug from Eastern Europe in *519* preserves a similar pattern of stacked torsos, though executed in three colors, not two. Note the division into compartments, as in *518*. The hourglass in the center of each compartment is virtually identical with the 'Almerian idols' surmounting *518*, while the dark column at the left of *519* finds its parallel in the dark column in the lower right of *518*.

519

Although *519* isn't a fur mosaic, its pattern probably derives, ultimately, from the mosaic technique. The techniques for making Kilims closely resemble the mosaic technique, since Kilims are made by sewing together alternately colored, interlocking, woven pieces.

Megalith, Saxony

The custom of erecting megalithic monuments spread rapidly throughout Western Europe during the transition from neolithic to bronze age. Insofar as they were mortuary & commemorative, such monuments were naturally inscribed with mementoes of the dead, particularly with representations of their clothing, even when the monument wasn't conceived as an actual effigy of the deceased, as it probably often was. Many of these stelae perpetuate motifs originally applied to skin garments.

Perhaps stone monuments were preceded by wooden mortuary effigies, on which the same designs were carved or painted. The sudden appearance of 'megalithic' monuments in Europe at the beginning of the bronze age followed the introduction of metal tools. For the first time it was possible to replace wooden monuments with stone ones whose durability was more appropriate to their commemorative purpose.

The megalithic tradition was short-lived in Europe. Yet the custom spread by a sort of osmotic process, largely along sea routes, to other places, some very distant. There the making of megalithic monuments, and practices associated with them, long continued, sometimes down to yesterday.

Consider 520, carved & painted in Saxony. Here we see evidence of the stitching together of rectangular panels to form what I assume was originally a garment decorated with genealogical motifs—presumably those of the tribal leader whose weapons were represented elsewhere on this monument.

One writer suggested that 520 reproduced a textile 'hanging' of woven panels stitched together and offered 520a as a hypothetical reconstruction. Even if textiles were then known, skin garments were probably still in use, or at least of ritual importance. Though the immediate model of 520 may have been woven, its ultimate prototype was surely a painted skin garment.

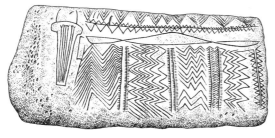

520

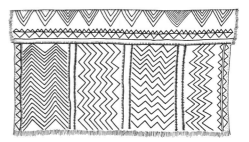

520a

Megalith, Wales

Megalith *521* stands in a chamber-tomb in Wales. Door-post *261* stands in a house in New Caledonia. Millennia separate them. Yet the genealogical statement engraved on each is the same statement, rendered in much the same way.

So the similarity between them isn't limited to decoration: it extends to meaning. Once we recognize that such carvings, no matter how widely separated in time *&* space, no matter how different the cultures that produced them, really represent a single type, it becomes apparent that neither example can be fully understood solely in terms of its immediate cultural environment.

Many differences in form *&* function, which seem at first to forbid comparison between such phenomena, are reconciled in the light of this common meaning. Differences in material, for example, need not disturb us. Megalithic monuments probably supplanted wooden monuments whose motifs they transmitted. Stela *521* supported the roof of a tomb; post *261* supported the roof of a house. But tombs—houses for the dead—often reflect domestic architecture. Stela *521* may simply replicate, or at least approximate, a contemporary wooden housepost.

By whatever route its design reached Wales, at whatever date, *521* itself represents the survival of a very ancient artistic concept, rooted in the paleolithic. Compare *521* with *522 & 523*, two miniature examples of ivory, both Magdalenian, from the Ukraine.

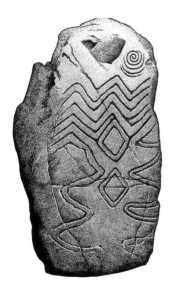

521

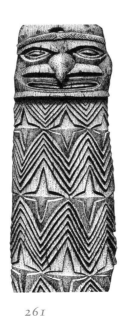

261

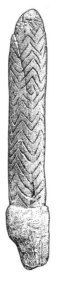

522

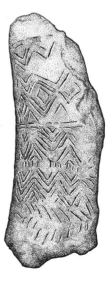

523

Dolmen-like Tomb, Sumba

The carved design of the capstone on a dolmen-like tomb, *524*, Sumba, Indonesia, has five rectangular compartments. One contains a column of Ms. The others each contain three 'stacked' Saint Andrew's crosses.

Each cross consists of four sets of parallel chevrons converging in a point. A horizontal line, or two such lines with a blank band between them, separate each cross from the cross above & below it. Zigzag bands surrounding each whole panel presumably represent the stitching of widths of pliable material together to form a garment.

Note the garment worn by *524a*, one of several stone figures forming part of this same monument. Each of these 'personages' wears a skirt or sarong or kilt decorated with panels of converging chevrons joined by zigzag seams, exactly as in *524a*. We could hardly ask for more cogent evidence that *524a* represents a stitched garment. Which brings to mind *525*, one of several minute, Magdalenian figurines from Mezin, Ukraine.

Another Sumbanese megalith, *526*, has Saint Andrew's crosses, again compartmented between bands suggestive of stitching. Compare all three Sumba carvings with *527*, a bark-belt from an isolated tribe in Papua.

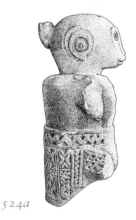

524a

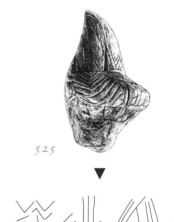

525

▼

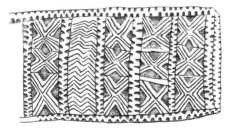

524

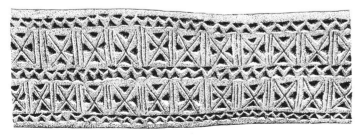

526

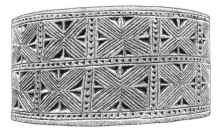

527

Vair

Diachromatic fur-mosaics in 'comple-
mentary' patterns served as garments
in medieval Europe. One of these
heraldic furs, the vair, *528*, was repre-
sented by bell- or cup-shaped spaces
of two or more tinctures, disposed
alternately, in imitation of small skins
arranged in a similar manner and
sewn together. A 1611 work on her-
aldry states: 'If you observe the pro-
portion of this vaire, you shall easily
discerne the very shape of the case or
skinne of little beasts, in them'.

The 'skins' or 'shields' of *528* not only
alternate in color, but interlock in al-
ternately upright & inverted position.
Each shield is evidently cut from the
skin of one animal; the result is thus a
mosaic of interlocking animal skins
tantamount to the interlocking of
those dark & light 'people' who com-
pose reciprocal genealogical patterns
and who represent men & women
from opposed, intermarrying moieties.

Making vairs required much skill &
labor. Their delicacy rendered them
unsuitable for ordinary wear. Medieval
Europeans reserved them for 'kings,
nobles, and prelates' or, as one his-
torian phrased it, 'for those people
who could afford it'. In France it was
ordained in 1294 that no ecclesiastic
but dignified clergymen wear vair,
gray or ermine. Alice Brand, in *Lady
of the Lake*, laments: 'If pall and vair
I no more wear'. The vair conferred
more than warmth on its owner.

Stela *529*, from a burial mound in
Germany, dates circa 2800–2400 BC.
Megalithic evidence merely shows
that garments composed according to
principles evolved in far earlier times
were still being made in the 3rd
millennium BC in Europe. There
they survived into the medieval
period, as *vêtements de luxe*.

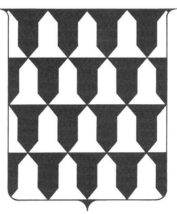

528

529

Heraldry

All these considerations suggest that a whole class of world-wide design patterns, namely patterns of connected, alternately upright & inverted human figures, executed in all kinds of materials, evolved originally out of robes of interlocking animal skins; that such patterns may be the oldest ever evolved; and that robe symbolism, and more specifically the symbolism of skin mosaics, is a kind of heraldry —that is to say, a symbolism of marital relationships—which, though less elaborate than medieval European heraldry, foreshadows many of its characteristics, and may be ancestral to it.

I assume that garments served, from the beginning, as a means of tribal identification and that skin robes in particular were emblems in a double sense: in composition they represented social groups as assemblages of individuals, while their design variations distinguished tribe from tribe.

What we call 'heraldry' is simply an abstraction of social diagrams represented by traditional garment schemes, and the elaboration from them of a more complex symbolic system, whose vestimentary origin is obscure, but can still be detected in exceptional cases.

The elaborate tabard in *530*, worn by a herald, dates from the reign of the Stuart Queen Anne, when the parliaments of Scotland & England were joined. Here the lion of Scotland joins with the lions of England, reducing France to a less important place in the arms than previously.

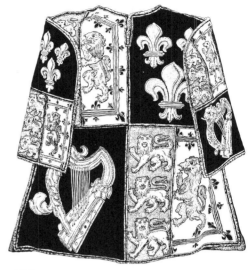

530

'Quartering' blazons to symbolize episodes in the marital history of clans or families has its obvious counterpart (and surely its origin) in tribal designs dividing the tribe into four clans eligible for intermarriage.

Even the heraldic escutcheon or shield on which amorial bearings are commonly depicted probably goes back to skin-covered shields. Like garments, shields served as emblems of recognition (as do miniature shields today), and were accordingly 'blazoned' with the same basic symbolism.

The chevron, vair, chequy & saltier (Saint Andrew's cross)—all popular devices in medieval heraldry—were equally popular in the Iberian eneolithic, eg 531, schist pendants.

Stippling, widely used to represent vairs & other diachromatic mosaics, may have served that purpose in 532, neolithic sherd, Czechoslovakia; and 533, shell pendants, Channel Islands, California. Just a guess. But an informed guess.

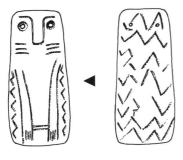 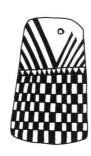 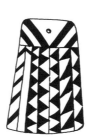 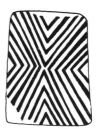

531

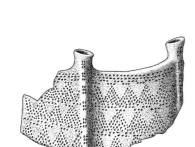

532

533

In Europe, the chequy device, placed on shields, *534*, as well as on burial covers & house facades, served as a genealogical statement. It carried much the same general meaning as *535*, a Dogon funeral blanket, West Africa; and *473*, the Cubeo house facade, Brazil.

Conceivably it also enjoyed that meaning in *536*, Maglemose culture, Denmark; *537*, pottery decoration, bronze age, Susa, Iraq; *538*, ceramic figure, Vinca culture, Yugoslavia; and *539*, bone pendant, Channel Islands, California.

All highly speculative, of course. Yet antlers & pendants engraved with heraldic devices were popular vehicles for representing human figures. And the checker device occurred widely as a tattoo, eg *540* & *541*, Micronesian figures, as sketched in 1839.

Obviously this simple design enjoyed various meanings. But when encountered in a genealogical setting, especially in association with other heraldic devices, as in *537*, it's not unreasonable to suspect a genealogical origin.

534

535

473

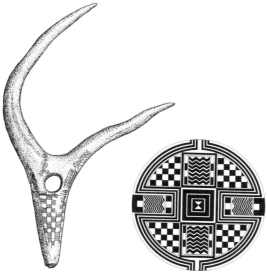

536 *537*

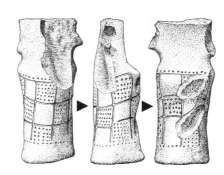

538

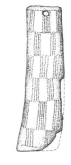

539

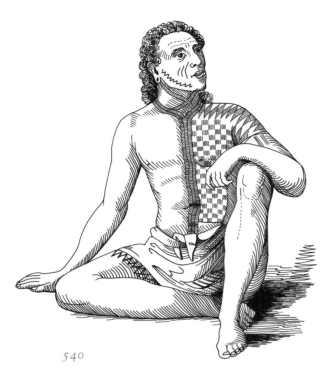

540

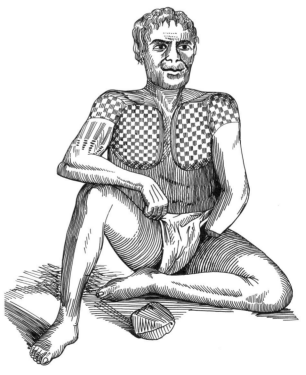

541

6

Compartmented Robes

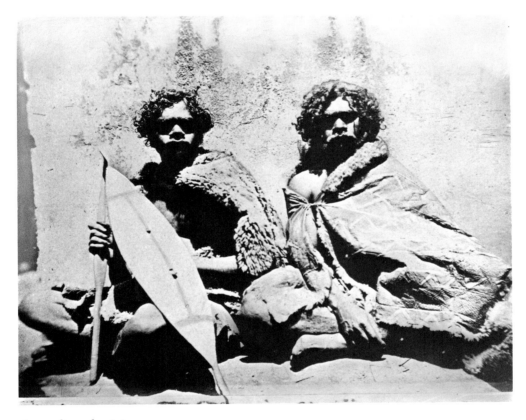

Australian aborigines

Compartmented Designs

Like the invisible giant, so huge he goes unnoticed, *Compartmented Designs*—so numerous, so widespread—generally go unnoticed until identified. Even when they appear on human figures, eg *542*, a petroglyph in the Sudan; or *543*, a pre-Columbian painted figure, Argentina, we may forget their origin in skin garments. This becomes especially true in areas far removed from the cold climates that witnessed their birth.

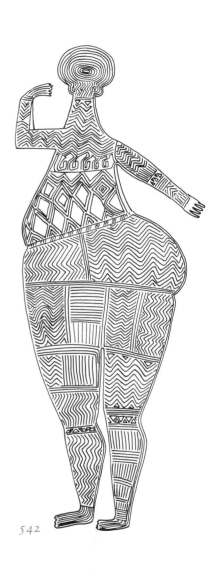

542

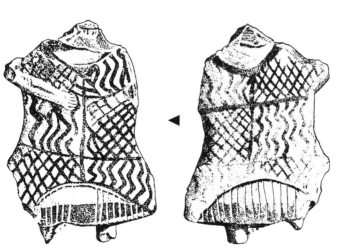

543

Jungles & atolls are unlikely places for fur & skin clothing, yet designs derived from them persist even in the tropics, eg *544*, New Guinea box; *545*, Micronesian dance wand; *546*, Melanesian bark cloth; and *547*, Samoan *tapa* (note the Saint Andrew's cross).

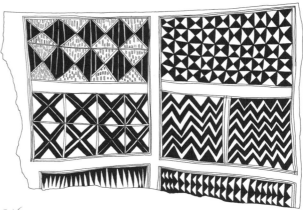

546

544

545

547

Compare *548*, tattooed on the hand of a modern Tunisian woman, with *520*, the megalith in Saxony:

548

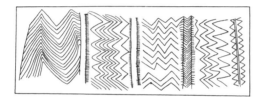

520

If we entertain any doubt about the traditional nature & antiquity of *548*, it's dispelled by observing similar designs in other, often distant, parts of the world, eg *549*, Micronesian thigh tattoo; and *550*, fur design from the Yakuts, Siberia.

The relation of *548* to stitched-garment decoration is supported by the spurred line across its top. This motif has innumerable prehistoric antecedents, eg *551*, a megalithic-period vessel, Germany.

549

550

551

Compartmentation of stacked Ws &
Ms occurs on *552*, bronze-age sherd
from Iran; *553*, from a Schleswig-
Holstein passage grave; *554*, rim sherd
from the Sarvas site, Yugoslavia;
555, miniature sarcophagus, Iraq; 3rd
millennium BC; and *556*, Moravian
painted ware, Czechoslovakia.

552

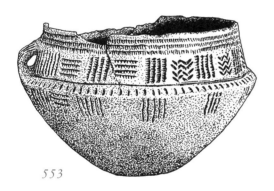

553

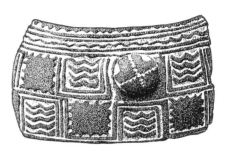

554

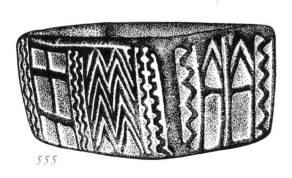

555

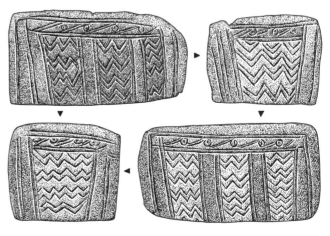

556

From among many paleolithic exam-
ples, let me illustrate six: *557*, incised
pebble, Grotta Romanelli, Italy; *558–
560 & 339*, engraved ivories from
Eliseevichi, western Russia; and *525*,
design engraved on one of the tiny
Mezin figurines, Ukraine.

557

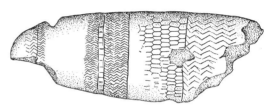

558

339

559

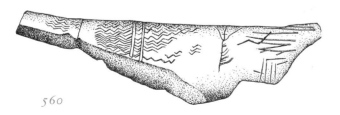

560

525

Probably the human body itself served as the prime vehicle for transmitting genealogical patterns in even remoter prehistoric times. If such designs were only later applied to skin garments, it follows that, even before the invention of stitched clothing, they were traditionally painted upon the body, though *not yet* compartmentally divided.

Tattoos inspired by skin clothing, eg *561*, a Solomon Islander, then represent a transfer back to the human body of what had previously been transferred from body to garment.

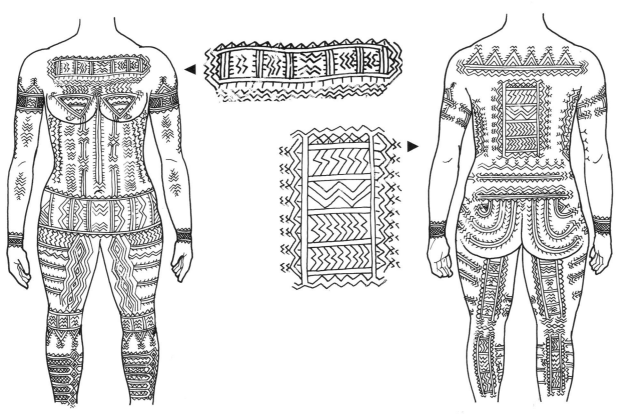

561

Australian Robes

Very few Australian robes were ever collected. Fewer still survive. Robe comes to us thanks to the Wilkes Expedition, 1838–1842. It is a rare, rare document.

Its twenty-four rectangular panels were first decorated with a scratch design, then stitched together. No trace of coloring appears. The preparation of separate panels is shown in 562. Here decorated panels are shown pegged out individually on pieces of bark, obviously before assembly.

Design 264a, which is repeated in other panels, reveals a standard *Type 1 Shadow System*. A pattern of linked 'human' bodies is inscribed behind a similar, more abstract pattern. Their overlapping or crossing may symbolize marriage, in the same sense as stitching or knotting.

Clearly, these human/reptile figures, joined by their limbs, represent a genealogy comparable to 479, sketched on the ground by the Kamilaroi.

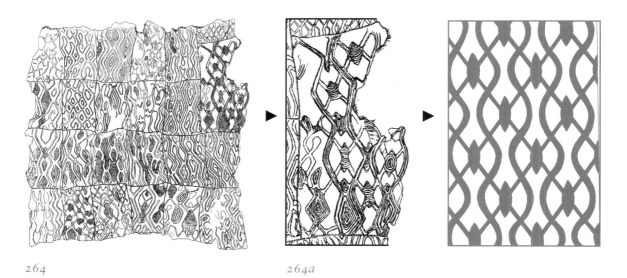

264

264a

562

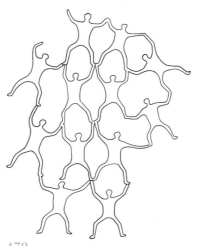

479

563

Consider *564*, another Australian robe, or at least a part of a robe, for the original was probably much larger. Again, it was stitched together out of rectangular pieces of opposum skin with scratched (and, in this case, painted) designs. And again, each skin was decorated separately, before stitching, though close correspondences exist between vertically adjacent panels. In *564A* & *564D*, these correspondences reach near-continuity.

Compare *564* with five separate panels. In *565a–e*, excerpted from another Australian robe; and *566*, from a third robe.

The repeated motif in *564A*, and to a lesser extent those in *564C*, look like shaved sticks or ramiforms, comparable to *563*, painted on a pre-dynastic Egyptian vessel. Add a stem or spine to *565a* & *565c* and they become ramiforms.

Motif *564B* resembles, but doesn't represent, an octopus. At first glance, *564B* & *565b* seem to have little in common. Yet both, I believe, are debased 'St. Andrew's crosses', comparable to *566*. If so, then the 'arms' or 'chevrons' of *564B* retain their original posture relative to the sides of the panel, while in *565b*, the cross has been upended and turned through 45°.

564

A B C D

565a *b* *c*

d *e* *566*

This scheme of decoration must belong to an immensely conservative tradition, for it enjoys many ancient prototypes. Robe *564* brings to mind *525*, the tiny ivory figurine from the paleolithic site of Mezin, in the Ukraine.

Both robe *564* and 'skirt' *525* (each is probably incomplete) have eight rectangles, arranged in two tiers. The decoration of the respective rectangles in each tier tends to continue across the median interruption between them. I assume that the blank band horizontally bisecting *525* represents a stitched seam.

Essentially the same scheme appears on *522* & *523*, two other engraved specimens from Mezin. Note the blank band dividing each into two zones or panels, much as in *525*.

In the upper panel of *523*, horizontally aligned zigzags with opposed points embrace concentric lozenges. This is evidently the complete scheme of which dissected portions appear in the two central panels of *525*.

If the cuts in *525* had been made so as to bisect each lozenge centrally, as in *A*, instead of falling between the lozenges, as in *B*, the result would have been a series of Saint Andrew's crosses.

564

522 523

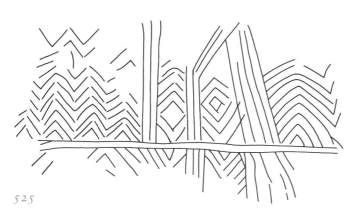

525

A B

The clue to the almost incredible tenacity of such traditions lies, I believe, in the circumstance that motifs were applied to *clothing*, which had to be constantly renewed. This highly conservative garment decoration may go back, ultimately, to body decoration. But the 'blank-band' in *523* surely indicates an application of this design to stitched clothing.

The undulating, parallel lines of *564D* & *565d* look like zigzags or rows of continuous limbs. I believe that is what they represent. If so, the seam in *564D*, besides being practical, conceptually relates to the design which it bisects. If it weren't conceptually important, why the persistent reminiscences of it in so many prehistoric artifacts & monuments that reproduce robe designs?

Compare *565d* to two modern Australian wooden objects: a shield, *567*, and a message stick, *568*; as well as to *557*, the paleolithic incised stone from Grotta Romanelli. In light of *564D*, design *557* was probably inspired by the decoration of skin robes, which must have been as familiar to its engraver as was design *564D* to the carvers of *567* & *568*.

564D

565d

567

568

557

Australian aborigines also carved robe motifs on trees as memorials for the dead, eg *569*. Early photographs of these dendroglyphs show that some were genealogical designs encircling the trunks on which they were engraved.

We might reasonably see such dendroglyphs as tribal markings, or as a selection of such markings. A robe's owner would naturally recognize it as his by virtue of minor peculiarities, much as we distinguish our coats from others hanging in a public wardrobe; but presumably only he or his intimates would so recognize it.

Garments decorated with this basic design, or its derivatives, must have been thoroughly familiar to many ancient peoples, who occasionally transferred them to imperishable materials. The reason for this transfer among the Australians isn't difficult to understand: robe designs were 'tribal' designs. Ultimately, they represented the tribe as an aggregation of human figures. More immediately, each design declared the tribe of the wearer and, when transferred to a shield or message-stick, identified the bearer of that object as well as if he wore that design on his robe.

In the 19th century, when such robes were still being made, European observers reported little beyond their impression that, as *waribruk* or *mombarai*, such robes were conceived by the natives as marks of identity or perhaps of possession. I suspect that this means little more than that these designs were customarily associated, perhaps in a loose sense, with the members of certain tribes. That is, they were 'tribal designs'—a term jusified by their composition, apparently without exception, out of human figures. Any hope that the modern successors of those who once made such robes can enlighten us about the significance of these designs is probably doomed to frustration.

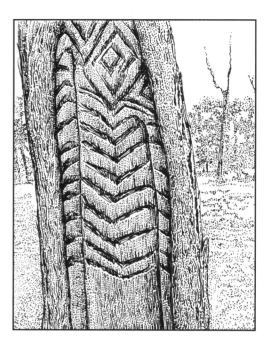

569

That the natives themselves have little to say about their own designs, except to recognize them, shouldn't surprise us. Traditional designs are tantamount to linguistic patterns. It's just as unreasonable to expect those who perpetuate such designs to tell us what they mean as it is to ask that homeless authority, the 'man on the street', to give us the etymology of a word he uses daily without reflection. The use of any language doesn't presuppose a knowledge of its history. That can only be reconstructed, in a measure, by a painstaking process of dialectal comparison.

The same is true of traditional designs like those applied to skin robes. If decorated skins severally & schematically represent social groups, as I think they do, we may reasonably conclude that stitching them together joins them in a larger social fabric, and the stitching itself symbolizes marriage ties.

My guess is that not only *564*, but already the paleolithic 'skirt' *525*, reflects a double system of social divisions. In both, the designs or 'blazons' on the panels vary from left to right, but not from top to bottom across the median horizontal division. Is this arrangement, which apparently survived an immense lapse of time, merely accidental & meaningless? If it has meaning, does it represent exogamous moieties cutting across other tribal divisions, dividing each unit again into two identical halves?

That animal skins compose such robes shouldn't be taken for granted. There may exist a significant relation between social groups symbolized by designs and by the animals whose skins bear those designs. This raises the question of totemic associations— not only in tribal Australia, but in early prehistory. And this in turn leads to the question of a totemic element in heraldry. Such an element may be implicit in the application of blazons to animal skins, eg on shields, just as it is explicit in 'bestial' motifs often associated with historic heraldry.

But to return to the designs themselves, one remaining motif, panel *565e*, appears so simple, it might be dismissed as merely decorative. Moreover, it finds no parallel in *564* unless cross-hatching be taken as such. Yet this tartan-like motif appears on other Australian robes, as well as on bull-roarers & shields. It belongs, I believe, to genealogical iconography.

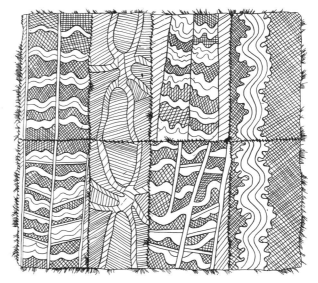

564

525

565e

The opposum-skin robe in *570*, one of several of its kind, was collected before 1860. Each of its eighteen panels has diagonal-lattice scoring interrupted by a scored band running horizontally (or vertically?). In some panels, the diagonal scorings tend to cut across this interruption, but in panel *570a*, the interrupting band is largely unviolated. Clearly the intention was that this transverse band interrupt the diagonals.

The remarkable straightness & spacing of these lines was achieved by folding the skin—matching folds, one after another—then scratching the folds with a sharp stone. Presumably the median band was folded first, and the robe-maker avoided crossing it with the stone tool when scoring subsequent folds.

I see an analogy, or homology, between Australian diagonal-lattice designs, *565e*, and clan emblems of Scottish Highlanders. Of course, modern Scottish tartans are woven on looms, and their clan-symbols differentiated by varying the colors of threads in the warp & weft. At first glance, this symbolism appears to be evolved from, and entirely dependent upon, a textile technique. But that appearance may

be deceptive. I think the association of this symbolism with weaving is an adaptation.

The idea of a 'social fabric' isn't contingent upon a textile technique. It vastly antedates the loom. The small variations in color which distinguish Scottish tartans correspond in their sophistication to the relatively small variations in the traditional devices of medieval heraldry, many of which, eg the chevron & saltier (St. Andrew's cross), may have evolved from a few basic motifs originally representing groups of human figures.

565e

570

◀

570a

Conceivably, the word 'plaid', meaning a Scottish robe with tartan design, derives from *peall*, skin or hide; and *peallid*, sheepskin. But even if this is not the origin of that word, pre-textile garments surely were made of skin. Records of early Highland garments are few, but several show compartmented designs. Though woven, those designs resemble composite skin garments.

Tartans long served as clan emblems, including in military units recruited from single clans. As late as 1859, Sir Colin Campbell, in the seige of Secundrabagh, called to Colonel Ewart: 'Ewart! Bring on the tartan!', and seven companies of the 93rd dashed forward.

Modern tartan combinations are largely 19th-century creations. Plaids were proscribed in 1746, after Culloden, on penalty of death. Nationalism led to their revival a century later. The resulting designs and color combinations are historically questionable, but the tartan motif itself is certainly ancient, in Scotland & elsewhere. Its resemblance to *565e* should not be lightly disregarded.

The four-line example in *571*, from the Middle Minoan period, Crete, was applied to a 'sacral knot', perhaps thus reinforcing the idea implicit in the overlapping lines. It's the earliest example I know, unless cross-hatching is a related form, in which case the tartan enjoys immense antiquity, eg *572*, an incised limestone slab from the paleolithic site of Parpalló, Spain, and *573*, its design counterpart from California. Conceivably, some cross-hatching may be an abbreviated form of that most common of all genealogical patterns: one composed of hockers.

Remember, when judging ancient analogs for *565e*, that its diagonal fascicules are cut off by the edge of the panel to which they were applied, the seamlines being horizontal & vertical, in contrast to the diagonality of the pattern. This particular feature helps us recognize similar designs scratched on pebbles in paleolithic & mesolithic Europe.

571

572

573

Chaco Robes, Argentina

Robe *574* comes from the Mataco Indians of the Argentine Chaco—an inhospitable region undesired & untouched by neighboring farmers. Even a preliminary glance at the robe's varied designs, painted on rectangles of otter skin, awakens memories of *564*, the Australian robe, and *525*, the Mezin 'skirt'.

Note the predilection in *574* for 'stacked zigzags'. These occur in *564D*; throughout *525*; and in *558*, the paleolithic engraved ivory from western Russia; and *557*, the paleolithic incised pebble from Italy.

I believe the transverse interruption of zigzags in *525* represents a stitched seam, as in *564D*. Although the zigzags of *574* nowhere continue on the other side of the horizontal seams, they are cut off by the edges of the panels on which they are inscribed, much as in *525*, *558*, *557* & *575*, a paleolithic inscribed pebble from Grimaldi, Italy.

A common peculiarity of the Chaco & Australian robes is blank (or hatched) wedges at the sides of the main patterns on many panels. That same feature occurs on the right side of the Côta stela, *518*. Evidently these compensate for miscalculations when patterns, ideally projected on rectangles, actually fail to fill them. Their occurrence on robes in Australia, Argentina & Portugal indicates a common characteristic of manufacture: the decoration of individual panels before assembly.

Such correspondences don't imply any direct relationship, but rather a relationship between living traditions of modern tribesmen and analogous traditions of robe-decoration in Eu-

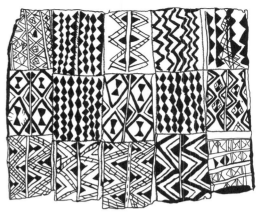

574

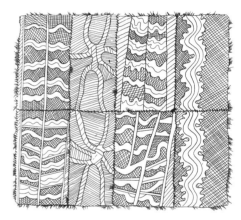

564

525

rope some 4000 years ago. The common origin of these traditions is the Upper Paleolithic. There we find indications of early development & fixation of basic types of schematic motifs. Only at the close of the European neolithic were traditional clothing designs extensively copied in stone on a monumental scale.

Among the 'stacked zigzags' in *574A/4*, the upper three largely parallel each other, but the lower three vacillate in relation to one another, as well as to the upper three. Obviously, these variations are due to carelessness, but about what was this designer so careless?

Whoever painted *574A/4* vacillated between *A*, limbs alone; and *B*, limbs with bodies.

558

557

575

574A/4

A

B

Other motifs on *574* betray anthropomorphic origins and Old World affinities. Panels *574B/3 & 574B/1* consist essentially of paired, aligned lozenges, each containing an hourglass figure. The framework of these two panels is probably the same as that of most of the other panels of *574*, namely opposed zigzags. If zigzags represent human limbs, then the lozenge-shaped opening between them presumably represents the bodies to which these limbs belong. So it's probably no accident that hourglass figures were inscribed between zigzags representing human limbs.

The essential similarity of the arrangement of *503*, the Tehuelche robe, to the split design of *574A/2*, and more especially to *518*, is self-evident. The columns of alternately upright & inverted, alternately integral & divided animal skins of *503* correspond to the columns of alternately upright & inverted, alternately integral & divided hourglasses (or quasi-hourglasses) of *518*.

If the split, interlocking columns of animal skins in *503* correspond to the split, interlocking columns of human figures in *518*, then *503* is older, in an evolutionary sense, than *518*, which surely derived from a pattern like *503*.

Intervals between alternate zigzags in *574A/2* are painted, thus forming a reciprocal pattern, vaguely reminiscent of *518*. Both designs are anthropomorphic; both split some elements vertically. Keep in mind that *518* is probably the painted copy of a reciprocal mosaic formed by the inverse interlocking of identically shaped pieces of hide or fur of contrasting colors. Reciprocal coloring and splitting may be concomitants of the same technique.

 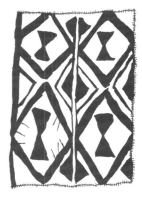

574B/3 *574B/1*

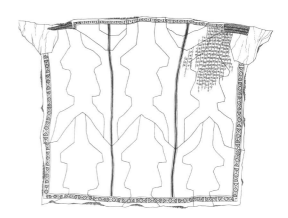

503

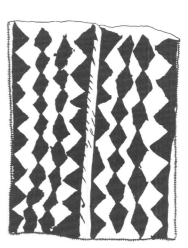

574A/2

518

As in paper cutouts of children, this technique involves a preliminary folding, then cutting from the folded material one half of the envisaged pattern, which appears in its entirety only after the cutout piece is unfolded. But if the original piece of material is rectangular, the cutting produces not only one bilaterally symmetrical cutout with the fold as its axis, but two asymmetrical halves of the same shape, their outer edges formed by the straight lateral edges of the rectangle. These can be thrown away, or salvaged & used.

A mosaic with reciprocal coloring presupposes that two layers of contrasting color were cut simultaneously, then the cutouts assembled alternately from the two layers. But if the material of both layers was originally rectangular in shape, the cutting would produce not only bilaterally symmetrical cutouts in both colors, but also twice the number of asymmetrical halves in each color, with their straight sides representing the sides of the original rectangles.

Such pieces (dark & light 'wholes'; dark & light 'halves') form a reciprocally colored mosaic, eg *518*. Incorporating 'split' halves utilizes all the material cut. Panel *574A/2* offers a remote reflection of such a reciprocal skin mosaic. Inasmuch as patterns of this type are cut with reference to a fold, they tend to be long & narrow. Reciprocal mosaics often serve as borders in modern cultures. Design *518* resembles an assemblage of sections cut from a border pattern.

Theoretically it's possible to cut all kinds of motifs out of skin, but historically the human figure was especially associated with this technique from early times, and persisted as a favorite motif for such cutout patterns in widely scattered modern traditions. The basic shape of these human figures was frequently an 'hourglass'.

The reason reciprocal patterns are so often—and perhaps basically—composed of alternately dark & light human figures may lie in the idea of the interaction of male & female partners in the social fabric. Many patterns based ultimately upon such a conception must have outlived the memory of their meaning. We may safely assume that the Chaco Indians weren't very clear about the ideas implicit in the designs they perpetuated, yet the archaism of the designs themselves is beyond question. In popular artistic tradition (as in language), forms often outlive their meanings. Yet lost meanings can sometimes be recovered through a comparison of forms.

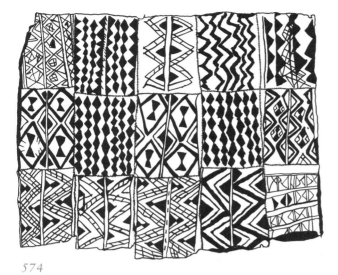

574

574A/2

Of the fifteen panels of *574*, eleven are 'split' by a median vertical division, generally in the form of two straight, parallel lines delimiting a 'blank band'. These aesthetically disturbing splits compete visually with vertical seams. The resulting disharmony suggests that vertical splits weren't invented by the Chaco Indians, but belong to designs the Chaco inherited from some earlier tradition, in which this feature originally had meaning.

I see the split in *574A/2* as an aperture between the straight edges of two pieces of a skin mosaic stitched to the foundation-layer of plain skin—with random lines within this aperture, perhaps representing stitches. Can this technological explanation account for the splits in the other panels of *574*, the designs of which are essentially linear and were presumably always applied to the skin, rather than cut out of it?

Compare *574A/3* with *576*, a panel from a modern Australian robe; and *577*, a typical 'schist idol' from a megalithic tomb, Portugal. Surely all three represent clothed figures.

I interpret the pairs of vertically opposed zigzags in *518* as representing the coalescent torsos or continuous limbs of columns of stacked human figures, in accordance with *Type 1* genealogical patterns. Essentially, these are ramiforms. Why, then, are they split in half?

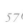

574A/3

576

577

It's easy to imagine conceptual reasons for splitting such composite human figures. But perhaps we should first seek an explanation in a technical circumstance. Such technical circumstance is at hand: already in prehistoric times, zigzag motifs derived from concatenations of human figures were applied especially to garments composed of rectangular panels, and zigzags were accordingly interrupted by seams that connected panels vertically or horizontally.

Zigzag patterns in *564* vary from compartment to compartment laterally, but not vertically. Conceivably, the split zigzags of *576 & 577* represent the fixation of one of the vertical divisions of a paleolithic robe in which, conversely, identical components were aligned not vertically but laterally.

Seams, I believe, symbolized marriage ties between clans or other social units represented by the designs on the panels they joined, while blank bands corresponded to the division of the tribe into moieties. If so, then the principle of social dichotomy presumably accounts for the splitting of *576 & 577*. If blank bands were simply seams enhanced by painted lines, it might be just as logical to represent this division by splitting the design of each individual panel, as by simulating a blank band across the whole robe and thus segregating its panel into opposed groups. Evidently this moiety division could be conceived in two ways: either as a major division cutting the tribe in two, or as a minor division within each of the smaller units comprising it.

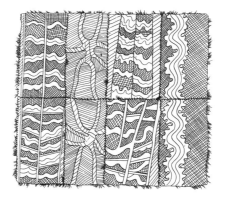

564

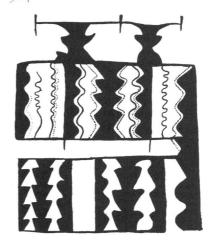

518

The panels of any skin robe can only be joined by stitching. Yet in many robes, eg *564*, there are two different modes of division among the panels: 'seams' and 'blank bands'. A seam simply joins one panel to another, while a blank band generally extends across the full width of the garment, separating panels into two groups above & below it, eg *564 & 518*.

But since the only possible means of connecting panels is by stitching, blank bands are probably simply seams enhanced by lines painted parallel to them, in order to indicate their relative importance in some social concept.

Compare the painted design on *574B/5* with the design engraved on *578*, a stone plaque from Argentina. Presumably the vertical & horizontal lines of *578* represent seams joining panels, each panel having a single set of opposing zigzags, as in *574B/5*, but lacking a blank band or central divider.

I infer that all divisions, whether between or within panels, referred—at least in principle—to social cleavage & union, and that the interplay & crossing of these two principles explains the divisions & subdivisions in these garments.

Although the simulated or painted seam in *574C/3* contradicts this thesis that blank bands were really enhanced seams, it does demonstrate the conceptual equivalence and close relation between these two modes of division. It also helps us to understand the 'confusion' between real & simulated divisions on the panels of this robe as arising from their conceptual equivalence. Actual seams and simulated splits should no more confuse us than primary & secondary quarterings in European medieval heraldry, to which these divisions probably correspond.

The practice of inscribing diagrams of social relationship on the skins of animals implies totemic ideas: in other words, identification of the social group with the animal upon whose skin it is projected. This idea may underlie many of the robes considered here. Totemism may also provide a key, ultimately, to certain schematic (and often anthropomorphic) designs applied to naturalistic representations of animals in Old World paleolithic cave paintings.

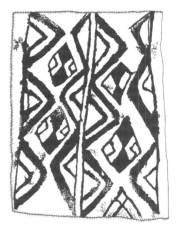

574B/5

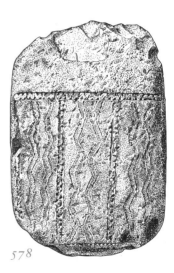

578

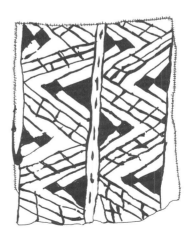

574C/3

But what are we to make of the splitting of the genealogical pattern which is effected by the splitting of the (presumably totemic) animal in such a way that human individuals are themselves divided in half?

This same question was raised earlier in regard to Plains Indian robes and I believe the same explanation can be offered: that the human individual is conceived as being himself 'split', or both split & joined, in the sense that he is the product of the marital union, or reunion, of representatives of two social sections. Simulated splitting of anthropomorphic patterns in Chaco & Australian robes would have the same meaning as the seams by which the panels carrying them are joined together: marriage between exogamous groups across a line of social dichotomy.

Splitting & stitching are thus inseparable correlatives of the social symbolism in terms of skin garments. The simulated character of median 'splits' in Chaco & Australian designs may reflect the ideal character of the social dichotomy, which divides human individuals into two halves, not in

actual fact, but only with reference to their origin or descent. The spinal column of the human figure thus takes on special symbolical significance as a line of division between the social sections united in the body.

If *175* & *174*, mesolithic painted pebbles from France are genetically related to *574A/3* & *576*, as I believe they are, they attest an almost incredible archaism for these modern robes. Moreover, the traditions which link them go back even earlier, to paleolithic times, *175* & *174* being themselves epigonous to paleolithic prototypes.

How were these traditions transmitted through so many millennia and across such vast distances? That question, so easily asked, isn't easily answered. Yet it's no more reasonable to demand an immediate archeological demonstration of historical connection than to expect a linguist to identify, say by phonographic recordings, the dates & places of the ramifications of a linguistic system, of which he nevertheless clearly recognizes the widely separated living branches.

175 *174* *574A/3* *576*

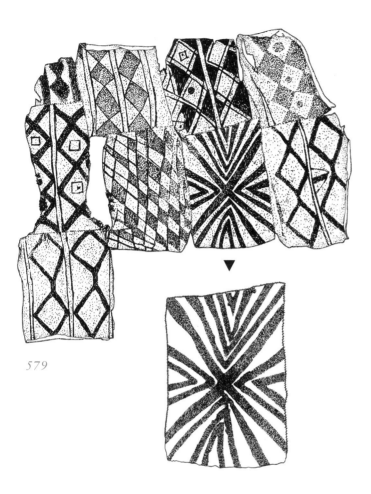

579

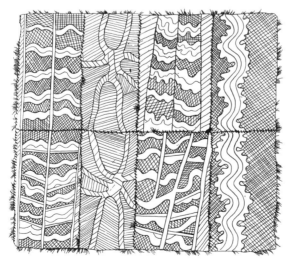

564

In at least one other particular, Chaco robes find distant parallels. Compare robe *579*, a Chaco assemblage of painted otter-skin panels, with *580*, a garment of antelope skin made by the Batwa, a people dwelling in the marshlands southeast of Bangweulu in Zambia—again an inhospitable, relatively inaccessible marshland.

The decoration of *580* is confined within a large rectangle laid out in the center of the antelope's skin and subdivided into smaller rectangles. These are occupied by various 'geometric' patterns, so chosen that each contrasts with all adjoining rectangles. This decorative scheme, so ill-adapted to the integral hide to which it is applied, shows a striking similarity, at least in general appearance, to Chaco robes, *579*, as well as to Australian robes, *564*.

The component parts of *564* & *579* were cut from the skins of small animals, decorated, then stitched together. Presumably *580* imitates such an assemblage, though in execution it was simply painted on a single hide. Transferring this decorative pattern from many small hides to one large hide may have occurred when the ancestors of the Batwa changed habitats and became marsh dwellers.

Rows of tiny triangles occupy two panels in the middle tier of *580*. These, too, have a long, significant prehistory, as well as a wide modern distribution, and may represent the ultimate débris of anthropomorphic hourglasses.

Most of the minute patterns in the rectangles of *580* have lost whatever anthropomorphism they probably once had, save for one exception, which has its precise counterpart in other skin robes, ancient *&* modern, eg *579*. For among the motifs painted on *579* and scratched on *580* is the motif of 'converging chevrons' or Saint Andrew's cross.

It will be recalled that this motif also occurs on Australian robes, eg, *566*; as well as in European megalithic tombs, eg *581*.

Design-wise, it's a simple motif. But its occurrence again *&* again on skin robes, with other traits in common, minimizes the likelihood of numerous independent inventions, and supports the thesis that it belongs to a very venerable tradition. Conversely, its recent recurrence in the traditional decoration of skin robes in widely separated regions supports the thesis that examples on stone *&* ivory represent human figures clothed in contemporary skin robes.

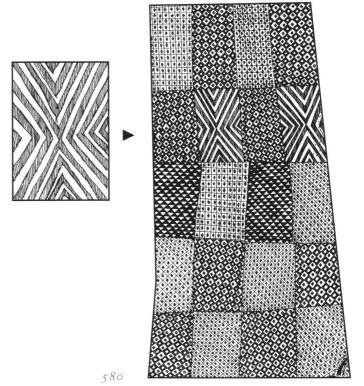

580

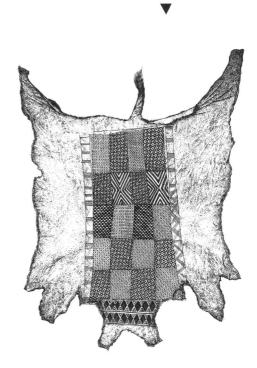

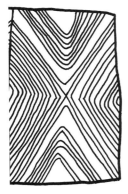

566

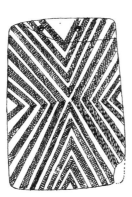

581

Argentina & Australia

Robe 582 is catalogued in the Museo Pigorini, Rome, as having been collected by the artist-photographer Guido Boggiani, in 1894 in the Argentine Chaco. Boggiani assembled an ethnographic collection from there. He also wrote and beautifully illustrated at least one book on his travels in that area. He never visited Australia. Yet 582 could easily pass for an Australian robe.

Most Australian robes were composed of opossum skins, though some were made of larger kangaroo skins. Chaco robes are made of either otter skins, smaller than the skins of 582, or red deer skins, roughly the size of those in 582. The pelts of 582 are catalogued as deer skins.

Chaco robes were generally painted in red ochre. Australian robes were scratch-decorated, with pigment sometimes rubbed into the scratches. In both cases, individual skins were decorated before being stitched together. And both shared one design peculiarity: a vertical band running through the center of many of the panels.

The most common Australian robe design consists of a lattice of paired, diagonal lines, sometimes interrupted by a median band, as in 570b.

The robe panels in 582, from Argentina, lack median bands but do have the lattices of diagonal lines. These were scratched into the skin without folding it. This was also sometimes done in Australia.

Schuster arranged to have a cutting of 582 sent first to the Deutsches Ledermuseum, Offenbach am Main, then to the Institut für Gerbereichemie an der Technischen Höchschule, Darmstadt. After comparisons & tests, it was determined, 'with some degree of certainty', that the pelts belonged to a species of red deer, just as the catalog stated.

The stitching thread of 582 is bast fiber; that used in 570 isn't the usual kangaroo sinew, but well-prepared linen thread, probably of European origin and presumably available to aborigines in the 1850's when it was collected. The few surviving Australian robes all appear to be late specimens, some of which contain string & cotton, their holes pierced with metal tools.

582

▼

570b

The native habitat of the red deer includes the Chaco region, but not Australia. The few deer imported to Sydney in 1803 failed to prosper. Farmers, suffering crop damage, shot them. This happened also in Queensland after their introduction during the 1860's in the rich Darling Downs region. In Victoria, even by the 1860's, deer were few and restricted in distribution. In any case, by the 1860's, the cooler southern lands of Australia—eg areas of skin-robe production—were already colonized.

If 582 comes from the Chaco, as I believe it does, it's a document of immense historical significance, attesting to the vast antiquity & distribution of a distinctive garment decoration.

582

The unformity of traditional decorations of skin robes of hunting peoples in Australia, Africa & America suggests a common origin. This origin, I think, lay in a single or at least fairly uniform culture of paleolithic times in the general area of Europe. Skin clothing must have been important among paleolithic hunters and, when decorated, a key factor in the diffusion of these designs. Many hunters must have been, at least for long periods, nomads whose possessions were largely limited to weapons & clothing. All their clothing need not have been decorated, but surely some of it was. And some of that decorated clothing, presumably, was worn by early migrants to the New World, across Bering Strait.

No remnant of such clothing survives, or at least has been identified. But, as we have seen, skin clothing with closely related genealogical motifs, arranged in *Compartmented Patterns*, survived among modern hunting peoples in Australia, Africa & America. I assume it diffused to each of these widely separated sources from a single source. This diffusion—really the dispersal of peoples—must have extended over many millennia and probably ended only with the extinction of traditional cultures.

Throughout this book I argue that, by paleolithic times, hunting peoples had already developed a schematic art made up of series of human figures, reduced to simple decorative forms and representing tribal groups in schematic 'genealogies'. They applied these designs to their own bodies, either directly by painting or tattooing, or indirectly in the decoration of garments. I see the scratched decorations on Australian & Chaco robes as modern survivals of this ancient tradition.

Australian & American robes aren't the only windows opening into deep time. Archaic customs & traditions also survive elsewhere, eg the Arctic, Oceania, etc. But by far the best evidence comes from the southernmost part of the New World.

Until recently, the very thesis of the Old World origin of New World cultures has been regarded in some quarters with great skepticism. Prejudice still surrounds the investigation of such connections. Remoteness of the New World from early centers of cultural impulse in the Old World seems to preclude comparison. Yet this very feature justifies it most. The extreme isolation of the New World, and especially of the remoter parts of its southern continent, evidently favored the survival of archaic cultural traits. I see certain artistic manifestations of the tribesmen of the Chaco as equivalents, in many respects, to those of Australia—and both of them as basically related to certain analogous cultural manifestations in Africa. Contrary to expectations, the New World provides keys to unlock some of the most baffling enigmas of Old World prehistory.

Baldwin Spencer, pioneer ethnologist among the Aranta of Australia, went to Tierra del Fuego at age 69 to compare Aranta & Ona religions. He wondered if these two belief systems, surviving at the ends of the two longest trails, had much in common. The answer eluded him, for shortly after landing, he died. The Ona soon followed.

Incised Stones

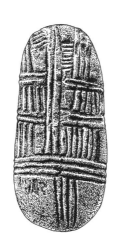

*Three paleolithic
incised pebbles, Italy*

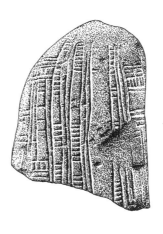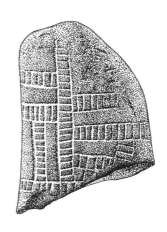

Patagonia

Let me begin where Baldwin Spencer died, at the end of the longest trail. Patagonia has many incised, anthropomorphic stones, known locally as *placas grabadas*. Though lacking anatomical features, they reveal their anthropomorphism in garment designs. These often take the form of complete genealogical patterns or excerpts from them.

The lower half of *583* is a *Reciprocal Hourglass Pattern* comparable to the robe design in *255*. The upper half shows a *Compartmented Pattern* with rising zigzags flanking blank bands.

If we treat the incised decoration of *584* as the cutting-line for a bichromatic skin mosaic, we obtain a reciprocal pattern of interlocking, vertical & erect human figures.

Compare *585 & 578*, both from Patagonia, with two panels from *574*, the Choco robe.

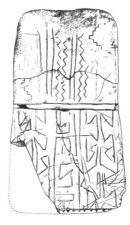

583 255

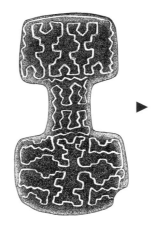

584

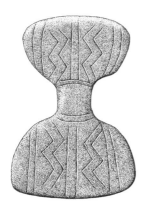
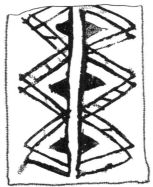

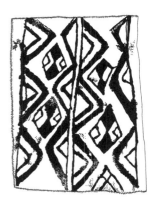

585 574 578 574

That same motif of rising zigzags flanking blank bands is seen on the 'front' of *586*. On the opposite side are designs comparable to those on *575*, the upper paleolithic pebble from Grimaldi, Italy. The painted robe of a Tehuelche of Patagonia, *587*, offers a possible explanation for both, as well as for the zigzags on *588*, also from Patagonia.

Patagonia's earliest, recognized incised stones date from the 6th millennium BC. Yet a Clovis site in Texas, dated 10,200 BC, produced many. Patagonian examples of comparable date may simply await discovery.

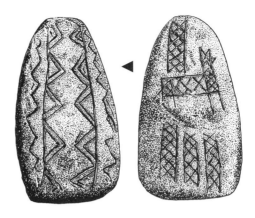

586

575

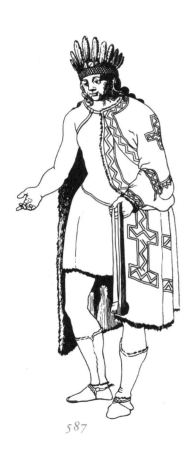

587

588

It's worth recalling what is known, or at least believed, about the First Americans. Passage through the quarantine of northern regions probably left these newcomers in top physical condition. When they 'came in out of the cold', they entered Eden. Vast herds, many of species soon to become extinct, filled both continents. No residents contested settlement. A population explosion surely followed.

Add to this the likelihood of adventure, each generation exploring for itself, the way Eric the Red settled Greenland, then Leif, his son, sailed to America.

If you start in Asia, it's a long walk to Patagonia. Yet immigrants may have made this trip in under a thousand years, perhaps in half that time.

By 10,000 BC, hunters with a paleolithic legacy were thinly but widely scattered on both continents. I assume that vestiges of this legacy survived into later periods, including methods for preparing & decorating skin garments. So it should not surprise us to encounter Old World garment designs incised on New World pebbles.

Compare *589–591* & *572*, Magdalenian stone plaques from Parpalló, Spain; with *592–594*, more recent examples from California. I see all these compartmented designs as imitations of scratched designs on skin panels, eg *570*, from the Australian robe.

589

590

591

572

592

593

594

570

Paleo-Indian groups introduced into the Americas the custom of dressing pebbles and maintained this custom until recently, especially in the Great Basin region and Patagonia. Both areas are rich in examples. One California archeologist found 1278 complete or fragmentary specimens in a single trench. Local collectors specifically search for them.

But the custom of dressing stones wasn't confined to the New World. In fact, the only large areas where incised stones aren't found are Africa south of the Sahara and between northern Mexico & Argentina.

We find a few Australian examples, both early, 595, and late, 596. But it's puzzling we don't find more, especially considering the role of *churingas* in historic times.

Examples from Easter Island, though anthropomorphic, 597, seem more sexual than vestimentary.

Stone 598, from mesolithic China, offers a familiar compartmented design. Stones 599 & 600, from Japan, were associated with very early neolithic 'Jomon' pottery. The anatomical details of 599 are unusual for incised stones generally, but here co-existed with more conventional forms.

Europe, North Africa and the Near East contain many conventional examples. I think that number will greatly increase as archeologists, now aware of these delicate, fragile engravings, begin to examine closely all unworked pebbles and refrain from scrubbing them.

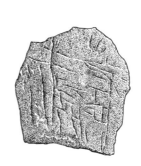

595

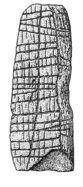

596

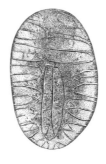

597

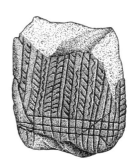

598

599

600

A peculiar marking, especially common in the Great Basin area and California, but also found, at early dates, from Alaska to North Carolina, merits close attention. This marking is achieved by 'walking' the edge of a burin or chisel-like implement of hard stone over the surface of a softer stone, and pressing down (tapping?) alternately at the two outer angles of the burin at each 'step'. This produces a double (or multiple) row of minute ticks at regular intervals. Various intermediate marks between the outermost ones in each horizontal group of the vertical series are caused by adventitious irregularities in the sharp edge of the burin.

This can easily be reproduced on a brick with a flint burin, but it's far more difficult to achieve on hard stone.

The number of points on the chisel blade (which evidently often had an irregular edge) determine the relative simplicity or complexity of such markings. These markings might be variously combined with, or deepened by, engraved lines to produce still more complex effects. The skill developed by some of the practitioners of this technique is amazing.

The polyhedral stone in *601*, from northern California, displays at least four distinctive patterns produced by this technique on four of its facets. Pebble *601* is especially puzzling because, unlike most examples, it is extremely hard.

Some examples resemble, by chance, minute dendritic patterns, ie plant-like figures produced on or in stone by a foreign mineral. Could the 'stalk' of such a 'dendritic' design be produced by dragging one point of the

601

chisel continuously while the other is successively lifted & tapped, as in certain forms of tattooing?

Walked-burin designs are common in stone, yet the technique itself hardly seems appropriate for stone. A softer material, say antler or bone, would seem more suitable. We have just that: a mammoth-bone tool from a Clovis 'tool kit', Richey site, Washington, circa 11,200 BC, bears such a mark. The characteristic 'zipper' design appears on a bone arrow from Trail Creek, Alaska. Similar marks appear on a sequence of specimens in central New York State, from 2600 BC–AD 900, and earlier in North Carolina. Markings made by this technique strongly resemble those found on mesolithic bone specimens from northwestern Europe.

Incised stones, when found today, are often broken and, even when complete, usually have highly abbreviated designs. This creates an impression of kaleidoscopic diversity. That is not the case. On the contrary, the vast majority share a handful of simple designs, with variations, of course, that exhibit remarkable similarities over vast distances & times.

Gorget *602*, from New Jersey; *603*, from California; and *604*, from New Brunswick, each divide roughly into three zones. One side of *602* shares bunched fringes with *603*, while its reverse side shares the same general design as *604*.

Stones *605–609* come from France, Idaho, Alaska, Utah & Texas. I assume each represents a man wearing an open robe, plus an apron.

602

603 *604*

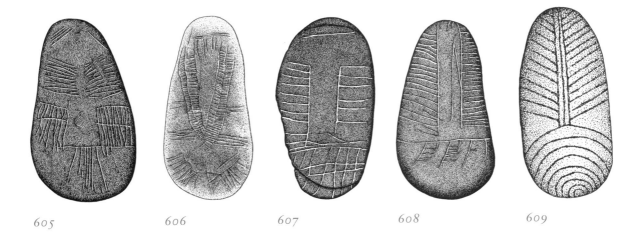

605 *606* *607* *608* *609*

Even when fragmentary and reduced to shorthand, complete designs aren't difficult to reconstruct, even for us, and they must have been obvious to those for whom they were intended. The overwhelming majority duplicate traditional body & garment decorations.

Compare *610*, from California, with *611*, a petroglyph in Death Valley; and *612–614*, also from California, with three panels from *574*, the Choco robe.

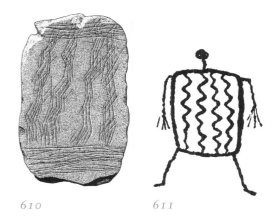

610 *611*

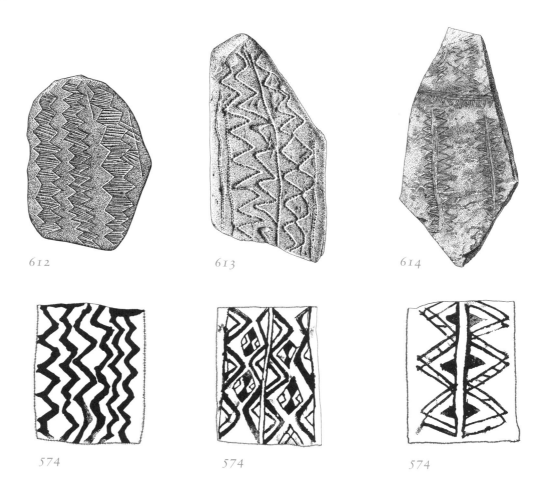

612 *613* *614*

574 *574* *574*

Stones *613* & *614* bear the familiar motif of rising zigzags flanking a blank band. This 'split tree' remains, even today, a common body decoration throughout much of the tribal world. It was especially popular in mesolithic Europe, engraved on bone; and equally popular in North America: *615* & *616*, painted pebble & pictograph, California; *617–619*, incised stones from the Great Basin; *620*, New Brunswick; *621*, Maine; *622*, Ontario; and *623*, Alaska.

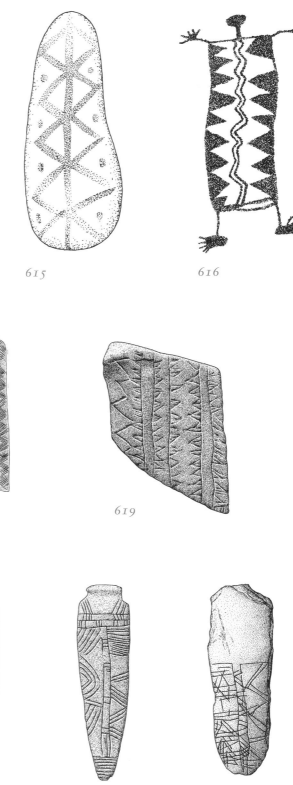

615

616

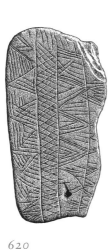

617

618

619

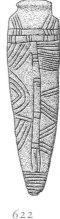

620

621

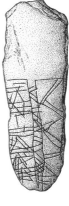

622

623

Most incised stones, especially early examples, limit their human identity to body & garment designs. Even when garments & ornaments are clearly rendered, anatomical features are shunned, eg 624–626, from California & Nevada.

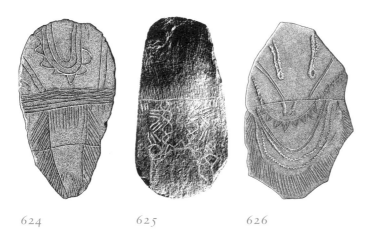

624 625 626

Exceptions include very late specimens from Alaska, 627; Utah, 628; and Texas, 629. But, in each case, these more naturalistic examples co-existed with designs limited to heraldic devices.

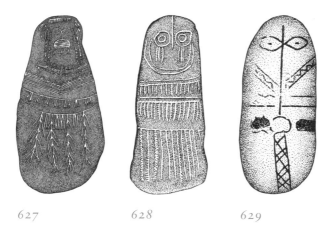

627 628 629

I doubt that conventionalization over many millennia explains this feature, for the oldest examples resemble some of the youngest. Function offers a better explanation.

Anthropomorphic pebbles were never intended as portraits of the living, nor likenesses of the dead. Their designs were corporate, not private. Tribal members were depicted as interchangeably alike. Private features were omitted. As with kinship systems, focus was on categories, not on individuals.

Even details are often alike. Note the 'straps' on 624 & 626, a common feature in Nevada & neighboring areas. They also appear on 622, from Ontario. Shared garments? Remembered art?

Anthropomorphic pebbles reveal loosely-linked traditions, probably converging ultimately at some unknown point in distant prehistory, when such things had consciously-known meaning. That meaning, in the course of millennia and untold migrations, has been largely lost. But not equally so everywhere. In various places in the New World, incised stones were consciously intended to represent clothed human figures. These examples presumably hold the clue to the original meaning of the type, even though it's difficult to discover the intention of the actual engraver.

I suspect that basically all incised stones, in both the Old & New Worlds, are related to Australian *churingas*. A *churinga* is the equivalent of an individual's soul. It mythically embodies a life-force inherited from an ancestor. In other words, *churingas* are something like people.

As this tradition spread, form out-lived meaning. Some incised stones, at least in North America, may have served as gaming counters. But basically and nearly everywhere they seem to have retained their original role as ancestral images, though not necessarily their highly sacred nature.

Decorated stones are sometimes found in caches or assemblages. This recalls the accumulation of *churingas* in hiding places by aborigines who sought to increase power by multiplying them, somewhat as in gambling.

Thus a hoard of *churingas* symbolized an assembly of ancestors—a tribe, perhaps, or some other social unit—gathered to protect their living descendants. The larger the number, the greater the power.

Essentially this same 'assembly' occurs on composite robes bearing heraldic devices, eg the Choco robe, *574*. Compare this to *630*, two pages from the armorial of the town of Como, Italy, 1593. Here the arms are arranged by alphabetical order of the families' names.

The man who wore *574* 'put on' his tribe. Anyone who puts on a uniform or wears a mask or plays a role, divests himself of private identity. To wear a uniform is to assume a corporate role.

A performer steps into a role the way he steps into a costume. He 'puts on his audience', takes his identity from that audience, then re-presents that audience to itself.

True, *630* was never worn, but other examples were, for European nobles clothed themselves, their attendants, even their houses, in heraldic devices and so did many tribesmen.

574

630

With roots in the paleolithic and branches among the living, genealogical iconography can be understood only within a very wide and historically deep framework. This is especially true of pebble designs: simple, reduced to shorthand, executed casually, yet some of our best evidence.

Clearly these pebble designs resemble heraldic body & garment designs. Moreover, body, garment & pebble designs often employed the same tools & techniques.

Thus the 'walking-burin' left the same mark on skin, stone & bone. Pebbles were incised the way human skin was scarified, and scratched the way skin garments were scratch-decorated. Then both pebbles & garments were dusted with red ochre. Australian aborigines incised stones 'to make them bleed' and filled those incisions with ochre.

Human & animal skins were decorated alike. Needle-and-thread tattooing employed the same stitching technique used for waterproof clothing and 'invisible' decorative seams.

Hides were sometimes decorated by incising a design on them, peeling away alternate areas of the upper layer, then dusting the whole with ochre which adhered to the raw underlayer. With stones, a dark pebble with light coating was incised, alternate areas of the outer surface chipped away, then dusted with ochre.

This pattern of correspondences suggested to Carl Schuster that 'dressed' stones represented, originally, ancestral spirits, comparable in many ways to Australian *churingas*. In designing these stones, engravers ignored anatomical features and focused on social devices copied from garment & body decorations. In other words, stones & bones incised with social devices, as well as those simply notched around the periphery, are basically & universally human effigies, accumulated with definite purpose. Australian *churingas*, he believed, provide our best insight into that purpose.

Few agreed. Carl assumed his readers knew a great deal about genealogical iconography. They did not. Where he recognized, even in fragments, heraldic devices, they saw 'geometric' decorations.

Moreover, his broad comparisons disturbed them. When he traced a memory-link from yesterday back to paleolithic times, they scoffed. They recognized no medium of transmission. But the medium was living people.

Art, as transmitter, shares much with language. Ideally, a language is a storage system for the collective experience of the tribe. Every time a speaker plays back that language, he releases a whole charge of ancient perceptions & memories. This involves him in the reality of the whole tribe. Language is a kind of corporate dream: it involves every member of the tribe all of the time in a great echo chamber to which each speaker constantly adds new sound tracks.

In this great echo chamber, like gives life to like. The dead are always with us, just as tribal elders say, and the simplest habits transcend generations & millennia.

'Come, sit beside me. Do as I do', says the basketmaker to her tiny daughter. 'Stand behind me, and do as I do', says the dancer to the novice. Not tombs, not libraries, but living people are the great repositories of tradition.

A small, conical shelter of piñon & juniper logs, *631*, nestled in a trough in the Panamint Mountains, California, was once the central feature of a tiny camp, probably Paiute.

Bale-wire still lashes the crossbeams to the centerpost. A soldered tin can, 5-gallon tin oven and metal buckets date its occupancy to the turn of the century, while a metate & maño suggest piñon collecting.

Four incised stones, all fragmentary, eg *632*, were recovered here, as well as a chalcedony flake, probably used to engrave them.

In the long history of incised stones, is this lonely mountain camp the final record? If so, it couldn't be more appropriate. Historic tribes of eastern California were mobile foragers whose way of life, in many respects, preserved habits & attitudes little changed, I suspect, from paleo-Indian times.

632

631

Rebirth

*Tibetan,
'Lord of the
Graveyard'*

Tribalism vs Individualism

What impresses me most about incised stones is their lack of personal identity. They certainly aren't portraits. They don't record So-&-So in such & such year. Their human identity is corporate.

This parallels early evidence. Paleolithic artists shunned personal identity, except on rare, rare occasions, eg *633*, a minute figurine from central Siberia, circa 8000 BC. Similarly, Eskimo artists were quite capable of making a good likeness, eg *634*, from Canada, circa 1800 BC, but rarely chose to do so. They preferred stereotyped, interchangeable images.

This applies to tribal arts generally. Several accounts tell of African tribesmen visiting funeral shrines to honor their parents, only to find themselves unable to identify their parents' images, for all the figures were of a kind.

Medieval Asian & European religious art made this same distinction between outward appearance and inward reality. Artists took as their subject the spiritual essence of man, not his mortal body. Religious images lacked private identity. Tribesmen went further: their anthropomorphic pebbles lacked even heads & limbs.

Many tribal artists focus on being, not becoming. They favor essence, not existence. They conceive of a single essence, found in everyone, but not unique to anyone. At death, it returns to its source, which is the First One. While in this world, it enlivens one body after another. Though president at every birth & death, it is itself never born and never dies.

633 *634*

In theory, at least, and in certain formal theologies, eg Hinduism, this immortal soul should not be confused with the private self which is accorded no perduring reality. The spirit is said to return to its source, and the dust to dust. Only the First One transmigrates.

Yet in daily thought, many tribesmen regard soul & self as inseparable. This identity, they say, experiences endless lives. The dead go to another place, but only temporarily, then return to live in new bodies. All living humans are simply reborn ancestors. This is the preferred belief of many tribesmen today and presumably was in the past.

Coincident with the rise in individualism and the fading of tribalism, belief in resurrection replaced belief in reincarnation.

With resurrection, each soul knows but one life, one death, one identity. Salvation depends upon the deeds of that once-and-for-all lifetime. Conversion to resurrection converts kin-group members into private individuals, their deeds now divinely judged.

These might seem trivial matters, but actually they denote a tremendous shift in perspective. Anthony Jackson writes: 'It is hard for us to see this difference because we think [tribesmen] were mistaken and should have known better'.

Eskimos offer a classic example of traditionalists who believe in reincarnation. They see all life as eternal, played out in this world and no other. The dead, they say, are always with us, reincarnated in new bodies.

Death is like sleep: in both cases the body reawakens. The soul periodically vacates each temporary home, then re-enters the next. Continuity is guaranteed.

Eskimos traditionally shunned the names of the dead until these were reincarnated. A tribe took its identity —its everlasting identity—from those names. An old woman stood by a woman in labor, reciting eligible names. When the infant appeared, the name that called it forth identified it.

Elderly traditionalists still assert they lived before and will live again: 'When one returns, beware! (old man, mocked); 'Our son comes, betrothed' (girl named after first wife, addressing her father at the approach of her half-brother).

Until missionaries arrived, there was no theme of soul jeopardy, no retributive judgement, no observances for salvation and, of course, no Heaven or Hell.

As for burial offerings in Old Bering Sea and Ipiutak graves, that's late Asian influence, like the art itself, which is metal workers' art done in ivory. Burial goods were probably prepared in advance by specialists. Death masks reflected a Chinese death cult. At the Ekven site on Bering Strait, girls may have been sacrificed for hunters who died at sea. Not really Eskimo.

Even today many Eskimos remain relatively unconcerned with after-life. Cessation of the heart beat remains but part of the cycle of life & death where, sooner or later, the body disappears as an entity, and the soul re-enters the cycle.

The why of all this doesn't concern them. They merely assert that death is not an end, but a beginning—a beginning of a new phase in a never-ending cycle. They meet the problem of death by denying the problem.

This may be more denial than conviction and some, like us, may fear death's finality. Still, they maintain they can run all risks, squander their lives, scatter their possessions, because they are immortal. They insist there is life beyond death, beyond the corruption of the flesh—beyond every evidence of the disappearance of the body.

Life, they seem to be saying, is superior to time. It cannot vanish, because death, like birth, is an event in time, and life is above time. This conviction is so strong & unshakable as to deny & defy the fact of death. To them, death is never an inevitability, obedient to natural laws. It is the work of a broken taboo or deity or witch— dependent upon individual, fortuitous causes.

A concept of death, as something conforming to unalterable natural laws, Eskimos never recognize. Nor do they recognize death as an ultimate end, as a final stop in the journey of life. The entire notion of man as mortal, by his nature & essence, is alien to them. They see death; they reject it. They regard it as only an episode along an unending trail.

Inversion

Were such views shared by paleolithic peoples? Possibly. Those familiar with the art of the Eskimo from earlier times, as brought to light by archeologists, have often noticed strange resemblances between this art and that of the prehistoric hunters of paleolithic times in Europe *&* Asia, whose way of life must have been, in many respects, like that of the modern Eskimo. The gap in time between even the earliest horizon of Eskimo archeology and the Upper Paleolithic of the Old World is enormous; yet the resemblances are unmistakable, and one cannot escape the impression that the Eskimo have in their art, as in other aspects of their life, somehow perpetuated paleolithic traditions into recent times.

Paleolithic figurines *635 & 636*, from France and European Russia, hung upside down. So did *637 & 638*, both from Malta, a late paleolithic site in central Siberia.

Not all paleolithic figurines were perforated in this way. But many were and those that weren't may have been attached by adhesion. Suspending them from their feet, presumably on necklaces or as single pendants, was clearly an established custom throughout wide areas in Eurasia, from Aurignacian through Magdalenian times. This practice continued in eastern Europe, the Near East, Polynesia-Indonesia, and especially arctic Canada-Greenland.

Figurines shared more than inverted suspension. Facial features were generally omitted, though not always. Arms were minimal or absent. Legs tapered to a common point. Buttocks suggested steatopygia.

635 636

637

638

Most Canadian-Greenlandic examples, eg 639–642, belong to a relatively late phase of Eskimo prehistory, the Thule culture, AD 900–1300. But one especially fine example, 643, appears to be a product of the antecedent Dorset culture which flourished in these regions 800 BC–AD 1300. Whether they were worn singly or alone, I don't know, but a small excavation near Igloolik produced several, much alike, raising the possibility that they were worn together. Moreover, pendants with two, even three inverted figures, eg 642, look like excerpts from necklaces.

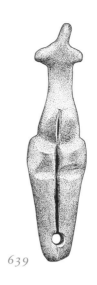

639

640

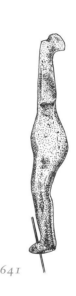

641

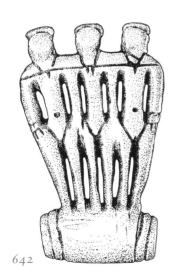

642

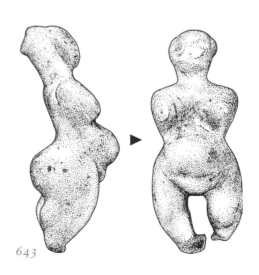

643

Eleven pendants of lignite, 644, from southern Germany, belong to the terminal Magdalenian, circa 8000 BC. Since they were found together, it's been assumed they formed a necklace. Larger pendants were perforated; smaller pendants were presumably attached by adhesion. The expansion just below each perforation, on the same side as the buttocks, must represent the calves. Which means these figures hung upside down.

Clearly the inverted-female pendant, singly or in graduated series on a necklace, persisted for many thousands of years in paleolithic times and into later eras. Eskimo examples originated, I believe, in the Old World paleolithic, not in neolithic times, and survived in the North until very recently.

The prominent feature of all paleolithic images of women is steatopygy, eg 645. Paleolithic artists presumably imitated nature. Eskimo artists presumably imitated art, for modern Eskimos aren't steatopygous. Thule artists retained the steatopygous form by emphasizing boots, eg 639, or amply endowing models. Compare 646, a paleolithic figurine from Italy, with 643, the Dorset figurine from Canada. Other Thule artists simply ignored this feature.

Such images survived into mesolithic & eneolithic times in Europe and the Near East. Consider 647, from Catal Hüyük, an early neolithic site, 7th millennium BC, Anatolia. Each bead, carefully examined, reveals an image of paired, steatopygous buttocks perforated for inverted suspension. Debased pendants resemble birds.

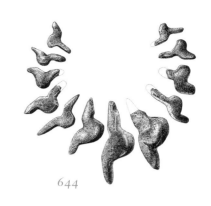

644

645

646 643

647

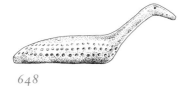

648

649

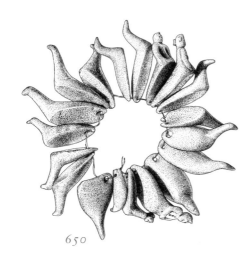

650

Ancient carvers, as copyists, may themselves have fallen into this misinterpretation. I see this as the origin of Eskimo images of swimming ducks, 648. Some had human busts, 649. Both types were popular from Alaska to Greenland. Eskimos used them in a game of chance, *tingiujaq*. They often perforated each bird at its tail and then, to store them, strung them on a cord—from which they hung, head down. Strung sets resembled necklaces of female images, 650.

The inverted human figure occurred in Polynesia, both in naturalistic form, eg 651; and in more abstract form, eg 652. Neighboring Borneo had entire necklaces of inverted human figures, eg 653.

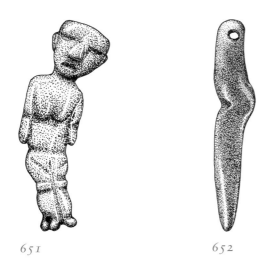

651 652

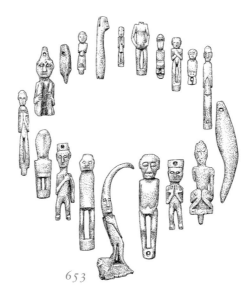

653

654

655

656

I see inversion as a means of indicating that figurines represented dead persons, ancestors. I think they were worn to invoke ancestral powers for the protection of the living. Such effigies weren't confined to necklaces. The grave house in *654*, on the Amur River, eastern Siberia, has inverted human *&* animal effigies, all highly stylized, hanging from protruding beams. Similarly, the figures surrounding *655*, a Haida house-model, British Columbia, are inverted, as are those in *656*, a New Guinea house-model (beam *&* figures enlarged in this drawing).

Necklace or house, the symbolism remained unchanged: a protective border of ancestors guarding the living, sometimes encircling a human neck, sometimes encircling a ceremonial house.

According to the natives from whom a missionary collected *656*, the two hanging figures represented particular members of the tribe who had recently died. This implies that it was the spirits or ghosts of the deceased whose apotropaic power was thus invoked for the protection of the building. No disrespect for the dead was intended by this inversion of their effigies: inversion simply showed that the persons so represented were deceased and had, in other words, become ancestors—for among tribesmen generally, ancestors are the chief protectors of the living.

Here then, we have as nearly as we may ever come to it, an explicit statement for the inversion; and it seems to me reasonable to extend this explanation to other manifestations of the phenomenon, not only locally, but to a much wider horizon.

In many parts of the world, the dead are shown inverted. Two wooden heads with human hair, *657*, were originally secured, upside down, on either side of the entrance to a Tlingit house, Alaska. They commemorated the killing of slaves when the house was erected.

In *658*, inverted human heads, with wool 'hair' hanging down, turn a Tsimshian Indian robe or 'Chilkat blanket' into a genealogical statement.

Some of these images represent dead enemies or sacrificed victims. But *659* illustrates an Indian gravepost engraved with the personal totem-animal of the dead man—suggesting that inversion was associated not only with the death of enemies, but also with that of ancestors. In *660*, the deceased himself, a Bella Coola Indian, is shown inverted.

Diogenes, when death was approaching, was asked as to his burial and replied, 'Bury me face downward for everything will soon be the other way up'.

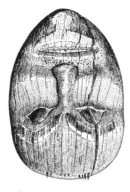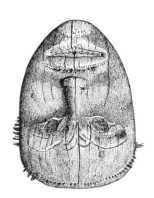

657

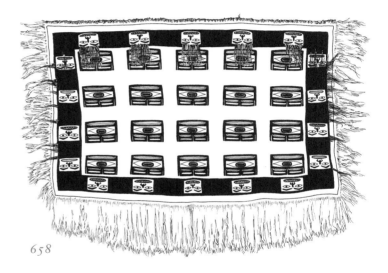

658

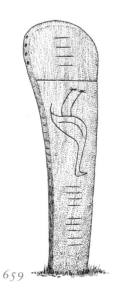

659

660

Certain Siberian tribesmen speak of an inverted Afterworld. To the Karen of Myanmar, the world of the dead is the land of inversion. The Toradjas of Celebes have an elaborate funerary symbolism based upon an idea that death is literally an inversion of life. Several groups in Borneo consider everything in the Afterworld to be inverted. The carved post in *661* comes from an ancestral house of the Yami, Taiwan.

I am particularly interested in this imagery on posts. Stacked heads are alternately erect & inverted on both *220*, from a Nias chief's house, Indonesia; and on *4*, a Y-post from New Guinea. On *662*, a stone pillar from a Celtic cemetery, France, the bottom head is inverted.

661

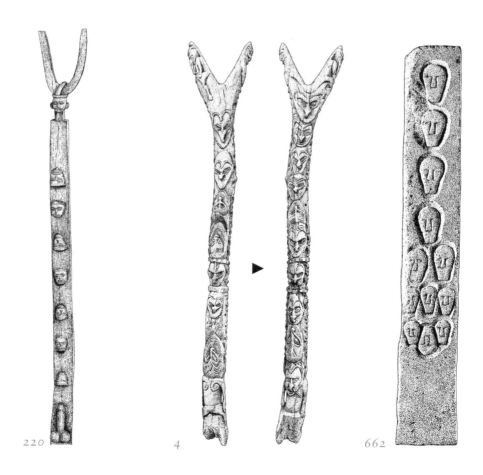

220 *4* *662*

Even in our own culture, this symbolism still plays a role in funeral ceremonies, especially for prominent persons. Soldiers stand at attention with inverted rifles; a riderless horse with reversed (if not inverted) boots follows the catafalque in the funeral procession, eg *663*; even a national flag may be flown upside down, as was done in the funeral of King Paul of Greece in 1964, *664*.

663

664

These observances aren't exactly the same thing as carving *&* wearing inverted effigies of the dead, but I think they ultimately go back to the same idea: that death is an inversion of life. And even if wearing inverted images about the neck seems to us a strange way of honoring the dead and invoking their protecion, it's no stranger than the custom of some tribesmen, eg in Australia and the Andaman Islands, to carry the actual bones of their deceased loved ones about on their bodies.

It remains to explain why ancestors were conceived as inverted. I think part of the explanation lies in cosmic games of rebirth, played on the body of a Primordial Ancestor. When 'fate' or chance allowed a player to fill each joint-mark on an image of this god, its figure (if portable) was then reversed; or the player reversed himself, if the image was executed as an earth drawing large enough to enter.

Reversal symbolized the departure of the soul from this world and its arrival in the next. The deceased, having achieved reunion with his primary ancestors (represented as joint-marks) or with the First Being (represented by the figure), was now re-membered, and therefore eligible to rejoin the living. There, in limbo, the soul awaited rebirth, head down, in the position of normal delivery.

By contrast, an 'un-remembered' ghost remained on earth, erect, haunting the living, seeking vengeance for its death, unable to accept its dismembered state.

Perhaps it was in terms of these ideas that paleolithic *&* later tribesmen wore these beautiful images dangling from their necks.

Rebirth Gaming Boards

Diagram *665* an Indian gaming board called 'Ladder of Deliverance', represents the world system of the Jains. Each compartment symbolizes a reincarnation, while snakes & ladders symbolize the hazards of Fate: ladders connect good rebirths, snakes connect bad rebirths. Dice (Fate) determine each move.

Players advance, beginning at the lower left, and proceed upwards, reversing direction in each row, passing through various reincarnations. A player who lands at the bottom of a blue ladder, climbs to the top of that ladder; if he lands on the head of a snake, the snake swallows, then defecates him.

From the 81st (9x9) square, a ladder leads upward across the face of a cosmic being (Lokaourusha?) and out of the system of rebirths for final escape (*nirvana* or *moksha*) from Earthly Existence (*samsara*).

This game is played in various parts of India, Persia & Tibet. Details vary locally, but generally it's played on the body of a human figure or god— usually *the* god. Points on the body of this deity, attained by players, in one way or another determine their fate. Passing through the deity's head (shown at the top of each diagram) symbolizes release from further incarnations. In short, this transmigrational diagram is a metaphysical diagram of the First Creation.

The ladders of *665* can be equated with Heavenly Ladders by which souls ascend the *axis mundi*; and the snakes with Cosmic Reptiles who swallow neophytes and dead souls, pass them through their joint-marked bodies, then defecate or vomit them, reborn. Escape from earthly existence appears to be simply a specialized, Indian adaptation of the more traditional goal: rebirth.

665

666

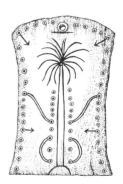

667

Such rebirth gaming boards had their counterparts 4000 years earlier in Egypt and the Near East, *666 & 667*. Players inserted pegs into anthropomorphic gaming boards, starting below one or another 'eye' (gaming boards were often called 'Evil Eyes'). Each player proceeded down one side of the 'trunk', then up the 'spine' toward the goal, shown as a common basin at the top. A player who landed in a hole marked by a short horizontal line lost one turn; a player who landed in a hole connected to a diagonal line moved to the opposite end of that line. Thus diagonal lines acted as both snakes (demotion) and ladders (promotion).

Sometimes the human trunk becomes a tree trunk, *667*. In genealogical iconography, human *&* aboreal charts are interchangeable.

I see no reason to limit this game to ancient Egypt. Even there, such diagrams were probably already ancient. Presumably the earliest diagrams were earth drawings, many of which represented, as do so many later examples, gods, men or Cosmic Reptiles.

The gaming board in *668*, from Gezer, Israel, has been called a representation of the 'Queen of Heaven'. Queen, perhaps; but Heaven, never. This creature of mixed human/reptilian anatomy never reigned in Heaven, nor lived on earth, but resided Below, in darkness, from the beginning.

The gaming board in *669*, from Egypt, rests on the back of a baby hippopotamus; while the Alexandrian or Coptic divination lamp in *670*, takes the form of a human frog with twelve joint-marks.

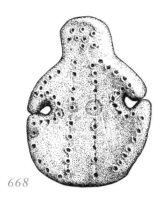

668

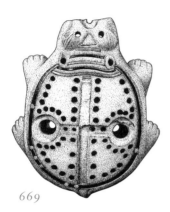

669

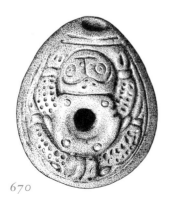

670

Each of a group of ivory gaming boards from Megiddo, Israel, circa 1300 BC, eg 671, has the body of a human turtle. Note the central 'hourglass', a motif widely used in ancient & tribal arts to represent a female ancestor.

Now compare 671 with 672, a sand drawing made by the Malakulans of Vanautu. The Malekulan artist first punched a framework of dots in the sand, then drew an unbroken, never-ending line around these dots to form a figure identified as, simultaneously, Human Ancestor & Cosmic Turtle. The dots or rosettes correspond to joint-marks.

The fact that another version of this Malekulan 'Guardian Ghost', 673, has two heads at the opposite ends of its body (each head identified by its 'eyes') suggests that the artist's intention went beyond mere symmetry. Those two heads are more explicit in 674, said by the Malekulans to represent 'two flying foxes [ie, ghosts] eating bread fruit'. Compare 674 to a Papuan example, 675, double-headed both vertically & horizontally. Though 675 isn't a sand drawing, it's nonetheless a continuous-line drawing constructed around a pattern of dots which also serve as joint-marks.

Surely opposing heads have a significance in keeping with the meaning of the figures as a whole. The most probable explanation is that opposing heads symbolize the point of departure of the soul from this world and the point of its arrival in the next.

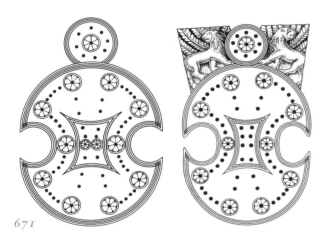

671

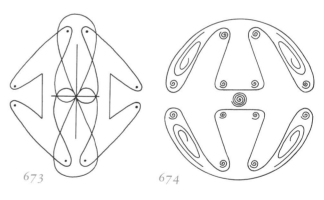

673 674

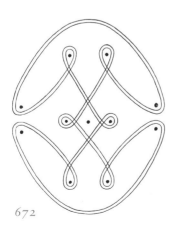

672

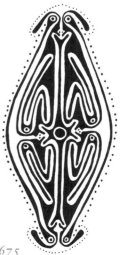

675

The widespread game of *mancala*, called *wari* by some tribes in Africa, is played on a board of opposing heads, usually stylized, but sometimes realistic, as in *676*. *Wari* boards have six pairs of cups, ie twelve joint-marks: shoulders, elbows, wrists, hips, knees, ankles. If you rotate the board half a circle (reversing heads), no loss of anthropomorphic symmetry occurs.

A pre-Hellenistic (probably Boeotian) example from Cyprus, *677*, has opposing heads, one male, one female. Neither *676* nor *677* differs significantly from those used by various peoples, eg the Caleb of Ethiopia, *678* either as boards or as rows of earth pits scooped out to hold pebble counters.

The famous Royal Gaming Board from Ur, Iraq, dates circa 2600 BC. Further evidence suggests this game was well established by 3300 BC. A cuneiform tablet, dated 177 BC, provided rules for similar boards used by gamblers in Babylonian taverns. A late 19th century board, found in an ancient, isolated Jewish community in Cochin, India, added another example. And an 85 year old woman, who migrated from Cochin to Israel in 1951, remembered how it was played.

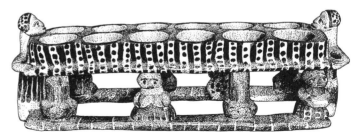

676

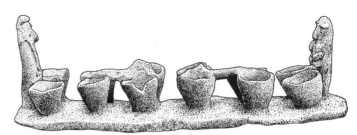

677

678

Monumental Gaming Boards

The Chinese peasant embroidery in *679*, with a different color in each corner, is a diagram of the Cosmos, seen from above. It offers an image of the Earth and its surrounding Seas, together forming the universe in microcosm. The game being played on it must have been a game of destiny.

A similiar game survived in Tonkin as late as the 1930's. Here Man-Coc women in brilliant attire with conspicuously checkered *trousers*, and Man-Tien women in drab costume, acted as living gaming pieces on *680*, a large game board improvised on the ground. Each moved from square to square, duplicating the moves of tribal dignitaries who played their game on a game board of the usual small size. Between moves, each woman sat on a chair placed astride the intersections of the lines, ie at the corners, not within the square.

That participants belonged to different branches of the Man tribe suggests deep tradition, plus social connotations. That players sat on chairs, with the legs straddling compartment crossings, may also have been symbolically significant, like knots on genealogical nets or charts. (Indian chess was always played on intersecting lines.)

Correspondences between *679 & 680* justify regarding them as distantly related, the more 'tribal' society preserving the actual game, *680*, of which *679* is but a remote reflection.

In old Beijing, a stone-flagged square, *Ch'i I'an Chieh*, 'Game-board Street', referred to a war game, *Wei Ch'i*, played with black & white counters on *324* points of intersection.

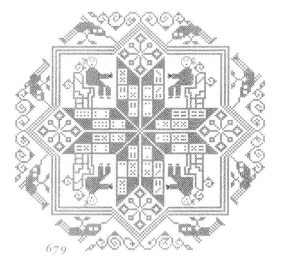

679

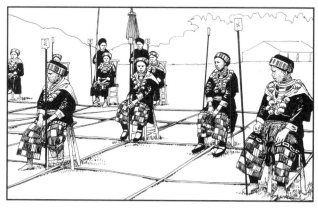

680

In 16th century India, slave girls acted as pawns in *pachisi* or *caupar*, a game played on a cuneiform diagram. Marble pavements on which this game was played survive in the 'Fort' at Agra and in the ruins of Fatepur Siki. A similar board once existed within the palace courtyard at Delhi. All date from the reign of Akbar, who was particularly fond of the game.

At Fatehpur Sikri, Akbar played in a royal manner. The harem court had in its center a large cross pattern divided into red *&* white marble squares. In the middle of this stood a stone dais, four feet high, on which he and a guest or two sat, while four groups of harem slaves (each group wearing the appropriate directional color) moved to the squares directed by throws of the cowrie shells used for dice. Akbar is said to have constructed similar courts in all of his palaces.

Beneath the modern paving of the plaza of Marostica, Italy, an older pavement, in the form of a chessboard, was uncovered. Today, living chessmen re-enact a contest, which allegedly occurred there in 1454 when two knights played for the hand of the governor's daughter. Modern 'knights' use a regular board, while live chessmen repeat their plays in the plaza, *681*. The game is similarly played in various other parts of Europe.

Henry IV witnessed a chess masquerade in 1407. Mohammed, Sultan of Granada, and Don Juan of Austria, last of the Crusaders, played it. Napoleon arranged such a living performance at the Champs-Elysees home of a friend, with Caroline Murat, Queen of Naples, as one of the chess queens.

This association with royalty suggests state games. I regard living chess as a venerable institution associated with rituals of state, where the stakes were once the state itself.

▼

681

Rituals of State

In Mongol chess, the king on the 'good' side was a Mongol noble, with male warriors (stallions or he-camels). The king on the 'bad' side was a Chinese viceroy, with female warriors (mares or she-camels).

On Saxon gaming boards, *hnefatafl* (at least one example predates AD 400), miniature battles were fought with unequal forces. The smaller force had a piece (usually a king) or pieces with special powers, which the larger force tried to hem in, while the smaller force tried to break out, or destroy the larger.

Linnaeus, the Swedish botanist, recorded the rules of this game and collected Tablut 'boards' (probably embroidered reindeer skin) in Lapland, *682*. One player had eight blonde Swedes and their monarch (larger than the other pieces); the other, sixteen dark Muscovites. Only this 'Swedish monarch' could occupy the central square, the *Konakis* or throne.

The Herverar saga recounts two riddles, proposed in a contest of wits between King Heidrek and Odin in disguise: 'Who are the maids that fought weaponless around their lord, the brown ever sheltering and the fair ever attacking him?' (Answer: the pieces in the *hnefatafl*). And 'What is the beast all girdled with iron that kills the flocks? It has eight horns but no head.' (Answer: the *hneft* or head-piece of the *hnefatafl*.)

Jason sowed the dragon's teeth (ivory gaming pieces) and up sprang armed men.

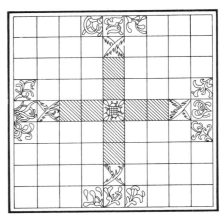

682

One Chinese tradition tells how the king *&* pretender played checkers for the Sky Realm; another tells of the game being played to choose an emperor. In Vedic India, at least in tradition, sovereignty was acquired by the decision of the dice; in Tibet, the Dalai Lama and the King of the Demons played cosmic dice for spiritual supremacy; in East Sumba, Indonesia, sovereign land was won *&* lost in a game of chance; in Africa, a Ruanda king played cosmic checkers to decide who would be king; and

On the Congo I meet a pretty canni-
 bal queen . . .
She propose poker to pass the time in
 between,
She promise she make me her king if I
 ween,
If I lose I wind up in her big soup
 tureen
With a bunch of bananas and a bottle
 of jean.

 Ogden Nash

Those great events that myths recount and rites portray—death & rebirth of the deity, victory over the powers of darkness, the dragon—were re-enacted on gaming boards. Players participated by submitting their destinies to fate.

In a game called 'Planetary Battles' in India and 'Celestial War' or 'Astrologer's Game' in 16th century Europe, dice force the player's hand. Skill plays little or no part.

Several kinds of 'proto-chess' combine boards & dicing: the number of 'eyes' revealed by the dice determines which figure moves. The *Rig-Veda* describes gods going around like *ayas*, ie casts of dice, while the name of the Indian world ages (*Yuga*) comes from dicing. Astrological & cosmic symbolism was all-pervasive in Egyptian games. In Chinese chess, the Milky Way divides the board into two camps. Even checkers was originally territorial & cosmic.

Today the right of asylum has only political meaning, but it once meant saving a life by timely arrival at a definite spot on a field of play.

Ancient games of chance, which to us seem mere play, had the most serious meaning for the participant: his destiny was at stake. He won no prize, palm or honor: he won or lost his life. That sentence might be merely prophesied. Or, in rituals of single combat, as in Homeric legends and Indian traditions of the *Mahabharata*, actually carried out. But, delayed or instant, sentence was passed.

In the Singers' Contest at Wartburg, five singers—five planets?—vie with each other, and the defeated fall to the executioner. Heinrich von Ofterdingen sings best, but by trickery is declared beaten.

Cheating a winner of his prize or the devil of his due, particularly in games of chance, is a beloved theme in the lore of many people. Tricksters everywhere correct fate, cheating nature of her tribute, for that is what death ultimately is.

Four Corners of the Earth

Design *683* shows the four-sided Mexican game *patolli* as depicted by an Aztec artist in the second half of the 16th century. Early Spanish accounts, as well as archeological evidence, preclude any recent origin for this popular game.

Compare *patolli* with *pachisi* as played in India, *684*. Here two sides compete with the same number of 'men', colored to distinguish sides: red & black opposing yellow & green. The 'field', reduced to a cross-shaped diagram, is commonly drawn on a piece of cloth and carried rolled up in keen players' turbans. The light cloth in the background of *683* symbolizes the Sky Dome.

The association of cardinal seas, mountains & colors, so common in Asiatic mandalas & games, persists in certain analogous American Indian games & cosmologies, including those of tribes far distant from seas.

In Zuni cosmology, four sacred seas & mountains mark the cardinal directions. The chief region is the North, designated Yellow and believed to be the source of the wind, as well as the place of winter, hence of violence, therefore masculine. The West, designated Blue, is seen as the source of water, as well as the place of spring, hence of birth, therefore feminine. The South, designated Red, is said to be the source of fire, as well as the place of summer, hence of fostering, and likewise feminine. And the East, designated White, is believed to be the source of seeds & earth, as well as the place of autumn and new years, hence of creation, and therefore masculine.

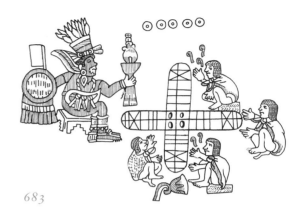

683

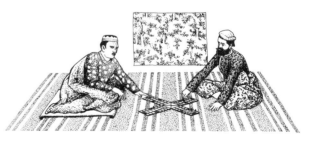

684

The Zuni, like many other American Indians, associate their four clans with these color-designated, cardinal directions. Clan members, competing in rites & games, wear appropriate symbols & colors.

In their game of *sho'-li-we*, four Zuni players, each representing his clan and therefore one of the quarters, employ four cane slips, carved & painted to symbolize these sacred regions, as conceived in Zuni dramography.

Above the *sho'-li-we* diagram in *685*, which was painted on hide and placed on the ground, a bowl was suspended from the center of the ceiling. Over this was stretched a white deerskin, analogous to the mirror and white cloth hung over many Asiatic gaming boards. Both symbolized the radiant light of Heaven beyond the Sky Gate. Four players took their places around *685*, according to their clan's respective geographical position.

The alignment of Babylonian planetary colors corresponded closely to corner placement of colors in the *Bhavischja Purana*. Both systems find a close analogy among the Dakota Indians of North America. Probably mere coincidence. Cosmic-corner colors vary greatly from culture to culture. But what is not coincidental is the widespread tradition of associating gods, elements & colors with cosmic corners. Surely early immigrants to the New World brought this association with them, and their descendants preserved vestiges of it down until yesterday.

We ourselves occasionally call the cardinal points 'four corners of the earth', which is the way they were conceived by many ancients, including Sumerians who oriented their temples toward corners, not toward the sides, as we do.

The Mimbres pottery vessel in *464*, from Arizona, shows four mythic players, each proceeding from a different corner of a gaming board or blanket.

In ancient India, four-sided chess, *chaturanga*, had two teams, each with two players. Each player had a king, elephant, horse, ship and four foot soldiers. Forces were deployed on the familiar chessboard to the left of center of each side. Four-sided die determined which piece should move. Stakes could be high: estates, principalities, petty kingdoms, even wives, children & relatives.

In the 6th century, dice were discarded and forces previously commanded by the team of two were united under a single player's command. One of the two kings on each side was demoted to counselor. In this form, chess diffused to the Near East, then to Europe. In the 16th century, the combined powers of rook & bishop were given to the counselor, who gradually became known as the queen.

685

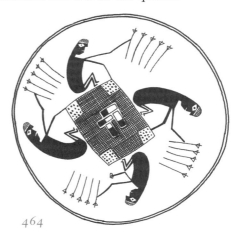

464

Divination Charts

Divination charts, soothsaying boards, astrological diagrams, calendric charts, etc, often rest upon, or are encompassed by, anthropological figures associated with the beginning of life. Many resemble rebirth gaming boards.

Rebirth gaming boards imply an underlying trial by fate: each player seeks the supreme goal (an earthly kingdom or passage into the Afterworld) through the body and over the head of God (in various guises). Passing from point to point on this deity's body (re-membering the First One) is akin to retracing one's ancestry through a human genealogical chart.

Anthropomorphic divination boards also provide charts on which participants move from point to point on a deity's body, and likewise reward those who re-member the First One. But divination is neither merely a pastime nor a means of enrichment: it involves the most serious questions about human destiny, put to fate.

Certain Indonesian divination diagrams, *ketika*, take the form of mythic, male figures, *686 & 687*. Red dots, alternately light & dark, mark their heads & joints. To divine the future, a Malay magician counts dots, starting at the top and proceeding clockwise.

This isn't a game, of course. But its basic idea is essentially the same as that underlying anthropomorphic gaming boards, namely a diagram on which one's fate is determined by movements from one point to another on the body of a 'superman' representing human destiny.

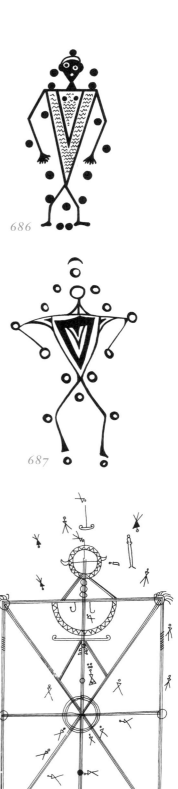

686

687

688

Other *ketika* figures include a 'Cosmic Woman' of hourglass form with central disk as navel, *688*. This symbol for woman is said to represent the correct anatomical proportions of the Original Ancestor. Human figures depicted on top of *688* suggest that such diagrams were executed originally as earth sculptures, large enough for participants to move about inside them, in the manner of hopscotch diagrams.

The Indian divinatory figure in *689*; the Chinese 'God of the Wind' in *690*; and the Thai chart from a sorcerer's handbook, *691*; all have symbols on or adjoining their primary joints, plus one at the genitals.

A German astrological chart, *692*, dated 1574, shows a hermaphrodite split vertically by sex, quartered by seasons & directions, and surrounded by twelve zodiacal signs located opposite primary joints. Most charts of this kind show the female half on the left. Some link the zodiacal signs to the joints by lines.

Heavenly examples were perceived as constellations. A continuous line 'reuniting' these celestial 'members' reassembled this primordial figure.

So: a cosmic figure with both kinds in One, vertically divided half-male, half-female; surrounded by twelve signs, each opposite a primary joint; and occult methods to re-embody when dismembered. That sounds like a genealogical chart placed on the body of the First One, here modified by medieval themes.

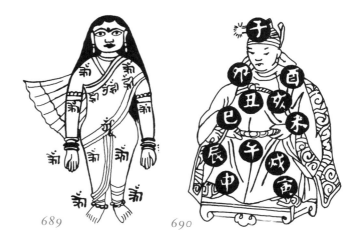

689 690

691

692

Genealogical Puzzle

Any genealogical pattern, 'read' down, illustrates descent. 'Read' up, that same pattern provides both a map of ancestry and a path for rebirth.

Consider *271*, the Patagonian pictograph. Its basic element, repeated four times at the top, is simply a headless, directionless, human figure. At the left, an erect figure links limbs (arms-legs) with four diagonally adjacent, horizontal figures to form a *Biaxial Pattern*: ego in the center, ego's parents above, ego's offspring below. The headlessness of each figure facilitates 'reading' this composition in any direction, depending upon the observer's point of view (somewhat as kinship terminology varies with the speaker's identity).

Close the gaps between the outermost limbs and the composition becomes a classic genealogical pattern. The fact that the designer included, at the lower right, two sketches of enclosed spaces excerpted from such a pattern, suggests he was aware of the derivation of this composition from an all-over genealogical pattern.

A related, but more elaborate example, *693*, takes the form of a linear picture puzzle. To Oswald Menghin belongs the credit for first recognizing *693* as a design of two continuous lines which nowhere cross. It is also a design composed of human figures identical with those at the top of *271*. This interpretation is supported by the presence of paired, concentric circles, presumably representing the heads of these figures. Four of these circles also serve as points of departure and points of arrival in the construction of a diagram of joined human figures.

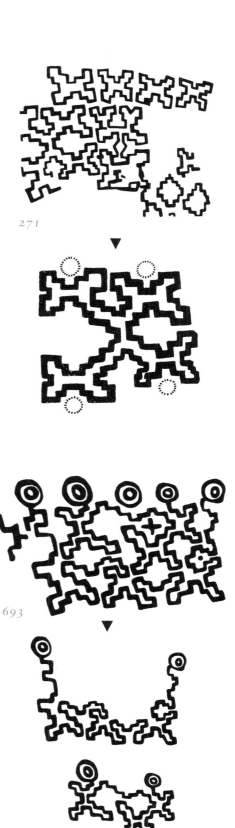

271

693

Design *693* may be regarded as the solution of an exercise or problem: the novice was confronted simply with a row of four circles (the fifth was probably superfluous; elsewhere I omit it) and was asked to supply bodies for these 'heads' by connecting two continuous lines which never cross.

This little exercise of ingenuity is a cultural/historical document of great interest; for the idea of a diagram connecting two points of departure and two points of arrival by means of two lines which never cross is strangely reminiscent of the labyrinth, in which essentially the same puzzle is laid out in a two-line diagram, *694*.

Though the labyrinth is generally drawn on the basis of a cross with four arcs and four dots, in certain circumstances it is the plan of an *exercise*, in which the movement begins simultaneously at the two points marked 'B' and ends simultaneously at the two points marked 'E', *694*. These lines cross once. Passage through the labyrinth requires but one line which never crosses itself.

The four 'heads' of *693* correspond to the two points of departure and two points of arrival in *694*. The single crossing of lines in *694* has its counterpart in the single cross gratuitously inscribed within the empty space of *693*.

That same unconnected cross occurs in *695*, a Malekulan sand drawing said to represent either the 'Path' by which the soul finds its way into the Land of the Dead, or the 'Guardian Ghost' who denies entrance to the Afterworld to all who cannot complete the 'Path' leading to it.

These two explanations are hardly at variance, for undoubtedly the Guardian Ghost *is* the labyrinthine Way or Path to the Afterworld. Insofar as the Afterworld is conceived as the world of ancestral spirits, the ritual tracing of such a human figure may be regarded as a means of achieving reunion with ones ancestors. The object of the exercise represented by both *695* & *693* is then the same as that commonly understood to be the object of tracing the labyrinth: namely, to gain admission to the Afterworld.

694

695

That such a chart is essentially a path to be followed into the Afterworld, by tracing one's origins, as it were, through the pattern of one's ancestors, appears in the decoration of *696*. This wooden disk, from the Barreales culture of northern Argentina, circa AD 500, probably served as a spindle whorl and was rotated around its central hole. Inscribed on one side are two human-headed patterns in inverse relation to one another. Twirling the disk would have the same effect of facilitating the passage of the soul into the Afterworld. The inverse ratio of the two images reflects the inverse relation of the Afterworld to the world of the living; and the twirling of the disk is thus tantamount to threading a two-headed maze.

This interpretation of *696* is supported by ethnological evidence from eastern Ecuador, in the form of a funeral gaming disk of the Canelos Indians, *697*. What we see here is not, to be sure, a game: rather, this disk reveals the basic idea upon which the rebirth chart is founded, and without which it is inconceivable. For the Canelos say that the human figure in *697* represents the soul of the deceased, and that the 'game' is played on a board laid directly on the corpse.

The surviving friends *&* relatives form two parties, one on each side of the corpse, who vie with each other in dropping kernels of corn (symbols of resurrection?) into the little cups surrounding the figure on the disk. These seven cups (joint-marks?) correspond to the eight 'dots' which serve as guides for the construction of *695*, the Malekulan 'Guardian Ghost'; and to the rosettes on *671*, the Megiddo gaming board.

The successful dropping of kernels into all of the cups of *697* is then tantamount to the completion of *695* around the eight points of its ghostly anatomy, and the completion of *671* by placing a peg successively in each of its primary joints.

The Canelos player of *697* who gets kernels into all seven cups, then takes hold of the disk by its rim and, without lifting it from the playing board, rotates it carefully on its rounded bottom, so as not to dislodge any of the kernels, until the head of the figure lies in a position diametrically opposite that which it occupied at the beginning of the game. If he then, after taking a new grasp, succeeds in completing the rotation of the disk back to its original position without spilling any of the kernels, he wins the game.

696

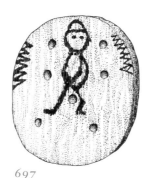

697

271

693

The degree of his success in performing this delicate operation is thought to be influenced by the wishes of the deceased. The fact that the fingers, in grasping the disk, communicate with the deceased, gives the game a certain spiritualistic character. It may also have an indirect relation to the widespread identification of finger joints with ancestors.

This by no means exhausts the significance of the Canelos game. The fact that the corpse is placed in the center of the dwelling, the gaming board on the center of the corpse, the gaming disk, 697, in the center of the board, and a special kernel of corn in the center of 697—all this suggests the idea of *cosmic alignment* of the soul, which is implicit also in the passing of a thread (symbolizing the cosmic axis) through the central hole of 696.

The cosmic symbolism of 697 appears more clearly in a game following this one, in which the Canelos mourners blow a flaming ball of cotton back & forth across the same corpse board. Here the breath presumably symbolizes the spirit, as do the flame and the volatile cotton, while the erratic course of the flaming ball symbolizes the labyrinthine Way to the Afterlife. The prophylactic purpose attributed to this game by the Canelos isn't necessarily at variance with this symbolism.

The analogy of this operation to the twirling of 696 with its two human charts is obvious: 271 explains both the application of genealogical charts to 693, and the meaning of this anthropomorphic 'map' as a path to the

Afterworld, conceived as an inversion of the world of the living. For the rotation of 697, like the spinning of 696, is tantamount to the threading of the two-headed chart. The exercises or performances associated with these designs all refer to one and the same thing: the departure of the soul from the world of the living and its arrival in the Afterworld. Hence the points of departure & arrival are, in these designs, so often arranged in diametric opposition.

If there were any doubt about the relation of the figure on 697 to the principle of the 'rebirth chart', the relation is supported by the circumstance that a 'cross' is scored to the credit of a Canelos player who succeeds in getting kernels into cups on opposing sides of the figure, thereby forming an imaginary line at right angles to the axis of the body. For this imaginary cross is equivalent to the cross in the middle of the Malekulan figure, 695; and to the cross which persists, albeit off center, in the Patagonian pattern, 693.

Presumably this cross has a metaphysical meaning: somehow it must represent a crucial point in the migration of the soul from one world to another. Though the Canelos say that the figure of 697 represents the soul of a particular deceased individual, while the Malekulan regard 695 as a kind of god or demon who arbitrates the destiny of each soul, the two sides are really the same: for in Ecuador, as in Malekula, and indeed everywhere, the destiny of the individual spirit is union with the universal Spirit—which was perhaps conceived, in the first place, as a composite of the spirits of all of the ancestors. Disk 697 is thus a document of prime importance for our understanding not only of 271, but of the 'rebirth chart' as an enactment of the idea which is represented statically in genealogical patterns.

695

671

Hopscotch

I see a fundamental relationship between hopscotch ('hop-a-scratch') and Indian table games. Both explicitly symbolize the progress of the soul from earth to heaven through various intermediate states. And both, I think, were played originally on an anthropomorphic ground drawing of an eschatological type which no longer survives, but which left unmistakable traces in many cultures.

Heaven & Hell, the goal & hazard of hopscotch, fit into this picture of hopscotch as related to gaming boards. So do the calendric associations in certain forms of hopscotch; while the pebble, which players kick or toss from court to court, corresponds to the pegs or counters moved from point to point on gaming boards.

Most such games have an edifying purpose closely associated with religious doctrine: the goal is to reach a place of redemption or rebirth. To reach it, one must escape Hell in hopscotch and malefic creatures in table games; skill (hopping or climbing between Worlds) determines success in hopscotch.

The hopscotch player who reaches Heaven, comes down on both feet, reverses himself, then hops back home. His trip symbolizes the departure of his soul from the world of the living, its arrival in the Afterworld, and its return to Earth. The immediate goal is the soul's reappearance on earth. Later that goal became, in India at least, escape from Earthly Existence.

Still later the whole was reduced to table games and children's sports.

Today's participants conform (perhaps all the more closely) to rules whose origins & meanings they never knew. Yet here & there, form & goal survive together: Unity leads to Liberty in modern Chinese hopscotch. In Paris in 1976, one player's goal was Labor's right to strike.

Certain hopscotch diagrams suggest a Cosmic Being upon whose body players progress upward, through stages or courts, to the Deity's head at the top. This is done on a ground drawing, often of anthropomorphic form. The proper route requires that the player land in sequence on each part (joint?) before reaching the deity's head.

This is also the route & goal on rebirth gaming boards: once a player achieves reunion with each of the deity's parts, life is said to be renewed. Whose life, the player's or the deity's, we're never told, but perhaps it's both: 'Step on a crack, break your father's back / Step on a line, break your mother's spine'.

Anthropomorphic diagrams survive in Macedonia, *698*; Rumania, *699*; Denmark, *700*; and various 'peripheral' areas of Europe.

Germans call hopscotch *Himmel und Hölle & Paradiesspiel*; Spaniards: *Infernaculo*; Norwegians: *Hoppe-Paradis*; Danes: *Paradisleg*; Walloons: *Paradi* or *Parados*. In France, the starting field is *terre*; the goal, *ciel*. The English generally call the last court 'paradise', 'crown' or 'glory'; and hazards: 'hell', 'poison', 'dragons' or 'fire'. Cypriote players who stumble into hell or transgress any rule are 'burnt', ie lose & yield to the next player. One Cypriote diagram, origi-

698 699 700

nally called *Fathkia* or *Kafkesai fothjia*, 'fire' or 'you are burnt in the fire', nowadays goes by the name Photis Ittas, in honor of a teacher burned alive in the Struggle for Liberation.

In *701*, clerics play hopscotch in a meadow outside the castle of Urbino. High functionaries of the Church officiate. Less-than-solemn spectators watch. Presumably the intent of this 20th century engraving was satirical: priests competing in a children's game to be the first to achieve salvation. But long before children played hopscotch, priests may have enacted this ritual of rebirth, watched by solemn spectators.

Hopscotch diagrams from Africa & Asia, at least those known to me from literature & experience, generally look European. Perhaps they were introduced by the children of missionaries. But sometimes local & alien motifs blend so harmoniously their elements cannot be distinguished. Certainly hopscotch is old in Persia. It is also found in Egypt, Syria, Iraq, Iran, Israel & Yemen.

Buramese call hopscotch *rupa*, a Sanskrit term for the human body. A related game in Sri Lanka is known as *chilamuburum*, after the temple city of Chilamakaram, in South India. Hopping games may be named after a particular city, conceived as the center of the world, eg London or Troy, the latter designation being widely applied to the labyrinth, which was also toured on foot.

In *702*, girls play hopscotch in Benares, beside the Ganges, on the Great Cremation ground at Manikarnika with its ceaselessly smoking pyres. Not all activities at this sanctuary are spiritual. Hopscotch diagrams may be

701

chalked on the wide, stone bathing *ghats* merely for convenience. Elsewhere in Benares they are drawn on the earth. Conceivably all are recent imports which arrived, as they remain: games for girls. Yet the local Hindi name for hopscotch, *samudra tapu*, means 'crossing the ocean', and refers to the Hindu vision of ultimate transcendence & liberation. Whatever the origin of *702*, players recognize this game as a means of leaving This World.

702

Spiral hopscotch, *703*, occurs widely in Europe, perhaps wherever hopscotch occurs. As usual, participants enter a ground drawing, hopping on one foot. Those who reach the center are declared 'reborn'. There they reverse direction, then hop back to earth.

Converted from earth drawing to table game, spiral hopscotch became the European game of 'Goose', sometimes called *jeu du labryrinthe.*

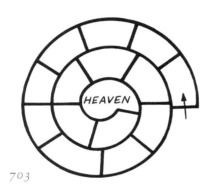

703

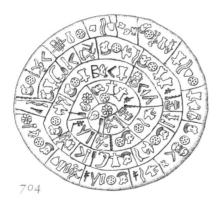

704

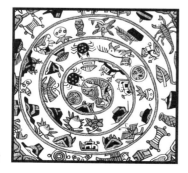

705

Compare *704*, the Mycenaean disk of Phaistos, 17th century BC, with a Chinese design, *705*. The latter is but a child's game, though it may once have been more: it depicts the mythical tale which developed out of Hsuan Tsang's journey to find the Buddhist Tripitaka. I'm not suggesting that *705* explains *704*. I simply wonder if *704* was a 'game' of destiny, with the soul's path leading inexorably inward.

An Egyptian grave painting, *706*, circa 2000 BC, shows a circular gaming board which, except for a handle-like addition, resembles a coiled, segmented snake. Its name, *mhn*, comes from the snake in whose coils certain gods were said to dwell. A relief, *707*, in the tomb of Rashebses, Chief Justice of the King of Saqara, 5th Dynasty, shows this game in progress.

Presumably *706* served a dead man in the Underworld, with the snake as his opponent, defeated only after lengthy struggle. This tradition recalls the belief of German mercenaries that a fallen comrade plays cards in the Underworld with the 'inn keeper' there.

Texts from the New Kingdom show a board game with thirty squares which, according to H. Ranke, a dead man plays with a snake. The deceased occupies one square after another, successively removing his opponent's pieces until he kills him. 'If these pieces originally represented, as in Egypt, amulets for various parts of the body, the esoteric purpose of the game seems to be to rob one's opponent of his vital organs until finally with the king, who is the head, comes mate—and death'.

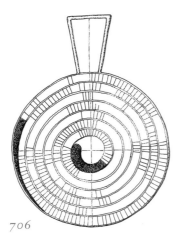

706

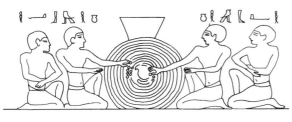

707

Many ancient games, surviving as children's games, are called 'seasonal', not in any sense of being favored by spring, but in a cosmic sense, as their names indicate. Calendric hopscotch presumably enjoys distant celestial associations. The sun & moon appear at the top of certain diagrams, just as they do in many gaming boards and divination boards. They remind us that, in old tradition, none of these activities relates to this world.

In Europe, hopscotch diagrams sometimes represent the seven days of the week, and these are still equated with the Seven Planets. A successful player lands in sequence on each day before

reaching his goal; there, on the Seventh Day, he rests; reverses himself; then returns to Earth. Children often call hopscotch 'the week'.

Several Russian diagrams include weekday names which look like confused translations of a list of planets, with 'sun day' corresponding to the goal. *Lune* is the last division before Heaven in at least one French diagram. Surely the frequent recurrence of such terms isn't accidental.

The final court, shaped like Heaven's Dome, has been interpreted as the apse of an early church. I doubt that interpretation. True, Indian table games often incorporate architectural features of temples or mosques at the top. But the 'dome', I think, is a reminiscence of the deity's head. Here players, having achieved reunion with the First One, reverse direction and return to Earth.

Seven remains by far the most common number of courts. But, if we don't count the head, that leaves six, each to be traversed twice, coming & going. Which makes twelve.

Twelve courts may be more significant than seven. One writer, who offered a solar interpretation of hopscotch, proposed that the stone kicked through the courts originally represented the sun passing through the twelve signs of the Zodiac.

Perhaps there were originally two rituals: one involving a Primordial Figure whose twelve primary joints must be reunited, the other representing the Seven Planetary Spheres, with heaven hopping (horizontal climbing) in both.

The Magically-Arrested Step

Rituals of royal ascension in Southeast Asia and Negro Africa often require a new king to stand on one leg, while grasping a sacred pole with his opposite arm, on top of a sacred mountain, throughout an entire night, or while the sun passes overhead. This difficult, protracted step publicly demonstrates the king's passage from one World to Another; or from mortality to divine kinship; or from the world of mortals to the world of gods, as befits a king.

A great deal of curious evidence supports this interpretation. Ethnologically this posture occurs as a simple 'resting position' in Australia, *708*; Africa, *709*; and South America, as well as among Gypsies *&* others. But where this posture is associated with rites, those rites generally relate to investiture or initiation.

As recently as 1934, during the installation of a *Yang di-Pertuan Besar* in Malaya, the herald 'adopted the attitude . . . prescribed for him by ancient custom. Standing on one leg, with the sole of [his] right foot resting against his left knee, his right hand shading his eyes, and the tip of the fingers of his left hand pressed against his right cheek, he made [a] proclamation. . . . Immediately the herald had made proclamation, he abandoned this curious attitude and did not resume it except to call upon the four *Undung* [counsellors] to make obeisance', *710*.

Thus the function of standing on one foot passed from the king himself (who should really be the one to practice it) to the herald who, while standing on one leg, announces the ascension of the new king.

708 709

710

Among the Asian gods who stand or dance on one leg, several in Chinese literature assume this posture on a sea-monster, while reaching with one hand for the stars, eg *711*, K'uei Hsing standing on the sea-monster Ao.

Tibetan 'Lords of the Graveyard', *chitipati*, *712*, not only stand on one foot, they dance in this manner. Most carry a stick.

A Javanese demon, *713*, assumes this one-legged posture; while Tinitiya, *409*, the highest Balinese divinity, stands in the posture of a 'climbing god', on a cosmic turtle bound by snakes which intertwine in the manner of a continuous-line drawing. Binding the turtle is said to prevent it, as fulcum of the world pillar, from causing earthquakes.

711

712

713

409

The easiest way to get from one World to Another is by *stepping* there, ie by raising one foot, then another. An heroic magnification of this idea is the 'Three Steps of Vishnu'. Vishnu Trivikrama, climbs the *axis mundi*,

714

shown in *714* as a lotus stalk set on the back of a turtle, 11th century, Ankor-Wat. The Hindu expression *trivikrama*, used as an epithet of Vishnu, means 'who strode over three worlds in three steps'.

This achievement involved grasping the *axis mundi* in a posture exactly the same as standing on one foot. When climbing this pole, Vishnu performed essentially the same role as the tribal shaman who climbs a pole, representing the World Tree, to peer through the Sky Gate and observe the supra-mundane world of the spirits.

The Siberian shaman who mounts the notched, anthropomorphic ladder in the center of his domed house and thrusts his head through the smoke-hole (figuratively the Sky Door), hopes to be granted the supreme gift: to see the empyrean, the transcendent, the sphere of Perpetual Light.

A Koryak shaman's parka, *715*, illustrates this achievement by placing the sky cover, represented by constellations, below the wearer's head.

The anomaly of *climbing* rites in the steppes of Siberia extends to the tree-less tundra of America. There shaman-acrobats performed from strung cords, later from ships' rigging. The blanket-toss offered a simpler method for visiting the Sky Realm. The skilled performer (arms folded, head back, balancing on one foot at a time) shot higher & higher into the air, each time figuratively peering through the Sky Gate. This same feat, performed on the ground, is popularly known as a Cossack dance, though surely it predates the Cossacks.

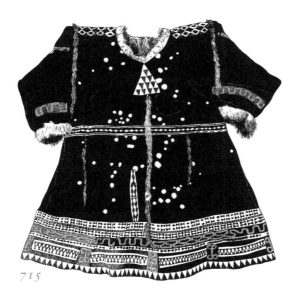

715

The *yoga* climbing posture, *716*, takes its name, *vrksasana*, 'tree-pose', from the widespread conception of the World Tree as a climbing pole.

The Scottish Sword Dance, *717*, is performed over & within each quarter of two crossed claymores. Touching a sword is regarded as an inauspicious omen. The thumb of the upraised hand remains in contact with the first joint of the middle finger.

European lore contains many vestiges of one-legged posture. In the 12th century mythical kingdom of Prester John, protocol required that guards stand on one foot, naked sword in hand. Hobgoblin, that protean, hobbling character of Western lore, carries a stick. So does the 'devil who limps' in an old French game. Diana spanned three worlds—Heaven, Earth, Hell—bow (staff pole?) in hand. Witches traveled between these worlds on broomsticks.

Many cultures conferred the status of king & queen on a groom & bride for their wedding day. In one area of Bulgaria, until at least 1885, the bridegroom, as 'king', was required to stand on one foot.

At funerals in rural Egypt, until recently, women hopped on one foot, symbolically following the departed. Early Egyptian wall paintings record this custom.

Initiates who followed the path of the labyrinth employed a curious 'three-step dance' (horizontal climbing?), much like that of hopscotch players who everywhere climb to Heaven, then descend to Earth, bypassing Hell.

716

717

The Labyrinth

To construct a continuous-line draw-
ing, an artist usually begins with a
framework of dots and around them
draws an unbroken line to form a
figure or pattern. Ideally this move-
ment flows gracefully, accompanied
by chanting or drumming.

695

People accustomed to making such
drawings often develop remarkable
skills in their execution. Dots may be
retained within the interstices of the
finished drawing, 695, a Melanesian
turtle drawing. Or dots may be erased
or simply absorbed by the drawing.
Sometimes points of intersection serve
as guides.

String figures also use construction
frameworks, 718, a Melanesian turtle
design. A player forms images by
passing a continuous string in & out
among his fingers: here fingers equal
dots. Presumably both modes of
execution coexisted for ages.

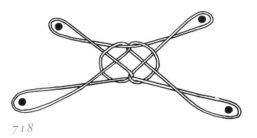

718

Both modes survive today, occasionally
with ritual & magical associations, eg
719, southern India. More often, ritu-
als that once mapped paths to Other
Worlds are reduced to children's games.

In the past, artists evoked mythic fig-
ures by re-membering, ie re-assembling
their physical or social 'members'.
To connect the joint-marks of 720, a
pottery design from Colima, Mexico,
draw a continuous-line like that in
721, a sand drawing from the Quioco,
Angola.

719

If isolated dots are conceived as the
dismembered & scattered parts of a
deity, then collecting them into a unity
becomes a creative act. Creation is thus
conceived as a cosmographic death,
followed by rebirth when the Many
are 'recollected' to the One.

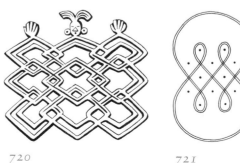

720 721

Continuous-line drawings also map paths to Other Worlds. Malekulans of Vanautu call the orthodox home of the dead, *'Wies'*, and say a ghost reaches it by traveling northwards, crossing the lagoon without effort, then passing through a distorted landscape. There it confronts Temes Savsaq, a female ghost who sits in front of a rock, with a sand-traced figure before her called *Nahal*, 'The Path', *722*.

722

'As the ghost approaches', writes John Layard, 'Temes Savaq wipes out half of the tracing and tells the traveller that before he proceeds any further he must complete the diagram correctly. Most men, during their lifetimes, have learned how to make this and other geometrical figures, so, on their deaths, they are able to do so as Temes Savsaq tells them, and pass safely on their way. But if a man should be ignorant as to how to complete the figure, Temes Savsaq seizes him and devours him so that he can never reach the land of *Wies'*.

A key dance in the Malekulan cycle of ceremonies represents, simultaneously, a sacred marriage, an initiation rite and, most important of all, the Journey of the Dead. At one point, participants enact a swimming movement to represent the crossing of the channel to the land of the dead. In the final movement, Maki-men form in two rows: then members of the introducing 'line', already fully initiated, thread their way between these ranks. This progression of initiates corresponds with the path followed by the dead man through the maze-like design *Nahal*.

Actually, *Nahal*, being unicursal, is no maze, no soul-trap of false turnings, blind openings. Instead, it maps, for initiates only, a sacred path, guiding them to *Wies & rebirth.

That is the role of the labyrinth. Ideally the labyrinth is drawn in two continuous lines, but an easier method is more commonly employed, *723*.

First draw a cross; then four arcs within the arms of the cross; then put a dot within each of the four arcs. Connect any of the four ends of the cross with the nearest end of the arc, either on the right or the left; and thereafter connect the following dot with the next position on the other side of the diagram, and so on in orderly progression until the design is completed.

This design is drawn in precisely this way by school children in Finland, Sweden & Ireland; housewives in southern India; Batak sorcerers in Sumatra; and American Indians in southwestern United States, Mexico & Brazil. There is good reason to believe it has been drawn in this way, though not exclusively this way, wherever the motif is known.

The procedure is simple—literally child's play in many parts of the world. Still, relatively few persons, seeing the design drawn according to this scheme for the first time, are able to reproduce it accurately. The blunders which most people make today are precisely the blunders that have been made for thousands of years, in many parts of the world. In fact, this motif has been more often bungled than made correctly—and these blunders are themselves illuminating.

Cretan labyrinths generally had a square form, *724*, from about 400 BC onwards through the reign of

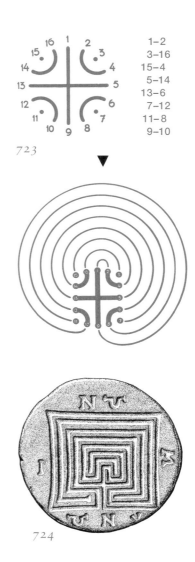

723

724

Augustus; and a round form, *725*, from about 200 BC until 67 BC, when Crete came under Roman control. It was used by the city of Knossos as a cachet on its coins to recall the famous labyrinth built by Daedalus for King Minos. This was the labyrinth in which Theseus killed the Minotaur and from which, with the help of Ariadne's thread, he escaped.

A labyrinth on the reverse side of a Linear B tablet found at Pilos, Greece, *726*, belongs to the Minoan-Mycenaean period of 1200 BC. Wunderlich suggests that Linear B tablets 'were short-hand notes given to the dead to take with them into the hereafter'.

The Pilos labyrinth, *726*, is the earliest dated labyrinth, but that doesn't mean that the labyrinth was invented in 1200 BC. On the contrary, it seems safe to assume that it was invented much earlier, and probably only once, by a stroke of graphic genius, at a point in time *&* space we may never know—perhaps the Aegean or ancient Orient.

The origin and, to a large extent, the prehistory of this motif remain, for the present, largely a matter of guesswork.

The bowl from a clay spoon or ladle, excavated in southern Denmark, *727*, has a jabbed decoration (*Stickband*?) which looks like an aberration of a labyrinth. It was found together with Funnel Beaker, First Northern pottery, early 3rd millennium BC.

If *727* relates to, or derives from, the labyrinth, it provides the earliest known evidence of that design. True, *727* is not a labyrinth, but its two loops are highly suggestive of the labyrinth and its pits can be connected somewhat in the manner of the labyrinth. Moreover, the most common aberration of the labyrinth is the enlargement of the 'entrance', often precisely as seen here, for the labyrinth was intended to be entered.

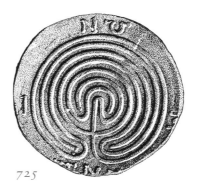

725

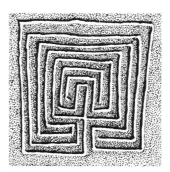

726

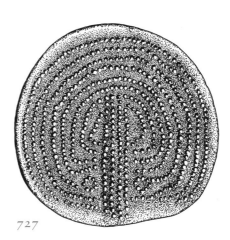

727

In various parts of the world, labyrinths show a human figure at the entrance or inside. Such figures imply a labyrinth large enough for a person to enter. And we find just that: the same design that was incised on exposed rocks in Spain, Ireland, England & the Caucasus is found in many parts of northwestern Europe as a field labyrinth, laid out in large scale as a path-like groove or ditch cut or worn into the sod, eg 728, or constructed of boulders, eg 729.

A boulder labyrinth in southern India, 730, lacks a cross, but has enough characteristic features of the labyrinth to confirm its identity. Its pattern is the classical one of the *chakra-vyuha*, by which the labyrinth is commonly known in India today.

One curious feature characterizes the use of monumental labyrinths, at least those for which we have records: participants employed a three-step dance as they toured the labyrinth's path. Moreover, in Roman funeral games where mounted youths traversed the *lines* of the labyrinth, their horses employed a three-step dressage. Were these horses trained to imitate hopping men?

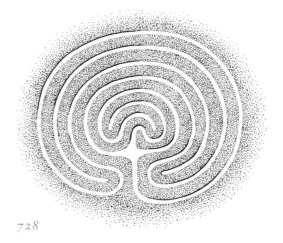

728

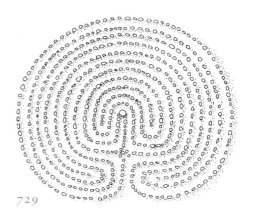

729

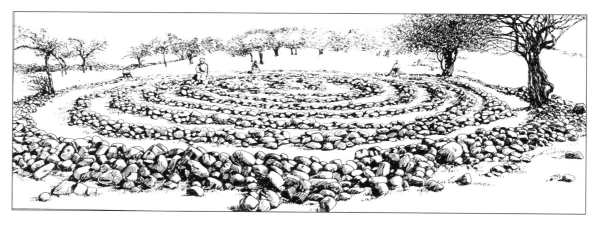

730

New World labyrinths differ from those of the Old World in only one particular: no example of irrefutable antiquity has been identified in the New World. In all other ways they are identical.

The labyrinth is still made by the Hopi and their neighbors. Earlier examples occur as petroglyphs in the Southwest Desert and adjacent regions, with scattered examples along the west coast of Mexico. North American examples include both round & square versions, *731* & *732*; boulder labyrinths, *733*; as well as paired labyrinths, just as in the Old World.

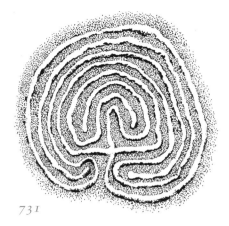

731

There is, however, the possibility of one difference, and that difference might be significant. Those who make the labyrinth often describe it as the refuge of some legendary rogue. The Finns have such a story. So do other Europeans who make this design. In India, the labyrinth is known as the domain of the demon Ravana, while the Bataks of Sumatra identify it as the refuge of the trickster Djonaha. In Crete, it served as the lair of the Minotaur, half-bull, half-human, who was given an annual tribute of seven youths and seven maidens.

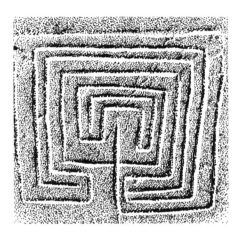

732

All these mythic beings now belong to the nursery. But originally, I believe, each represented the First Being, in various forms. That primordial ancestor didn't reside *within* the labyrinth, but was *itself* the labyrinth.

It is here that we see a possible difference between Old & New World examples, for though a few Indian tribes mention a monster within, such warnings are far less common than in the Old World. My impression is that many Indians who make the labyrinth regard it as a sacred symbol, a beneficial ancestor, a deity. In this they may be preserving its original meaning: the ultimate ancestor, here evoked by two continuous lines joining its twelve primary joints.

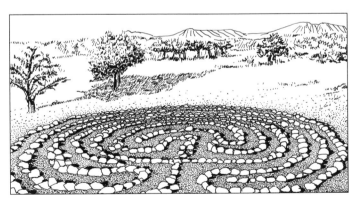

733

From India, the labyrinth traveled to Sumatra & Java, and then (at least in debased form), penetrated into remoter islands of the Pacific. I trace this eastward migration through not only the labyrinth form itself, but also through an apparently incidental & extraneous ornament around the periphery of the design.

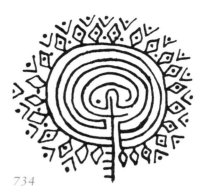

734

The fringe of leaf-like elements around a tattoo from southern India, *734*, doesn't seem to belong properly to the design or have any function in relation to it. Rather it seems to come from another type of continuous-line drawing popular in India and based on the principle of forming connections on a grid of evenly-spaced dots.

Thus the motif of a labyrinth with a surrounding fringe of leaf-like elements may be a distinctly Indian development. But these extraneous elements turn up again on labyrinths drawn by the Batak of Sumatra, in at least two forms: that of leaf-like appendages, *735*, and that of rows of simple hooks or prongs, *736*.

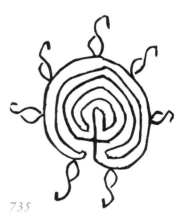

735

Designs used in Batak sorcery parallel popular Indian designs on wall paintings, ground tracings & tattoos. I assume the labyrinth found its way to Indonesia from India, along with other cultural goods.

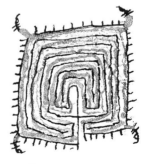

736

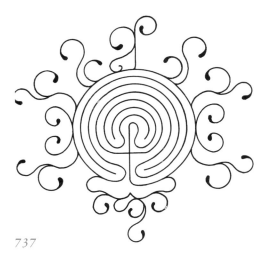

737

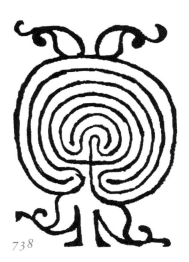

738

In 1935, Claude Lévi-Strauss collected in the field a drawing of a labyrinth, *737*, made by a Caduveo of Brazil. Darcy Ribeiro of the Brazilian Service for the Protection of Indians collected another example in 1947–48, *738*. Ribeiro told Schuster that he refrained from inculding it among the illustrations of his *A Arte dos Kadiueu* because he regarded it as extraneous to Caduveo art. Nevertheless, the woman who drew the design insisted that it was traditional among her tribe, and had not been introduced by Europeans. Both examples possess the same leaf-like appendages as the Batak labyrinth, *735*, and the Indian tattoo, *734*.

The antiquity of the labyrinth among the Caduveo and among the Indians of the Southwest Desert, many of whom claim the design as indigenous, is a similar problem. If this design was brought to the New World by the Spanish, as some people have assumed, then we shall have to make the further assumption that these same Spaniards brought with them a large complex of associated ideas and artistic traditions, including the making of boulder laby-rinths and double ones at that. From what we know of the conquistadors and the clerics who accompanied & followed them, they were motivated by other complexes. I doubt that they would have instructed the Indians in traditions which in Spain by that time had been reduced to child's play, or forgotten altogether.

In drawing the labyrinth, some adepts may have used a cross, twelve dots and four lines, *739*. This is essentially the same framework used to render a likeness of mythical human, reptilian & avian ancestors with twelve joint-marks, *740*.

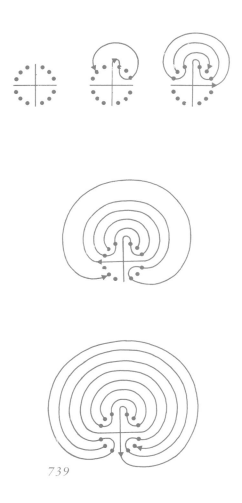

739

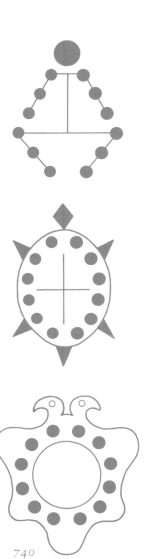

740

Although the cross-arc-dot method is by far the easiest way to draw the labyrinth and undoubtedly contributed to its popularity & longevity, the one essential feature of all such designs is that they be drawn by means of continuous lines, without raising the hand.

Yet drawing the labyrinth in two lines, 741, is most demanding. Only someone committed to the notion that 'Labyrinth & Ancestor are One' would attempt it and only a skilled artist could achieve it. That would take us back to the earliest years of the labyrinth. Unfortunately we know this design best from more recent times, its original meaning and presumed method of production having long since been modified & debased.

Are the arcs mere guidelines for novices? Those who have mastered this design and acquired a feeling for it, say it's easier and more satisfying to omit them. Simply draw a cross, add four dots, then connect lines to dots, completing the whole in four rhythmic strokes, 742.

This procedure might explain why so many labyrinths are bungled and why so many bungled labyrinths contain dots, but not arcs. It might also explain the popular motif of the 'cross with four dots'.

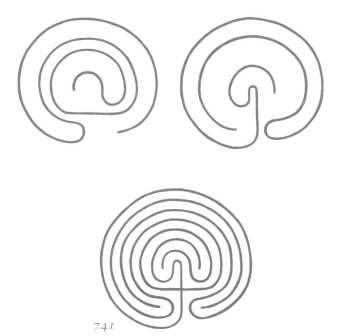

741

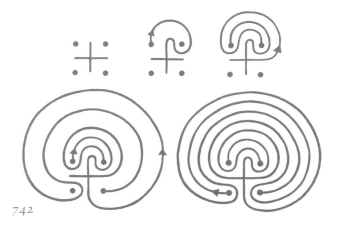

742

Schuyler Cammann, a life-long friend of Carl Schuster, wrote of the satisfaction he experienced in drawing this design:

'How can we account for the enormous range and longevity of the labyrinth? What was there about this motif that exerted such strong appeal? It could not have been just its form, because people continued to draw it when they no longer remembered how to draw it correctly. Its fascination must have derived from its meaning —actually meanings: for the labyrinth, like all great symbols, had many meanings.

'On the lowest plane of Being, in the World Below, it symbolized the Land of the Dead. In some cultures, it was conceived as a monster who swallowed dead souls, either to hold them in perpetual oblivion or to disgorge them reborn. Alternately, it was placed where both dead and bereaved could search for the meaning of death and the prospect of rebirth.

'But the symbolism of the labyrinth was by no means limited to the Under World: it involved all three traditional layers of the Cosmos, or levels of Being.

'On our Earthly level, it seems to have embodied a rather different kind of symbolism—though that, too, involved the idea of a search or quest. A first clue to the inner meaning of the labyrinth in the Human World is revealed by the way it was constructed.

'The earliest method employs a cross, and four dots set off by arcs or angles; but the latter are not absolutely necessary and probably were often

omitted as soon as an artist sensed the rhythm of lines and felt greater freedom without them. In that case, after simply drawing a cross with four dots, he could reconstruct the rest with only four continuous lines, [742].

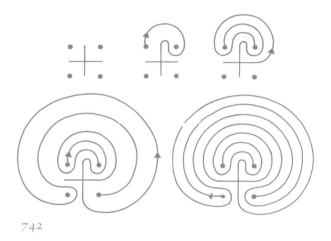

742

'The persistently alternating rhythm —line to dot, dot to line; right to left, left to right—is very satisfying, and when done slowly and deliberately, helps to induce contemplation. One day, as I was thoughtfully drawing the labyrinth, it suddenly occurred to me that, in addition to the symbolism of the Search, or the Conquest of Death, etc, implicit in this design, the actual process of drawing it contained within itself a profound symbolic meaning, which alone would suffice to account for the long persistence of the labyrinth as a revered symbol.

'On first setting down the cross with the four dots within its outstretched arms, I noted that the individual dots suggested four distinct nuclei, separated from each other by the arms of the cross—separated even more if one has used arcs or angles to set off the dots. As the pattern progressed, the four scattered dots merged with the developing lines, and disappeared.

'Then, as I threaded my way back through the narrow lanes in the completed pattern, to place a large dot at the end of the passage in its center, I suddenly realized that, by doing this, I replaced the formerly scattered nuclei, now lost, by a single, central nucleus. In other words, the initial symbol of disorientation, had developed into a symbol of well-integrated wholeness, a veritable con*centr*ation.

'This seemed to represent the active process of achieving personal integration on the human plane—whether that was accomplished through tribal initiation-training, or though the spiritual alchemy of the Middle Ages, or through modern psychoanalysis.

'The whole process of making the labyrinth, then entering it to add the central nucleus, so neatly represents man's Eternal Quest—for self-knowledge, the way to full maturity, the path to spiritual enlightenment, I feel sure this realization could not have been unique with me. It must have occurred to many others, over centuries, and would easily account for the use of the labyrinth in training youths among the Hopi and other peoples. This seems to me the most significant meaning of the multivalent labyrinth —on the human level.

'Even these explanations would not have exhausted the subject for Carl Schuster. Although he was generally reticent about discussing the inner meaning of traditional symbols, he more than once intimated to me that, like the sages of old and his mentor Ananda Coomaraswamy, his mind continued to climb the *Axis Mundi* on the greatest of all quests: the spiritual ascent to find the meaning of Life, at the core of the Third Labyrinth, on the highest level of existence, beyond the Sky Door.

'Various religions have tried to predict what must be there, but the reality at the heart of that uttermost labyrinth must ever remain hidden from full human comprehension. Tradition has maintained that only totally purified souls could ultimately reach the goal of that highest quest—perhaps after many lifetimes of preparation—but the concept of that search has provided an aim for seeking minds, and has given to many persons in the past a reasonable explanation for the meaning and ends of human existence'.

References

Except for the examples listed below, all specimens illustrated here, as well as all sources quoted, are identified at length in Carl Schuster and Edmund Carpenter, *Social Symbolism in Ancient & Tribal Art*, Rock Foundation, New York, 1986–1988. Copies of this work have been deposited in 600 libraries throughout the world.

Cover: engraving (detail) of tattooed Marquesan male, based on 1804 drawing by A. Tureziycb; from Adam Johann von Krusenstern, *Atlas zur Reise um die Welt . . .* St. Petersburg, 1814, pl. 8. Design: South Street Seaport Museum.

18: petroglyph, Yenisey, Siberia, Anatoly I. Martynov, *The Ancient Art of Northern Asia*, 1991, fig. 135; *35*, megalith, 7th–8th century, Senegal, Musée des Arts de l'Afrique et l'Oceanie, Paris; *251*, woven bag, New Guinea, Michael O'Hanlan, *Portraying the New Guinea Highlands*, 1993, fig. 40; *p. 75*: drawing of Ratak male, Micronesia, Ludovic Choris, Beineke Rare Book and Manuscript Library, Yale University, New Haven, see Louis Choris, *Voyage pittoresque à tour du monde*, 1822, pl. XIII; *336*: Ban Chiang painted vessel, Jeannine Auboyer *et al*, *Oriental Art:*

A Handbook of Styles and Forms, 1980, p. 199, #160; *377*: spatula, Trobriand Islands, Field Museum of Natural History, Chicago, 275965; *387*: one of a pair of Tlingit house posts, Alaska, National Museum of Natural History, Washington, 231038/9; *447*: kinship diagram, Anthony Jackson, 'Pictish Symbol Stones?', *The Association for Scottish Ethnography, Monograph 3*, 1993, p. 29; *463*: Mimbres painted vessel, Arizona, Harriet S. and Cornelius B. Cosgrove, 'The Swartz Ruin', *Papers of the Peabody Museum of Archaeology and Ethnology*, 15:1, 1932, fig. 228d; *464*: Mimbres painted vessel, Arizona, J. J. Brody *et al*, *Mimbres Pottery*, 1983, fig. 124; *465*: Bidahochi jar, Arizona, private collection, Aspen, Colorado; *p. 188*: quotation, James Boswell, *Life of Johnson*; *537*: painted pottery jar, Susa, Iran, Musée des antiquites nationales, St. Germain-en-Laye, #63772; *633*: paleolithic figurine, Malta site, Siberia, Henri Delacorte, *L'image de la femme dans l'art préhistorique*, 1993, p. 199, fig. 24; *p. 28*: quotation, Anthony Jackson, *ibid*, 1993, p. ii; *692*: wood engraving, *Quinta*, 1574, by Leonhardt Thurneysser.